VISUAL ARTSGUIDE

VISUAL ARTSGUIDE

A Basic and Cyber Sourcebook

Dennis J. Sporre

Upper Saddle River, New Jersey 07458

Library of Congress Cataloging-in-Publication Data

Sporre, Dennis J.
 Visual artsguide : a basic and cyber sourcebook / Dennis J. Sporre.
 p. cm.
 Includes bibliographical references and index.
 ISBN 0-13-041613-4
 1. Art appreciation—Study and teaching (Higher) I. Title.
 N345 .S68 2001
 709—dc21

 2001021420

Editorial Director: *Charlyce Jones Owen*
Acquisition Editor: *Bud Therien*
Director of Marketing: *Beth Gillett Mejia*
Managing Editor: *Jan Stephan*
Production Liaison: *Fran Russello*
Project Manager: *Publications Development Company of Texas*
Prepress and Manufacturing Buyer: *Sherry Lewis*
Art Director: *Jayne Conte*
Cover Designer: *Bruce Kenselaar*
Marketing Manager: *Sheryl Adams*

This book was set in 10/12 Goudy by Publications Development Company
of Texas and was printed and bound by RR Donnelley & Sons Company.
The cover was printed by Phoenix Color Corp.

© 2002 by Pearson Education, Inc.
Upper Saddle River, New Jersey 07458

10 9 8 7 6 5 4 3 2 1

ISBN 0-13-041613-4

Pearson Education Ltd., *London*
Pearson Education of Australia Pty. Limited, *Sydney*
Pearson Education Singapore, Pte. Ltd.
Pearson Education North Asia Ltd., *Hong Kong*
Pearson Education Canada, Ltd., *Toronto*
Pearson Educación de Mexico, S.A. de C.V.
Pearson Education—Japan, *Tokyo*
Pearson Education Malaysia, Pte. Ltd.
Pearson Education, Upper Saddle River, New Jersey

To my wife, Hilda

Contents

Preface

The purpose of a textbook is to provide information that meets its intended audience where they are. *Visual Artsguide* seeks a specific niche as a basic, concise, and inexpensive compendium for courses that introduce art to general students. (Its length and illustration program are dictated by its purpose.) *Visual Artsguide* also attempts to stimulate an active pursuit of new experiences in a familiar venue: the Internet. This book will not serve every circumstance nor meet every expectation. It is for those who wish a skeletal compendium of basic information. It provides an outline that allows instructors room to fill in the spaces according to their own predilections and the specific needs of their courses and students.

Visual Artsguide accepts the challenge that most artistic terms and concepts are complex and subject to change. Definitions and concepts in this text are treated at a basic and general level. If a course demands greater sophistication, an instructor easily can add those layers. Knowing what to look at in a work of art

is one step toward developing discriminating perception and getting the most from a relationship with art. Introducing the aesthetic experience through terminology may be arguable, but this approach gains credence from the College Board's statement on Academic Preparation for College, where use of "the appropriate vocabulary" is emphasized as fundamental. Vocabulary isolates characteristics of what to see in individual works of art and focuses perceptions and responses. We cannot understand or recognize how art works nor communicate our discoveries with others without the command of an appropriate vocabulary.

This step, however, is only the beginning. When we develop confidence in approaching works of art by knowing certain basic terms and concepts, then we want more, and that leads to making study and involvement with the arts a lifetime venture. That lifetime involvement (as a consumer of and respondent to rather than a maker of art) ought to be the goal of every general art introduction course.

I humbly bring to this project nearly half a century of studying, practicing, teaching, and experiencing the arts. Even that, however, does not make every piece of information in this book a reflection of my own general knowledge. With regard for readability and the general nature of the text, I have tried to avoid footnotes. In that regard, the bibliography at the end of the text (under the heading "Further Reading") provides a reference list of the works used in preparation of this text. I hope this method of presenting and documenting the works of others meets the requirements of both responsibility and practicality.

I wish to acknowledge the following Prentice Hall reviewers: Stephen Smithers, Indiana State University; Alberto Meza, Miami-Dade Community College; Sarah McCormick, Kapiolani Community College; Herbert R. Hartel, Jr., John Jay College, City University of New York; Gene Hood, University of Wisconsin Eau Claire; Michael R. Kapetan, University of Michigan; Dennis Dykema, Buena Vista University; and Mary Francey, University of Utah. I am grateful, as always, to Bud Therien at Prentice Hall, who, for more than twenty years, has been my editor, publisher, and guide, for the idea for this book. I am even more grateful to my wife, Hilda, for her patience, editorial and critical assistance, and love.

DENNIS J. SPORRE

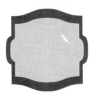

Introduction

Where Are We Going?

How Do I Use This Book and Learn about Art?

Driving a car for the first time usually requires a preoccupation with mechanics and an intense concentration on keeping the car moving in a straight line. As technical details become habitual, drivers can attend to more important details of driving.

Experiencing art is somewhat like driving a car. When the experience is new and when studious attempts are made at doing it "right," or amassing materials for a classroom assignment, the details often can interfere with the larger experience. Obsession with finding specific details—what a book or a teacher has indicated should be the objects of looking—frequently robs the occasion of its pleasure and meaning. Nonetheless, with practice, the details do fall into place, and the payment in heightened enjoyment and sense of personal achievement—sophistication, some might say—expands exponentially.

Getting to that point, however, requires a beginning. Perceiving anything requires understanding what there is to perceive, and one purpose of this book is to provide a usable outline of the basics: things that can be seen and responded to in works of visual art and architecture. In addition, this book can serve as a reference for understanding the fundamental qualities of artistic style. The chapters treating art history comprise an outline of art history, with Internet hyperlinks to additional examples to study.

WHAT HAPPENS WHEN WE CONNECT TO THE WORLD WIDE WEB?

When using this book in the "cyber" world, URLs to connect with the World Wide Web serve as springboards for further investigation. Some of the URLs lead to actual artworks, and these can further illustrate the principles and

styles discussed and illustrated in the text. Many of the Web sites yield more detailed information about artists, styles, periods, general history, and so on. With regard to URLs, however, a warning is necessary. First, things change. A Web site that was active when this book went to press may no longer exist. (Wherever possible, works from major museums have been chosen, and those Web sites should remain active or should be accessible by finding museum's home page through a standard search engine. Then, using the "collection" option will lead to an index from which the artist and work can be accessed.) Second, an initial attempt to link to a site may prove unsuccessful: "Unable to connect to remote host." A rule of thumb is to try to connect to the site three successive times before trying another URL. Be careful to type the URL exactly. Any incorrect character will cause the connection to fail. (Capital letters matter.)

In addition to the specific Web addresses listed in the text, some general sites can provide a wealth of additional information. An easy and vast reference for visual art and architecture is the Artcyclopedia at http://www.artcyclopedia.com/index.html. Here, individual artists can be referenced along with their artworks, as can searching by style, medium, subject, and nationality. A good architectural archive is Mary Ann Sullivan's Digital Imaging Project at http://www.bluffton.edu/~sullivanm/index/index2.html#P, although this site is among the redirects located in the Artcyclopedia just mentioned. Art History Resources on the Net, at http://libweb.sdsu.edu/sub_libs/cfields/art.html, provides many useful hyperlinks.

HOW DO I PRONOUNCE ALL THE NAMES AND TERMS?

The study of art brings us face to face with many challenging terms (many of them in a foreign language) and names. To assist

acquaintanceship, each term or name not pronounced exactly as it appears is followed, in parenthesis, by a pronunciation guide. This guide has two features. First, it uses familiar English consonant and vowel representations, rather than International Phonetics. Second, emphasis is indicated by capital letters.

The realm of art holds potential for great personal enrichment and excitement. Hopefully, this book will stimulate curiosity and lead the reader to find so much in works of art that the world will no longer appear as it once did. This book will have done its job when, at some time in the future, the reader no longer needs its references because the contents have become, like the aesthetic experiences they treat, old friends and comfortable companions.

HOW DO WE PUT THIS STUDY IN CONTEXT?

Humans are a creative species. Whether in science, politics, business, technology, or the arts, we depend on our creativity almost as much as anything else to meet the demands of daily life. Any book about art is a story about us: our perceptions of the world as we have come to see and respond to it and the ways we have communicated our understandings to each other since the Ice Age, more than 35,000 years ago (Figure I.1, The Cave at Lascaux).

Our study in this text will focus on vocabulary and perception, as well as on history. First, however, we need to have an overview of where visual art and architecture falls within the general scope of human endeavor.

We live in buildings and listen to music constantly. We hang pictures on our walls and react like personal friends to characters in television, film, and live dramas. We escape to parks, engross ourselves in novels, wonder about a statue in front of a public building, and dance through the night. All of these situations involve forms called "art" in which we engage and are engaged daily.

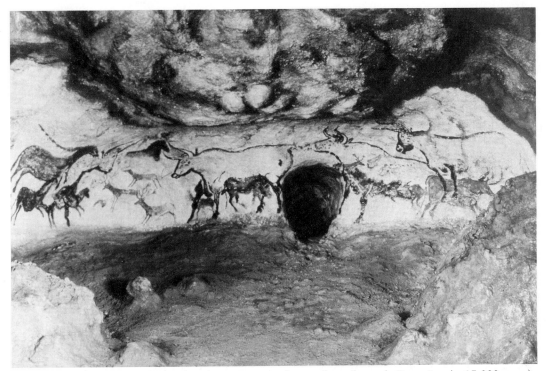

Figure I.1 General view of cave chamber at Lascaux, France, from the early Stone Age (c. 15,000 B.C.E.) /AKG London Ltd.

Curiously, as close to us as these "art" activities are, in many ways they remain mysteries. How do they, in fact, fit into the larger picture of the human reality that we experience?

We have learned a great deal about our world and how it functions since the human species began more than 35,000 years ago, and we have changed our patterns of existence. However, the fundamental characteristics that make us human—that is, our ability to intuit and to symbolize—have not changed. Art, the major remaining evidence we have of our earliest times, reflects these unchanged human characteristics in inescapable terms.

As we begin this text, learning more about our humanness through art, let us start where we are. That means two things. First, it means relying on the perceptive capabilities we already have. Applying our current abilities to

perceive will develop confidence in approaching works of art. Second, starting where we are means learning how art fits into the general scheme of the way people examine, communicate, and respond to the world around them. A course in art, designed to fulfill a non-major requirement for a specified curriculum, means that art fits into an academic context that separates the ways people acquire knowledge. Consequently, our first step in this exploration of art will be to place art in some kind of relationship with other categories of knowledge. Visual art and architecture belongs in a broad category of pursuit called the "arts and humanities," and that is where we begin.

The humanities, as opposed, for example, to the sciences, can very broadly be defined as those aspects of culture that look into what it means to be human. But despite our

desire to categorize, there really are few clear boundaries between the humanities and the sciences. The basic difference lies in the approach that separates investigation of the natural universe, technology, and social science from the search for truth about the universe undertaken by artists.

Within the educational system, the humanities traditionally have included the fine arts, literature, philosophy, and, sometimes, history. These subjects are all oriented toward exploring what it is to be human, what human beings think and feel, what motivates their actions and shapes their thoughts. Many answers lie in the millions of artworks all around the globe, from the earliest sculpted fertility figures to the video and cyber art of today. These artifacts and images are themselves expressions of the humanities, not merely illustrations of past or present ways of life.

In addition, change in the arts differs from change in the sciences, for example, in one significant way: New technology usually displaces the old; new scientific theory explodes its predecessors; but new art does not invalidate earlier human expression. Obviously, not all artistic

The Cave at Lascaux

Perhaps a sanctuary for the performance of sacred rites and ceremonies, the Main Hall, or Hall of the Bulls (Figure I.1), elicits a sense of power and grandeur. The thundering herd moves below a sky formed by the rolling contours of the stone ceiling of the cave, sweeping our eyes forward as we travel into the cave itself. At the entrance of the main hall, the eight-foot "unicorn" begins a larger-than-lifesize montage of bulls, horses, and deer, which are up to twelve feet tall. Their shapes intermingle with one another, and their colors radiate warmth and power. These magnificent creatures remind us that their creators were capable technicians who, with artistic skills at least equal to our own, were able to capture the essence beneath the visible surface of the work. The paintings in the Main Hall were created over a long period of time and by a succession of artists, yet their cumulative effect in this thirty- by one-hundred-foot domed gallery is that of a single work, carefully composed for maximum dramatic and communicative impact.

Nonetheless, we can only speculate about *why* Ice Age people created these paintings, and about the role the paintings may have played in that culture. Despite the cumulative effect of the paintings, there does not seem to be any overall planned composition, suggesting, perhaps, that the act of painting was more important than the finished product. Perhaps the purposes were ritualistic. The paintings are deep in the caves, whereas daily life was lived near the entrances, perhaps implying that the paintings may have been intended to suggest the "womb" of mother earth in the hope that more of the creatures, whom paleolithic people hunted, would be born.

approaches survive, but the art of Picasso cannot make the art of Rembrandt a curiosity of history the way that the theories of Einstein did the views of William Paley. Nonetheless, much about art has changed over the centuries. In Chapters 7 through 11, it will become clear that the role of the artist can change depending on the nature of the age. Using a spectrum developed by Susan Lacy in *Mapping the Terrain: New Genre Public Art* (1995), we learn that at one time an artist may be an *experiencer*; at another, a *reporter*; at another, an *analyst*; and at still another time, an *activist*. Further, the nature of how art historians see art has changed over the centuries—for example, today we do not credit an artist's biography with all of the motivations for his or her work; and we now include works of art from previously marginalized groups such as women and minorities. These shifts in the discipline of art history itself are important considerations as we begin to understand the nature of art.

Finally, works of art can be approached with the same subtleties we normally apply to human relationships. We know that people cannot simply be categorized as "good" or "bad," as "friends," "acquaintances," or "enemies." We relate to other people in complex ways. Some friendships are pleasant but superficial, some people are easy to work with, and others (but few) are lifelong companions. Similarly, when we have gone beyond textbook categories and learned how to approach art with this sort of sensitivity, we find that art, like friendship, has a major place in the growth and quality of life.

What Does Art Do?

What's in This Chapter?

We begin our study with a foray into the foundation structure of art itself and how it might relate to us. We will do this in response to five general questions: (1) *What Concerns Art?* (2) *To What Purposes and Functions?* (3) *How Should We Perceive and Respond?* (4) *Can We Figure Out Style?* and (5) *How Do We Live with Art?*

WHAT CONCERNS ART?

Scholars, philosophers, and aestheticians have attempted to define art for centuries without yielding many adequate results. The pop artist Andy Warhol, whose work includes the painting *Green Coca Cola Bottles* (Figure 1.1), reportedly said that "Art is anything you can get away with." Introducing such a statement so early in our study, and doing so without further discussion about Warhol and his art, might seem to undercut the seriousness that a study of art requires. There is merit in such a reaction. The study of art is serious because without serious study we cannot comprehend the profound implications that art has on the quality of our lives. Warhol's supposed quote, without explanation, does no service to understanding art and its significant role in human history or our current existence. On the other hand, of course, we should be careful not to confuse the study of art with art itself, because there is a danger that we might equate seriousness of study with sanctification of art, which would be equally problematical. Some art is serious, some art is profound, and some art is highly sacred. On the other hand, some art is light; some, humorous; and some, downright silly, superficial, and self-serving for its artists. For some artists, art may very well be anything they can get away with, but there is more to it than that, as the centuries-old scholarly debate noted at the beginning of this paragraph has frustratingly revealed.

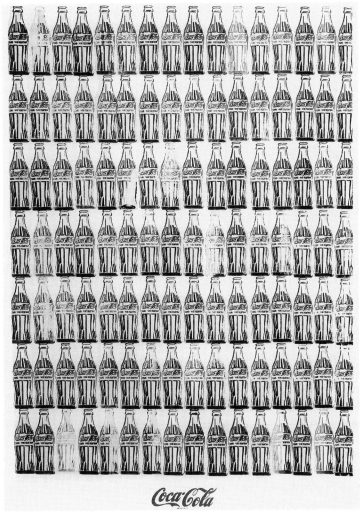

Figure 1.1 Andy Warhol, *Green Coca Cola Bottles* (1962). Oil on canvas, 209.6cm × 144.8cm (6'10" × 4'9"). Collection of Whitney Museum of American Art, New York. Purchased with funds from the Friends of the Whitney Museum of American Art (68.25). Photograph Copyright © 2001, Whitney Museum of American Art. © 1999, The Andy Warhol Foundation for the Visual Arts, Artists Rights Society (ARS), New York.

Why must we concern ourselves with such details? We need to attend to what art might be, might attempt, and might concern, because we need a sense of order—that is, an idea of what we're dealing with—for the discussions following in this text. We begin with some concerns that, although they may not define art, at least comprise important aspects of it, through history. These concerns comprise (1) creativity; (2) aesthetic communication; (3) symbols; and (4) "fine art" and "applied art."

Creativity

Art has always evidenced a concern for creativity—that is, the act of bringing forth new forces and forms. How this functions is subject for further debate. Nonetheless, something

happens in which humankind takes chaos, formlessness, vagueness, and the unknown and crystallizes them into form, design, inventions, and ideas. Creativity underlies our existence. It allows scientists to intuit that there is a possible path to a cure for cancer, for example, or to invent a computer. The same process allows artists to find new ways to express ideas through processes in which creative action, thought, material, and technique combine in a medium to create something new, and that "new thing," without words, triggers human experience—that is, our response to the artwork. Creativity lets Peter Paul Rubens find a way to express sacred ideas in complex forms, lines, and colors (Plate 1), different from his Renaissance predecessors (Figure 2.17). Creativity lets a contemporary artist take the human form and, through high technology, turn it into a map (Figure 11.10) as opposed to the lifelike representation of Michelangelo (4.10).

In the midst of this creative process is the art medium. Although most people can readily acknowledge the traditional media—for example, painting, traditional sculpture, and printmaking—sometimes when a medium of expression does not conform to expectations or experiences, the work's very artistry is questioned. For example, Figure 1.2 shows one gigantic installation, in two parts, of blue and yellow umbrellas in Japan and the United States, respectively, created (and entirely financed) by the artists Christo and Jeanne-Claude. The umbrellas were only the physical manifestation of a larger idea that the artists considered to be the whole work.

Aesthetic Communication

Art usually involves communication. A common factor in art is some humanizing experience. Arguably, artists need other people with whom they can share their perceptions. When artworks and humans interact, many possibilities exist. Interaction may be casual and fleeting, as in the first meeting of two people, when one or both are not at all interested in each other. Similarly, an artist may not have much to say, or may not say it very well. For example, a poorly conceived and executed painting probably will not excite a viewer. Similarly, if a viewer is self-absorbed, distracted, unaware, has rigid preconceptions not met by the painting, or is so preoccupied by what may have occurred outside the museum that he or she finds it impossible to perceive what the artwork offers, then at least that part of the artistic experience fizzles. On the other hand, all conditions may be optimum, and a profoundly exciting and meaningful experience may occur: The painting may treat a significant subject in a unique manner, the painter's skill in manipulating the medium may be excellent, and the viewer may be receptive. Or the interaction may fall somewhere between these two extremes. In any case, the experience is a human one, and that is fundamental to art.

Throughout history, artistic communication has involved *aesthetics.* Aesthetics is the study of the nature of beauty and of art and comprises one of the five classical fields of philosophical inquiry—along with epistemology (the nature and origin of knowledge), ethics (the general nature of morals and of the specific moral choices to be made by the individual in relationship with others), logic (the principles of reasoning), and metaphysics (the nature of first principles and problems of ultimate reality). The term *aesthetics* (from the Greek for "sense perception") was coined by the German philosopher Alexander Baumgarten in the mid-eighteenth century, but interest in what constitutes the beautiful and in the relationship between art and nature goes back at least to the ancient Greeks. Both Plato and Aristotle saw art as *imitation* and beauty as the expression of a universal quality. For the Greeks, the concept of "art" embraced all handcrafts (see p. 10), and the rules of

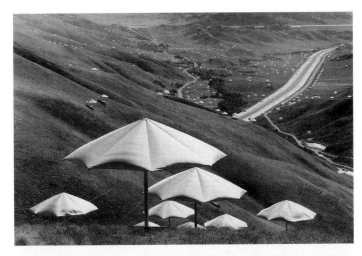

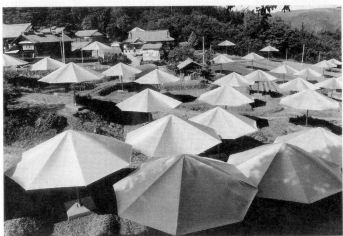

Figure 1.2 Christo and Jeanne-Claude, *The Umbrellas,* Japan-USA (1984–1991). (Top) Valley north of Los Angeles, California, USA site. 1,760 yellow umbrellas; (Bottom) Valley in prefecture of Ibaraki, Japan, 1,340 blue umbrellas. Combined length: 30 miles. © Christo, 1991. Photographs: Wolfgang Volz.

symmetry, proportion, and unity applied equally to weaving and pottery, poetry and sculpture. In the late eighteenth century, the philosopher Immanuel Kant revolutionized aesthetics in his *Critique of Judgment* (1790) by viewing aesthetic appreciation not simply as the perception of intrinsic beauty, but as involving a judgment—subjective, but informed. Since Kant, the primary focus of aesthetics has shifted from the consideration of beauty per se to the nature of the artist, the role of art, and the relationship between the viewer and the work of art.

Symbols

Art is also concerned with symbols. Symbols are things that represent something else. That is, they are a physical emblem of something abstract. Artists often use a material object to suggest something less tangible or less obvious: a wedding ring, for example, might signify

eternal love and devotion. Symbols differ from signs, which suggest a fact or condition. Signs are what they denote. Symbols carry deeper, wider, and richer meanings. Look at Figure 1.3. Some people might identify this figure as a plus sign in arithmetic. But the figure might also be a Greek cross, in which case it becomes a symbol because it suggests many images, meanings, and implications. Artworks use a variety of symbols to convey meaning. By using symbols, artworks can relay meanings that go well beyond the surface of the work and offer glimpses of the human condition that cannot be sufficiently described in any other manner. Symbols make artworks into doorways leading to enriched meaning.

Fine and Applied Art

Having said all that, we may not be any closer to defining art precisely, but we should have a better understanding of what art may concern or seek to be. One last consideration in our understanding of art's basics involves the difference between *fine art* and *applied art*. The "fine arts"—generally meaning painting, sculpture, and architecture—are prized for their purely aesthetic qualities. During the Renaissance (see Chapter 8), these arts rose to superior status because Renaissance values lauded individual expression and unique aesthetic interpretations of ideas. The term

"applied art" sometimes includes architecture and the "decorative arts" and refers to art forms that have a primarily decorative rather than expressive or emotional purpose. The decorative arts include handicrafts by skilled artisans, such as ornamental work in metal, stone, wood, and glass, as well as textiles, pottery, and bookbinding. The term may also encompass aspects of interior design. In addition, personal objects such as jewelry, weaponry, tools, and costumes are considered to be part of the decorative arts. The term may extend, as well, to mechanical appliances and other products of industrial design. The term *decorative art* first appeared in 1791. Many decorative arts, such as weaving, basketry, or pottery, are also commonly considered to be "crafts," but the definitions of the terms are somewhat arbitrary and without sharp distinction.

TO WHAT PURPOSES AND FUNCTIONS?

Another way we can expand our understanding of art is to examine some of its purposes and functions. In terms of the former—that is, art's purposes—we are asking, What does art do? In terms of the latter—that is, art's functions—we are asking, How does it do it? Essentially, art does four things: (1) It provides a record; (2) it gives visible form to feelings; (3) it reveals metaphysical or spiritual truths; and (4) it helps people see the world in new or innovative ways. Again, art can do any or all of these. They are not mutually exclusive.

Until the invention of the camera, one of art's principle purposes was to enact a record of the world. Although we cannot know for sure, very likely the cave art of earliest times did this. Egyptian art, ancient Greek art, Roman art, and so on, all undertook to record its times in pictorial form, whether on a vase or, as in the case of the eighteenth-century Italian painter Canaletto, in highly naturalistic *vedute*

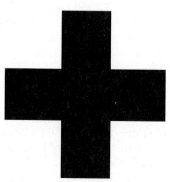

Figure 1.3 Greek cross?

(vay-DOO-tay; Italian for *views*) that he sold to travelers doing the grand tour of Europe. Interestingly, some *vedutisti* sometimes altered the "real" views of the cities they represented. This, of course, raises the issue of how even what appears a verifiably real, record, can, in fact, be an illusion.

CYBER EXAMPLE

Canaletto, *Grand Canal from Palazzo Flangini to Palazzo Bembo* (Minneapolis Institutute of Arts, Minnesota)
http://www.artsmia.org/uia-bin/uia_doc.cgi/query/2?uf=uia_StJqWj

Art can also give visible form to feelings. Perhaps the most explicit example of this aspect of art comes in the Expressionist style of the early twentieth century. Here feelings and emotions of the artist toward content formed a primary role in the work. A discussion of this style and its objectives can be found in Chapter 10, page 172, but we can note at this point that "feelings" can be referenced in works of art through technique—for example, brush stroke—and through color, both of which have long associations with emotional content.

A third purpose of art can be the revelation of metaphysical or spiritual truths. Here, for examples, we can turn to the great Gothic cathedrals of Europe (Chapter 7), whose light and space perfectly embodied medieval spirituality. The rising line of the cathedral reaches, ultimately, to the point of the spire, which symbolizes the release of earthly space into the unknown space of heaven. A tribal totem, such as a Bakota ancestor figure (Figure 4.5) deals almost exclusively in spiritual and metaphysical revelation.

Finally, as a fourth purpose, most art, if it is well done, can assist us in seeing the world around us in new and surprising ways. Art that has, for example, abstract content may reveal a new way of understanding the interaction of life forces, as does the work of Piet Mondrian (peet MOHN-dree-ahn; Figure 2.22 and associated discussion).

In addition to its purposes (what it does), art also has many functions (how it does what it does), including (1) enjoyment, (2) its use as a political and social weapon, and (3) its existence as an artifact. One function is no more important than the others. Nor are they mutually exclusive; one artwork may fill many functions. Nor are the three functions just mentioned the only ones. Rather, they serve as indicators of how art has functioned in the past and can function in the present. Like the types and styles of art that have occurred through history, these three functions and others are options for artists and depend on what artists wish to do with their artworks.

Enjoyment

Works of art can provide escape from everyday cares, treat us to a pleasant experience, and engage us in social occasions. Works of art that provide enjoyment may perform other functions as well. The same artworks we enjoy may also create insights into human experience. We can also glimpse the conditions of other cultures, and we can find healing therapy in enjoyment.

An artwork in which one individual finds only enjoyment may function as a profound social and personal comment to another. Grant Wood's painting *American Gothic* (Figure 1.4) may amuse us, and/or provide a tongue-in-cheek commentary about rural American life, and/or move us deeply. The result depends on the artist, the artwork, and us.

Political and Social Commentary

Art may have political or social function, such as influencing the behavior of large groups of people. It has functioned thus in the past and continues to do so. Eugène Delacroix's (deh-luh-QUAH) painting *The 28th July: Liberty*

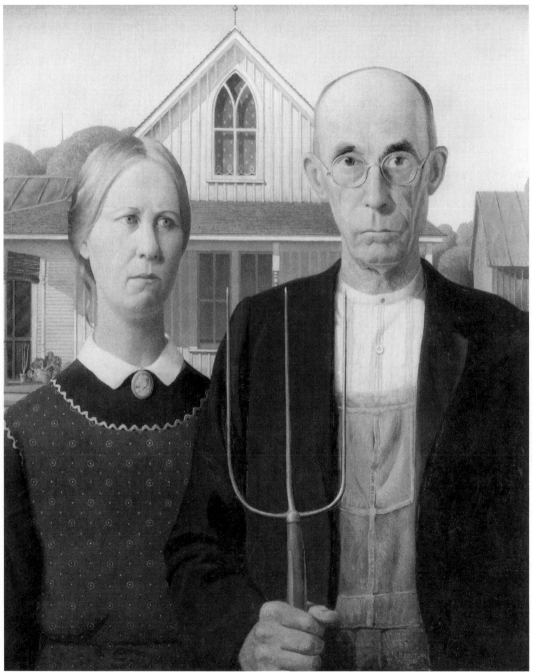

Figure 1.4 Grant Wood, American (1891–1942), *American Gothic* (1930). Oil on beaver board, 76cm × 63.3cm (30″ × 25″). Friends of American Art Collection. Photograph © 1990. All rights reserved by The Art Institute of Chicago and VAGA, New York.

Leading the People illustrates. In July 1830, for three days known as the Trois Glorieuses (the Glorious Three), the people of Paris took up arms to bring in a parliamentary monarchy, in hopes of restoring the French Republic. Eager to celebrate July 28, Delacroix painted the allegorical figure of Liberty waving the tricolor flag of France and storming the corpse-ridden

PROFILE

Grant Wood
American Gothic

Grant Wood's painting *American Gothic* (Figure 1.4) represents the realist tradition (see Glossary) in American painting. It is a wonderful celebration of the simple, hard-working people of America's heartland. There is a lyric spirituality behind the façade of this down-home illustration. The elongated forms are pulled up together into a pointed arch that encapsulates the Gothic window of the farmhouse and escapes the frame of the painting through the lightning rod. Rural American reverence for home and labor is celebrated here with gentle humor as Wood contrasts conservative, down-home, plain farm folks with the sophisticated "old-world" culture of Europe.

barricades with a young combatant at her side. The painting was reviled by some Frenchmen and was hidden in 1831 for fear of inciting public unrest. In the United States today, many artworks act as vehicles to advance social and political causes, or to sensitize viewers to particular cultural situations such as racial prejudice and AIDS.

Artifact

A work of art also functions as an artifact. A product of a particular time and place, an artwork represents the ideas and technology of that specific time and place. Artworks often provide not only striking examples but also, occasionally, are the only tangible records of some peoples. Artifacts, like paintings, sculptures, and buildings, enhance our insights into cultures, including our own. Consider, for example, the many revelations we find in a sophisticated work like the Igbo-Ukwu roped pot on a stand (Figure 1.5). This ritual water pot from the village of Igbo-Ukwu in eastern Nigeria was cast using the *cire perdue* (seer pair-DOO) or "lost wax" process (a casting method using wax to create a mold; see Figure 4.8) and is amazing in its virtuosity. It tells us much about the vision and technical accomplishment of this ninth-century African society.

The Igbo-Ukwu pot suggests that when we examine art in the context of cultural artifact, one of the issues we face is the use of artworks as items in, or as part of, a religious ritual. We could consider ritual as a separate function of art. We may not think of religious ritual as art at all; yet, in a broad context, ritual often qualifies as art. The Igbo-Ukwu pot certainly serves as a good example. Here is a work of sculpture in whose beauty and craftsmanship we may find an aesthetic experience. Yet, its original purpose served ritualistic ends. Often we cannot discern where ritual stops and secular occurrence starts. Whenever ritual, planned and intended for presentation, uses a traditional

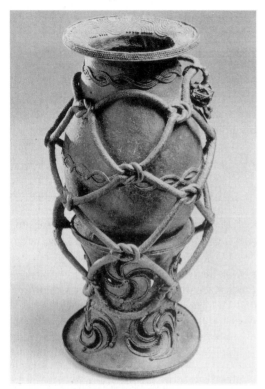

Figure 1.5 Roped pot on a stand, from Igbo-Ukwu (ninth or tenth century). Leaded bronze, height 12½"/South African Tourism Board.

artistic medium, whether two-dimensional art, sculpture, architecture (or music, dance, and theater), we can legitimately study ritual as art, and see it also as an artifact of its particular culture.

HOW SHOULD WE PERCEIVE AND RESPOND?

The question of how we go about approaching art, or how we study it in a text, presents the next challenge. Myriad methods are available, and so it remains to choose one and carry on from there. The purpose of this book is to provide a concise reference that covers all the visual arts. We assume those who are interested in such a work have had only limited exposure to the arts. So we have chosen a method of study that can act as a springboard into art, as a point of departure from the realm of the familiar into the unknown. Inasmuch as we live in a world of facts and figures, weights and measures, it seems logical to begin our study by dealing with some concrete characteristics. In other words, from mostly a practical point of view, what can we see in the visual arts?

To put that question in different terms, how can we sharpen our aesthetic perception?

- First of all, we must identify those items that can be seen in works of art.
- Second, we must learn—just as we learn in any subject—some of the terminology relating to those items.
- Third, we must understand why and how what we perceive relates to our response.

It is, after all, our response to an artwork that interests us. We can perceive an object. We choose to respond to it in aesthetic terms.

An aesthetician (a critic concerned with the theory of beauty and the fine arts), Harry Broudy, has suggested that one way of approaching art is to ask four questions about it: (1) What is it? (2) How is it put together? (3) How does it affect the senses? (4) What does it mean? Although we do not follow this formula precisely in this book, further explanation of this approach can assist us in dealing with works of art.

When we respond to the question, What is it?, we make a formal response. We recognize that we are perceiving the two-dimensional space of a picture, the three-dimensional space of a sculpture, or a piece of architecture. We also recognize the form of the item—for example, a still life, a human figure, or an office building. (The term *form* is a broad one: There are art forms, forms of art, and forms in art.)

When we respond to the question, How is it put together? we respond to the technical elements of the artwork. We recognize and respond to, for instance, the fact that the picture has been done in oil, made by a print-making technique, or created as a watercolor. We also recognize and respond to the elements that constitute the work, the items of composition—line, form or shape, mass, color, repetition, harmony (see Chapter 2)—and the unity that results from all of these. What devices have been employed, and how does each part relate to the others to make a whole?

Moving to the third question, we examine how the work stimulates our senses—and why. In other words, how do the particular formal and technical arrangements (whether conscious or unconscious on the part of the artist) elicit a sense response from us? Here we deal with physical and mental properties. For example, our response to sculpture can be physical. We can touch a piece of sculpture and sense its smoothness or its hardness. In contrast, we experience sense responses that are essentially mental. For example, upright triangles give us a sense of solidity. When we perceive the colors green and blue, we call them "cool"; by contrast, reds and yellows are "warm" colors. Pictures that are predominantly horizontal or composed of broad curves are said to be "soft" or placid. Angular, diagonal, or short broken lines stimulate a sense of movement. These and other sense responses tend to be universal; most individuals respond in similar fashion to them.

We can also ask a fourth question about a work of art: What does the work mean? We may answer that question in strictly personal terms. For example, a particular painting may remind us of some personal experience. However, we cannot limit the question, What does it mean? to purely personal references. Meaning in a work of art implies much more. The ultimate response to an artwork goes beyond mere opinion to encompass an attempt to understand what the communicator may have had in mind. It is not sufficient, for example, merely to regard to disproportionate forms of a Mannerist painting like Parmigianino's (pahr-mih-zhee-ah-NEE-noh) painting *Madonna*

CYBER EXAMPLE

Parmigianino, *Madonna with the Long Neck* (Uffizi Gallery, Florence, Italy)

http://sunsite.auc.dk/cgfa/p/p-parmigi1 .htm

with the Long Neck as "strange." Meaning implies an understanding of the discomforting circumstances of religion and society that existed during that period. When we understand that, we may understand why the paintings of that period appear as they do. We may also sympathize with the agonies of individuals trying to cope with their universe. As a result, the "strangeness" of the artwork may come to mean something entirely different to us from what we first thought. Sometimes meaning in an artwork can be enhanced by understanding cultural or historical contexts, including biography. Sometimes artworks spring from purely aesthetic necessity. Sometimes it is difficult to know which case applies, or indeed whether both cases can apply.

CAN WE FIGURE OUT STYLE?

The manner in which artists express themselves constitutes their style. Style is tantamount to the personality of an artwork. However, applying its connotations to a body of artworks calls for breadth and depth of knowledge. Style is that body of characteristics that identifies an artwork with an individual, a historical period, a school of artists, or a nation. When we talk about a work of art as realistic, or expressionistic, or abstract, and so on, we are taking about its style. Applying the

term means assimilating materials and drawing conclusions.

Therefore, determining the style of any artwork requires analysis of how the artist has arranged the characteristics applicable to his or her medium. If the usage is similar to other art works, we might conclude they exemplify the same style. A comparison of the precision and symmetry of the Parthenon (PAHR-theh-nahn; see Figure 5.2) with the ornate opulence of the Palace of Versailles (vair-SIGH Fig. 5.29) suggests that, in line and form, the architects of these buildings treated their medium differently. Yet the design of the Parthenon is very much a visual companion, stylistically, of David's (dah-VEED) *The Oath of the Horatii* (hor-AY-shee-eye; see Figure 8.12) while Versailles reflects an approach similar to that of Giovanni Battista Vanni's (VAH-nee) *Holy Family with St. John* (Plate 6).

We can take our examination one step further and perform a simple stylistic analysis with four paintings. The first three of these paintings were done by three different artists; the fourth, by one of those three. By stylistic analysis, we will be able to identify the painter of the fourth painting. Inasmuch as we have not yet dealt with definitions in composition or broader contextual influences of style, our analysis will be as nontechnical as possible. We will examine three characteristics only: line, palette, and brush stroke. These characteristics are basic to how style appears on a canvas, but we should not infer that line, palette, and brush stroke are the only elements that form a style. Paintings, including the ones in our exercise, often have different reasons for being, and that influences style as well. We will discuss issues of style, including the ones represented here, in much more detail in Chapters 7 to 9. We will learn that styles are not always clear-cut and may be a mixture of many conflicting elements—for example, the interplay of the rational and the emotional; controlled simplicity versus elaborate ornamentation; straight, or direct, undecorated lines versus decorated, ornamented ones; and so on. For now, however, we will forego more complex elements and take a less involved course to illustrate the basics of style and how we might perceive it using three fundamental artistic elements as our guides.

The first painting (Figure 1.6) is Jean-Baptiste-Camille Corot's (coh-ROH) *A View Near Volterra*. We can see that Corot has used curvilinear line primarily; moreover, that line (which creates the edges of the forms or shapes in the painting) is somewhat softened. That is, many of the forms—the rocks, trees, clouds, and so on—do not have crisp, clear edges. Color areas tend to blend with each other, giving the painting a softened, somewhat fuzzy or out-of-focus appearance. That comfortable effect is heightened by Corot's use of palette. Palette, as we will note later, encompasses the total use of color and contrast. As with his use of line, Corot maintains a subtle value contrast—that is, a subtle relationship of dark and light. His movement from light to dark is gradual, and he avoids stark contrasts. He employs a limited range of colors, but does so without calling attention to their positioning. His brush stroke is somewhat apparent: If we look carefully, we can see brush marks, individual strokes where paint has been applied. Even though the objects in the painting are lifelike, Corot has not made any pretensions about the fact that his picture has been painted. We can tell the foliage was executed by stippling (by dabbing the brush to the canvas as you would dot an *i* with a pencil). Likewise, we can see marks made by the brush throughout the painting. The overall effect of the painting is one of realism, but we can see in every area the spontaneity with which it was executed.

The second painting (Figure 1.7) is Pablo Picasso's *Guernica* (gair-NEE-cah). We hardly need be an expert to tell that this painting is by a different painter—or certainly in a different style—from the previous one. Picasso has joined curved lines and straight lines, placing them in such relationships that they create

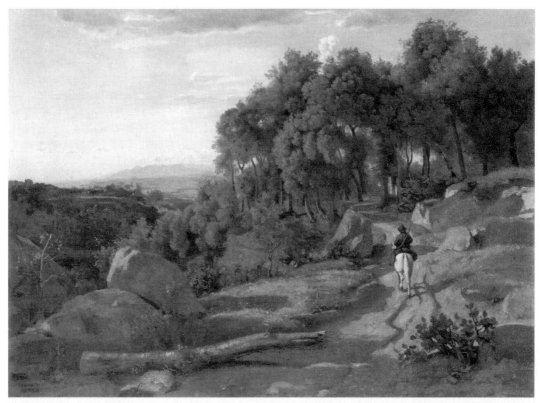

Figure 1.6 Jean-Baptiste-Camille Corot (French, 1796–1875), *A View Near Volterra* (1838). Canvas, 0.695m × 0.951m (27³⁄₈″ × 37½″). National Gallery of Art, Washington, DC. Chester Dale Collection.

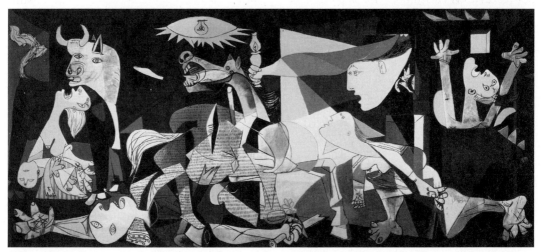

Figure 1.7 Pablo Picasso, *Guernica* (mural) (1937, May–early June). Oil on canvas, 11'6″ × 25'8″. Museo Nacional Centro de Arte Reina Sophia, Madrid. © 2002, Estate of Pablo Picasso/Artists Rights Society (ARS), New York.

movement and dissonance. The edges of color areas and forms are sharp and distinct; nothing here is soft or fuzzy. Likewise, the value contrasts are stark and extreme. Areas of the highest value—that is, white—are forced against areas of the lowest value, black. In fact, the range of tonalities is far less broad than in the previous work. The mid or medium (gray) tones are there, but they play a minor role in the effect of the palette. In palette the work is limited to blacks, whites, and grays. The starkness of the work is also reinforced by brush stroke, which is noteworthy in its near absence

of effect. Tonal areas are flat, and few traces of brush exist.

The third painting (Figure 1.8) is Vincent van Gogh's *The Starry Night*. Use of line is highly active although uniformly curvilinear. Forms and color areas have both hard and soft edges, and van Gogh, like Picasso, uses outlining to strengthen his images and reduce their reality. The overall effect of line is a sweeping and undulating movement, highly dynamic and yet far removed from the starkness of the Picasso. In contrast, van Gogh's curvilinearity and softened edges are quite different in effect

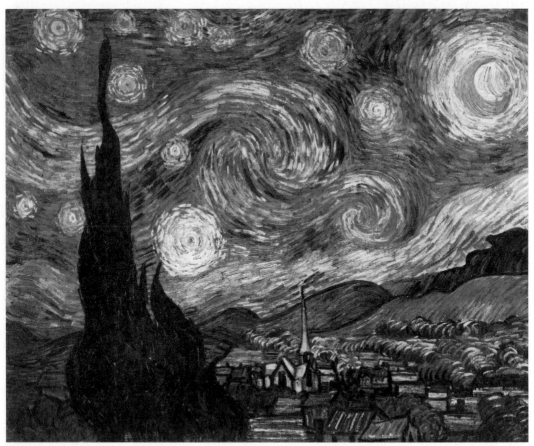

Figure 1.8 Vincent van Gogh, *The Starry Night* (1889). Oil on canvas, 73.7cm × 92.1cm (29″ × 36¼″). The Museum of Modern Art, New York. Acquired through the Lillie P. Bliss Bequest. Photograph © 2001, The Museum of Modern Art, New York.

from the relaxed quality of the Corot. Van Gogh's value contrasts are very broad, but moderate. He ranges from darks to lights, all virtually equal in importance. Even when movement from one area to another is across a hard edge to a highly contrasting value, the result is moderate: not soft, not stark. It is, however, brush stroke that gives the painting its unique personality. We can see thousands of individual brush marks where the artist applied paint to canvas. The nervous, almost frenetic use of brush stroke makes the painting come alive.

Now that we have examined three paintings in different styles and by different artists, can you determine which one of these three artists painted Figure 1.9? First, examine the use of line. Form and color edges are hard. Outlining is used. Curved and straight lines are juxtaposed against each other. The effect is active and stark. By comparison, the use of line is not like Corot's, a bit like van Gogh's, and very much like Picasso's. Next, examine palette. Darks and lights are used broadly. However, the principal utilization is of strong contrast—the darkest darks against the lightest lights. This is not like Corot, a bit like van Gogh, and most like Picasso. Finally, brush stroke is generally unobtrusive. Tonal areas mostly are flat. This is definitely not a van Gogh and probably not a Corot. Three votes out of three go to Picasso, and the style is so distinctive that you probably had no difficulty deciding, even without the analysis. However, could you have been so certain if asked whether Picasso painted Figure 1.10? Some differences in style are obvious; some are unclear. Distinguishing the work of one artist from that of another who designs in a similar fashion becomes even more challenging. However, the simple analytical process we just completed is indicative of how we can approach artworks to determine how they exemplify a given style, or what style they reflect. As we progress through the text, we will learn

much more about style and what additional characteristics reflect and influence it.

HOW DO WE LIVE WITH ART?

Artworks make some people uncomfortable, probably because dealing with an artwork means stepping into unfamiliar territory. Unfortunately, that discomfort is heightened by some artists and by a few, self-proclaimed sophisticates who try to keep the arts confusing and hidden to all but a select few. Nonetheless, this book is about empowerment—giving you the knowledge of how to access works of art comfortably and with the understanding that art and life are irrevocably intertwined. Knowledgeable interaction with works of art makes life better: We see more of what there is to see, and we hear more of what there is to hear. Our entire existence grows richer and deeper.

Recognizing the artistic principles and influences all around us makes our world more interesting and habitable. (Refer to our discussion of fine and applied art on p. 101.) For example, Figure 1.11 is a line drawing of an eighteenth-century highboy chest of drawers. The high chest was designed to meet a practical need: the storage of household goods in an easily accessible, yet hidden, place. However, while designing an object to accommodate that practical need, the cabinetmakers pursued the additional need of providing an interesting and attractive object.

Careful observation and imagination can enhance our experience of this piece of furniture. First, the design is controlled by a convention (a commonly accepted set of rules or principles) that dictated a consistent height for tables and desks. Therefore, the lower portion of the highboy, from point A to point B, designs space within a height that will harmonize with other furniture in the room. If we look carefully, we also can see that the parts of the highboy are designed with an intricate and

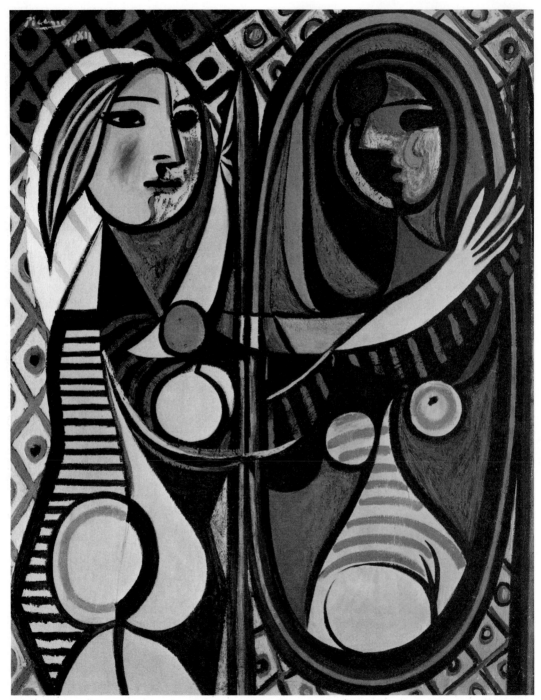

Figure 1.9 Exercise painting. See Plate 5 for identification.

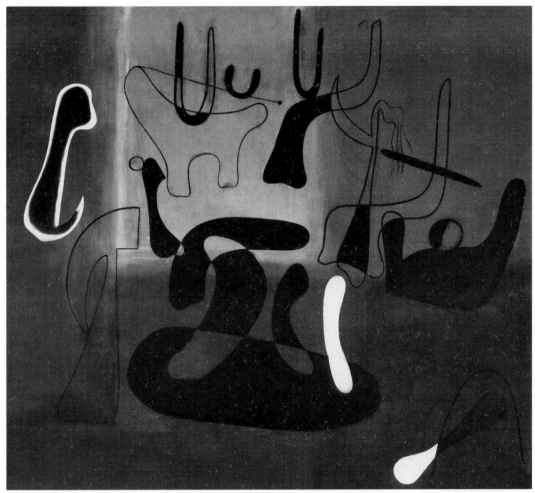

Figure 1.10 Joan Miró, *Painting* (1933). Oil on canvas, 174cm × 196.2cm (68½″ × 65¼″). The Museum of Modern Art, New York. Loula D. Lasker Bequest (by exchange). Photograph. © 2001, The Museum of Modern Art, New York. © 1999, Artists Rights Society (ARS), New York/ADAGP, Paris.

interesting series of proportional and progressive relationships. The distance from A to B is twice the distance from A to D, and is equal to the distance from B to C. The distances from A to F and C to E bear no recognizable relationship to the previous dimensions but are, however, equal to each other and to the distances from G to H, H to I, and I to J. In addition, the size of the drawers in the upper section decreases at an even and proportional rate from bottom to top. None of these interrelationships is accidental.

Much of what we experience daily employs similar artistic devices: Colors and labels on food cans, advertising, building exteriors, automobiles, and patio furniture use artistic principles

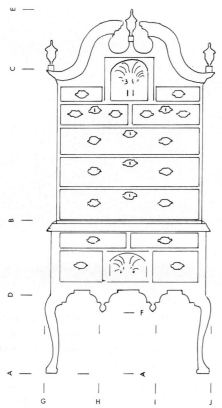

Figure 1.11 Scale drawing of an eighteenth-century highboy.

to make products more attractive and to manipulate us into buying them or following a prescribed course when we contact them.

Art interacts significantly with culture. Think for a moment about how people worship—that is, about the environment or architecture of worship—in churches, synagogues, mosques, and temples. Here, probably more than anywhere else, culture merges with art in a fundamental life experience. If we think about it, we can find innumerable ways in which art and culture feed and reinforce each other, as in the design of the Volkswagen Beetle shown in Figure 1.12. Here repetition

of form reflects a concern for unity, one of the fundamental characteristics of art. The design of the 1953 Beetle, or "Bug," used strong repetition of the oval. We need only to look at the rear of the car to see variation on this theme as applied in the window, motor-compartment hood, taillights, fenders, and bumper. Later models of the Volkswagen differ from this version and reflect the intrusion of conventions, again, into the world of design. As safety standards called for larger bumpers, the oval design of the motor-compartment hood was flattened so a larger bumper could clear it. The rear window was enlarged and squared to accommodate the need for increased rear vision. The intrusion of these conventions changed the design of the Beetle by breaking down the strong unity of the original composition.

Finally, in an article titled "The Humanities Can Irrigate Deserts" (*Chronicle of Higher Education*, October 1, 1977, p. 32), Edwin J. Delattre compares the purpose for studying technical subjects to the purpose for studying the humanities or the arts. He writes:

> When a person studies the mechanics of internal combustion engines the intended result is that he should be better able to understand, design, build, or repair such engines, and sometimes he should be better able to find employment because of his skills, and thus better his life. . . . When a person studies the humanities [the arts] the intended result is that he should be better able to understand, design, build, or repair a life—for living is a vocation we have in common despite our differences. . . . The humanities provide us with opportunities to become more capable in thought, judgment, communication, appreciation, and action.

Delattre goes on to say that these provisions enable us to think more rigorously and to

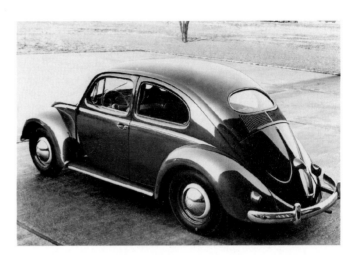

Figure 1.12 Volkswagen Beetle (1953). Courtesy of Volkswagen of America.

imagine more abundantly: "These activities free us to possibilities that are new, at least to us, and they unbind us from portions of our ignorance about living well. . . . Without exposure to the cultural . . . traditions that are our heritage, we are excluded from a common world that crosses generations."

The poet Archibald MacLeish is more succinct: "Without the Arts, how can the university teach the Truth?"

The information in this text helps us to understand the elements that comprise works of art, to which we can respond and which make our lives more rewarding.

How Is Art Put Together?

What's in This Chapter?

In this chapter we move to the study of the technical elements of which works of art are composed. These elements may be found in all works of visual art and architecture, and they are the building blocks that artists manipulate. In the material that follows, we will examine an inclusive concept called "composition" that comprises five "elements": (1) line, (2) form, (3) color, (4) mass, and (5) texture; and four "principles": (1) repetition, (2) balance, (3) unity, and (4) focal area. In addition, we will discuss some additional factors, including perspective, content, articulation, chiaroscuro, dynamics, *trompe l'oeil,* and juxtaposition.

HOW DOES COMPOSITION WORK?

Understanding artworks centers on understanding the elements and principles of composition: basic concepts whose definitions and applications help clarify experiences with art.

Elements of Composition

In the next few pages we will examine the elements of line, form, color, mass (space) and texture.

Line

The basic building block of a visual design is the line. To most people, a line is a thin mark such as this: _____ . That denotation exists in art was well. In Joan Miró's (HOH-ahn mee-ROH) *Painting* (Figure 1.10), we found amorphous shapes. Some of these shapes are like cartoon figures; that is, they are identifiable from the background because of their outline. In these instances, line identifies form and illustrates the first sentence of this paragraph. However, the other shapes in Figure 1.10 also exemplify line. The edges of the shapes constitute a second aspect of line: the boundary between areas of color and between shapes or forms. A third aspect of line is implied rather than physical. The three rectangles in Figure 2.1 create a horizontal line

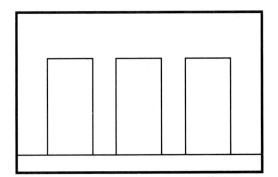

Figure 2.1 Outline and implied line.

Artists use line to control vision, to create unity and emotional value, and, ultimately, to develop meaning. In pursuing those ends, and by employing the three aspects of line noted earlier, artists find that line has two characteristics: It is curved or it is straight. Whether expressed as an outline, an area edge, or by implication, and whether simple or in combination, a line is some derivative of the characteristics of straightness or curvedness. Some people also speculate whether line can be thick or thin. Certainly that quality is helpful in describing some works of art. Yet, those who deny this quality bring up an interesting and challenging point that leads to our next topic: If line can be thick or thin, at what point does it cease to be a line and become another element of composition, form?

that extends across the design. No physical line connects the tops of the forms, but their spatial arrangement creates one by implication. In an even less obvious way, Jackson Pollock's *One (Number 31, 1950)* (Figure 2.2) uses implied line to carry a sense of action around and through the work.

In two dimensions, an artist uses line to define form. Thus, in painting, for example, line is a construction tool. Without line, painters

Figure 2.2 Jackson Pollock, *One (Number 31, 1950)* (1950). Oil and enamel on unprimed canvas, 269.5cm × 530.8cm (8'10" × 17'5⅝"). The Museum of Modern Art, New York. The Sidney and Harriet Janis Collection Fund (by exchange). © 1999, Pollock-Krasner Foundation/Artists Rights Society (ARS), New York. Photograph. © 2001, The Museum of Modern Art, New York.

cannot reveal their forms. In sculpture and ar-chitecture, however, the case is nearly re-versed. It is the form that draws attention, and discussion of line in three dimensions must be done in terms of how it is revealed in form.

Form

Form and line are closely related both in def-inition and, as we noted, in effect. Form is the shape of an object within the composition, and the term *shape* often is used as a synonym for *form*. Literally, form is that space described by line. A building is a form. So is a tree. They appear as buildings or trees, as do their individual details, because of the line by which they are composed. In two-dimensional works, shape can be defined as a flat, two-dimensional space that, with the addition of illusionistic use of shading, can become a form, or a three-di-mensional space.

In sculpture, particularly, but also in two-di-mensional works, one additional quality relat-ing to form emerges. Obviously, not all works are completely solid; they may have openings. Holes are called *negative space* and can be ana-lyzed in terms of their role in the overall work. In some works, negative space is inconsequen-tial; in others, it is quite significant. Analysis of the work determines how negative space contributes to the overall piece and its effects.

Color

An additional, and very important, aspect of the composition of a work of art is its color. There are many ways to approach color. We could begin with color as electromagnetic en-ergy; we could discuss the psychology of color perception; and/or we could approach color in terms of how artists use it. The first two possibilities are extremely interesting, and the physics and psychology of color provide many potential crossovers between art and science and life. Nonetheless, we will limit

our discussion to the last of these. Color char-acteristics differ in light and pigment. For ex-ample, in light, the primary hues (those hues that cannot be achieved by mixing other hues) are red, green, and blue; in pigment, they are red, yellow, and blue. Mixing equal propor-tions of yellow and blue pigment create green. An interesting difference that you may have noted is that, in pigments, green can only be achieved by mixing; in other words, in pig-ment, it is not primary. While in light, green is a primary color. However, no hues can be mixed that will create green light. Inasmuch as response to artworks usually deals with col-ored pigment, the discussion that follows con-cerns color in pigment rather than in light, and focuses on the three color components of hue, value, and intensity.

HUE. Hue can be defined as the spectrum notation of color—that is, a hue is a specific pure color with a measurable wavelength. The visible range of the color spectrum, or the range of colors we can actually distinguish, ex-tends from violet on one end to red on the other (Figure 2.3). The color spectrum consists

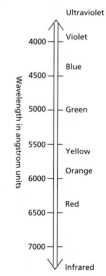

Figure 2.3 Basic color spectrum.

of seven hues (red, orange, yellow, green, blue, indigo, and violet), which include primary hues and secondary hues that are direct derivatives of the primaries. These hues are the basic components of the color spectrum, and each has a specific, measurable wavelength (Figure 2.4). In all, there are (depending on which theory one follows) from ten to twenty-four perceptibly different hues, including these seven. These perceptible hues are the composite hues of the color spectrum.

Assuming, for the sake of clarity and illustration, that there are twelve basic hues, it is helpful to visualize color by turning the color spectrum into a color wheel (Figure 2.5). With this visualization, artists' choices with regard

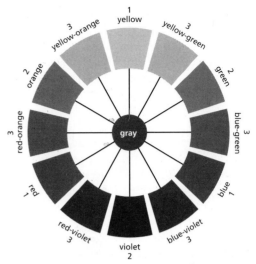

Figure 2.5 Color wheel.

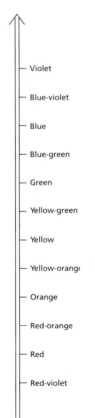

Figure 2.4 Color spectrum, including composite hues.

to color become clearer. First, an artist can mix the primary hues of the spectrum, two at a time in varying proportions, which creates the other hues of the spectrum. For example, red and yellow mixed in equal proportions make orange, a secondary hue. Varying the proportions—adding more red or more yellow—makes yellow-orange or red-orange, which are tertiary (TUHR-shee-air-ee) hues. Yellow and blue make green, and also blue-green and yellow-green. Red and blue make violet, blue-violet, and red-violet. Hues directly opposite each other on the color wheel are complementary. When they are mixed together in equal proportions, they produce gray.

VALUE. Value, sometimes called key, is the relationship of blacks to whites and grays. The range of possibilities from black to white forms the value scale (Figure 2.6), which has black at one end, white at the other, and medium gray in the middle. The perceivable tones between black and white are designated light or dark. The lighter, or whiter, a color is, the higher is its value. Likewise, the darker a color, the lower

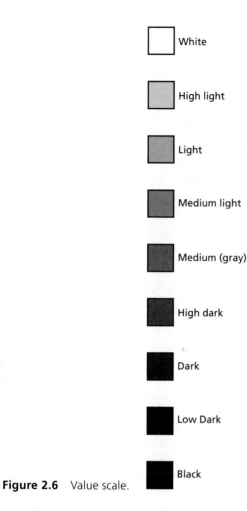

White

High light

Light

Medium light

Medium (gray)

High dark

Dark

Low Dark

Black

Figure 2.6 Value scale.

its value. For example, light pink is high in value, and dark red is low in value, even though they both have as their base the same primary red. Adding white to a hue (like primary red) creates a tint of that hue. Adding black creates a shade.

Some hues are intrinsically brighter than others—a factor we will discuss momentarily—but it is possible to have a brightness difference in the same color. The brightness may involve a change in value, as just discussed—that is, a pink versus a grayed or dull red. Brightness may also involve surface reflectance, a factor of considerable importance to all visual artists.

A highly reflective surface creates a brighter color, and therefore a different response from the viewer, than does a surface of lesser reflectance, all other factors being equal. This is the difference among high gloss, semigloss, and flat paints, for example. It is highly probable that surface reflectance is more a property of texture than of color. Nonetheless, brilliance is often used to describe not only surface gloss but also characteristics synonymous with value. As just mentioned, some hues are intrinsically darker than others. That situation describes the concept we discuss next: intensity.

INTENSITY. Intensity is the degree of purity of a hue. It is also sometimes called *chroma* or *saturation*. Every hue has its own value; that is, in its pure state each hue falls somewhere on the value scale, as in Figure 2.7. The color wheel (Figure 2.5) illustrates how movement around the wheel can create change in hue. Movements across the wheel (for example, by adding green to red) also alter intensity. When, as in this case, hues are directly opposite each other on the color wheel, mixing them will gray the original hue. Therefore, because graying a hue is a value change, the terms *intensity* and *value* are occasionally used interchangeably. Some sources use the terms independently but state that changing a hue's value automatically changes its intensity. Graying a hue by using its complement differs from graying a hue by adding black (or gray derived from black and white). Because gray that is derived from complementaries has hue, it is far livelier than gray derived from black and white, which does not have hue.

COLOR RESPONSE. Colors are typically referred to as warm or cool depending on which end of the color spectrum they fall. For instance, reds, oranges, and yellows are said to be warm colors. These are the colors of the sun and therefore call to mind our primary source of heat; thus, they carry strong implications of

	W	
	HL	Yellow
Yellow-green	L	Yellow-orange
Green	ML	Orange
Blue-green	M	Red-orange
Blue	MD	Red
Blue-violet	D	Red-violet
Violet	LD	
	B	

Figure 2.7 Color-value equivalents.

warmth. Colors falling on the opposite end of the spectrum—blues and greens—are cool colors because they imply shade, or lack of light and warmth. These associations comprise mental stimuli with a physical basis. Value and color contrast can also affect the senses. Stark value contrasts yield a harsh result; gentle contrasts, the opposite. Many sense stimuli work in concert and cannot be separated from each other.

Artists' overall use of color is called *palette.* Palette can be broad, restricted, or somewhere in between, depending on whether an artist utilizes the full range of the color spectrum

An Analysis of Color
Peter Paul Rubens, The Assumption of the Virgin *(Plate 1) and Pablo Picasso,* Guernica *(Figure 1.7)*

As bright as the colors in Rubens's *Assumption of the Virgin* appear, and as lively and colorful as it is, Rubens's palette is fairly restricted. With the exceptions of the shadows in the upper right and two cloaks in the lower left, his overall use of color remains definitely on the warm side of the spectrum. Most fascinating is how Rubens uses color to create attraction for the eye to draw attention to the figure of the Virgin, which is the central focus of the painting. Juxtaposing high and low values gives the painting a dynamic sense that otherwise would not exist.

On the other hand, Picasso's palette in *Guernica* lacks hue completely. It is, thus, less broad than Rubens's. This black and white composition, however, is no less dynamic and may, arguably, be more forceful because of the starkness of its monochromatic palette. Like Rubens, Picasso juxtaposes high lights and low darks to create contrast and dynamic attraction.

and/or explores the full range of tonalities— brights and dulls, lights and darks. Analyzing palette consists of deciding what uses of color have occurred. Comparisons between or among paintings can be phrased in terms of which displays a more restricted or, conversely, broader palette.

Mass

Only three-dimensional objects have mass—that is, take up space and have density. However, two-dimensional objects give the illusion of mass, relative only to the other objects in the picture.

Unlike a picture, a sculpture has literal mass. It takes up three-dimensional space—that is, it has volume—and its materials have density. Thus, the mass of a sculpture that is made of stone is less than one the same size made of balsa, and the apparent mass of the two works would affect us differently. Artists sometimes disguise the material from which their work is made. For instance, marble polished to appear like skin or wood polished to look like fabric can change the appearance of the mass of a sculpture and significantly affect its effect on a viewer. In fact, the deliberate disguising of a material may have a number of purposes. For example, the detailing of the sculpture might reflect a formal concern for design or, perhaps, a concern for lifelikeness. When sculpture deemphasizes lifelikeness in order to draw attention to the substances from which it is made, it is called *glyptic*. Glyptic sculpture emphasizes the material from which the work is created and usually retains the fundamental geometric qualities of that material. Consideration of emphasis on natural qualities of materials leads us to another element of composition, and that is *texture*.

Texture

Texture is the apparent roughness or smoothness of a surface. In two dimensions, texture ranges from the smoothness of a glossy photograph to the roughness of impasto, a painting technique in which pigment is applied thickly with a palette knife to raise areas from the canvas. The texture of a picture may be anywhere within these two extremes. Texture may be illusory in that the surface of the picture may be absolutely flat, but the image gives the impression of three-dimensionality. So the term can be applied to the pictorial arts either literally or figuratively.

Texture is a tangible characteristic of sculpture. Sculpture allows its texture to be perceived

Comparing Mass and Texture
Michelangelo's David *and Alberto Giacometti's* Man Pointing

Michelangelo's *David* (Figure 4.10), standing larger than life size, has a mass that provides the viewer with a sense of strength and power. It was intended to stand atop a buttress high above ground on Florence, Italy's cathedral, and its mass can partially, at least, be accounted for by its need to be seen from a distance. Its marble has been polished to give it the soft sheen of human flesh.

In contrast, Giacometti's (jah-coh-MEHT-ee) *Man Pointing* (Figure 4.13) is life-size in height, but its thinness creates a skeletal and stark experience—a deemphasis on mass—that draws attention to the artist's exploitation and emphasis on the bronze metal from which it is made (glyptic). Through mass and texture Giacometti's man, in strong contrast to Michelangelo's, presents us with a completely different set of circumstances, bringing us to think, perhaps, of a different set of criteria or qualities about "man."

through physical touching. However, even when sculpture cannot be actually touched, its textural effects can be perceived and responded to in both physical and psychological ways. Sculptors go to great lengths to achieve the texture they desire in their works. In fact, much of a sculptor's technical mastery manifests itself in the ability to impart a surface to a work.

Principles of Composition

Our next step in this chapter will be to move from looking at the elements of composition to discussing the principles of repetition, balance, unity, and focal area.

Repetition

Probably the essence of any design lies in its repetition, which can be defined as how the basic elements in a picture are repeated or alternated. Repetition encompasses three concepts: rhythm, harmony, and variation.

RHYTHM. Rhythm is the ordered recurrence of elements in a composition. Recurrence may be regular or irregular. If the relationships among elements are equal, the rhythm is regular (Figure 2.1). If not, the rhythm is irregular. However, examination of the entire composition must occur in order to discern if patterns of repetitions exist and whether or not the patterns are regular, as they are in Figure 2.8.

HARMONY. Harmony is the logic or repetition. Harmonious relationships occur when components appear to join naturally and comfortably. If an artist employs forms, colors, or other elements that appear incongruous, illogical, or out of sync, then dissonance occurs. In other words, the constituents simply do not go together in a natural way. However, when considering how harmony affects an artwork's composition, it is important to keep in mind

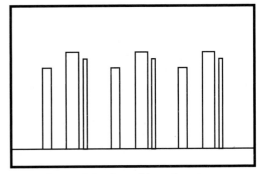

Figure 2.8 Repetition of patterns.

that ideas and ideals relative to harmonious relationships in color or other elements often reflect cultural conditioning or arbitrary understandings (conventions). An examination of Peter Paul Rubens's *Assumption of the Virgin* (Plate 1) reveals what most would conclude are harmonious relationships among forms and colors. On the other hand, the strong, unnatural blue outlines that the painter Henri Matisse gives to the distorted female form in the well-known painting *Blue Nude (Souvenir of Biskra)* definitely explores dissonant harmonies in its form and color relationships.

CYBER EXAMPLE

Henri Matisse, *Blue Nude (Souvenir of Biskra)*, Baltimore Museum of Art. (In Mark Harden's Artchive)

http://www.artchive.com/artchive/M /matisse/blue_nude.jpg.html

VARIATION. Variation is the relationship of repeated items to each other; it is similar to theme and variation in music. How does an artist take a basic element in the composition and use it again with slight or major changes? Pablo Picasso's *Girl Before a Mirror* (Plate 5)

Pablo Picasso (1881–1973)

Pablo Picasso was born in Málga, on the Mediterranean coast of Spain. He studied at the Academy of Fine Arts in Barcelona; but having already mastered realistic technique, he had little use for school. At age fifteen he had his own studio in Barcelona. In 1900 he first visited Paris, and in 1904 he settled there. His personal style began to form in the years from 1901 to 1904, a period often referred to as his blue period because of the pervasive blue tones he used in his paintings at that time. In 1905, as he became more successful, Picasso altered his palette, and the blue tones gave way to a terracotta color, a shade of deep pinkish red. At the same time, his subject matter grew less melancholy and included dancers, acrobats, and harlequins. The paintings he did during the years between 1905 and 1907 are said to belong to his rose period.

Arguably, the most important painter of the twentieth century, Picasso played an important part in the sequence of different movements. He said that to repeat oneself is to go against "the constant flight forward of the spirit." Primarily a painter, he also was a consummate printmaker, a fine sculptor, and ceramicist.

composition of the girl. The circular motif also is repeated throughout the painting, with variations in color and size—similar to the repetition and variation in the design of the Volkswagen noted in Figure 1.12.

Balance

The concept of balance is very important. It is not difficult to look at a composition and almost intuitively respond that it does or does not appear balanced. Most individuals have this second sense. Determining how artists achieve balance in their pictures is an important aspect of our own response to works of art.

SYMMETRY. The most mechanical method of achieving balance is symmetry—specifically, bilateral symmetry, the balancing of like forms, mass, and colors on opposite sides of the vertical axis (often referred to as the centerline) of a work. Symmetry is so precise that we can measure it. Works employing absolute symmetry tend to be stable, stolid, and without much sense of motion. Many works approach symmetry but retreat from placing mirror images on opposite sides of the centerline.

ASYMMETRY. Asymmetrical balance, sometimes referred to as psychological balance, is achieved by careful placement of unlike items, as occurs in Julie Roberts's painting *The Little Girl Rosalia Lombardo; Embalmed* (Figure 2.9). It might seem that asymmetrical balance is a matter of opinion. However, intrinsic response to what is balanced or unbalanced is relatively uniform among individuals, regardless of their aesthetic training. Often color is

has taken two geometric forms, the diamond and the oval, and created a complex painting via repetition. The diamond with a circle at its center is repeated over and over to form the background. Variation occurs in the color given to these shapes. Similarly, the oval of the mirror is repeated with variations in the

Figure 2.9 Julie Roberts. *The Little Girl Rosalia Lombardo; Embalmed* (2000). Oil on canvas, 50cm × 50cm (19¹¹⁄₁₆″ × 19¹¹⁄₁₆″) (JR-46). Courtesy Sean Kelly Gallery, New York.

used to balance line and form. Because some hues, such as yellow, have great eye attraction, they can balance tremendous mass and activity on one side of a painting by being placed on the other side. For example, the Japanese print-maker Hiroshige depicts a bird on a tree and skillfully balances space, line, and form around the central object of the painting, which dif-

fers in color from the other elements (see Cyber Example on p. 32).

Unity

In general, it can be argued that artists strive for a sense of self-contained completeness—in other words, unity—in their artworks. Thus, an

important characteristic in a work of art is the means by which artists achieve this unity. All the elements of the composition work together toward meaning. Often, compositional factors are juxtaposed in unusual or uncustomary fashion to achieve a particular effect. Nonetheless, that effect usually comprises a conscious attempt at maintaining or completing a unified statement—that is, a total picture. Critical analysis of the elements of a work of art should lead to judgment about whether the total statement comprises a unified one.

Discussion of unity also raises the issue of whether or not an artist allows the composition to escape the frame. Although closed composition, or composition in which line and form combine to redirect the eye back into the work, certainly can assist in creating a sense of unity, that device (as illustrated in Figure 2.10) does not by itself achieve unity. Nor, on the other hand, does open composition—that is, composition that allows the eye to escape the work—imply lack of unity. Figure 2.11 illustrates how line takes the eye to the edge of a frame and allows it to wander off. The design, nonetheless, is unified. It stays together as a single piece.

However, this apparent distinct difference between closed and open composition is not as clear as it seems. Keeping the artwork within

Figure 2.11 Open composition (composition allowed to escape the frame).

the frame is a stylistic device that has an important bearing on the artwork's meaning. For example, in Giacometti's *Man Pointing* (Figure 4.13) the composition is open, which profoundly influences the way we react to the piece. On the opposite hand, Giovanni Paolo Panini's (pah-NEE-nee) painting *Interior of the Pantheon* (Plate 8), adhering to a different set of stylistic principles, is predominantly kept within the frame. This illustrates a concern for self-containment and precise structuring according to classical (see Glossary and Chapter 7) standards of the time. Anticlassical design, in contrast, often forces the eye to escape the frame, suggesting, perhaps a universe outside or the individual's place within an overwhelming cosmos. El Greco's (ehl GREH-koh) painting, *Saint Jerome* follows that set of principles.

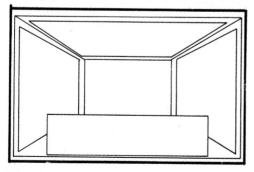

Figure 2.10 Closed composition (composition kept within the frame).

Focal Area

The areas of greatest visual appeal in a work of art are called *focal areas*. An artwork usually has primary focal area and secondary focal areas. The former comprises the areas of strongest attraction, and the latter, areas of lesser strength. People often describe a work of the latter type as "busy"; that is, the eye bounces at random from one point to another on the work without much attraction at all.

Focal areas are achieved in a number of ways: through confluence of line, by encirclement, or by color, to name just a few. To draw attention to a particular point in a work, an artist may make all lines lead to that point (confluence of line), may place the focal object in the center of a ring of objects (encirclement), or may give the object a color that demands attention more than other colors in the work. Again, for example, bright yellows attract the eye more readily than do dark blues. Artists use focal areas (of whatever number or variety) to help control what images, and the sequences of these images, we see when we look at an artwork. Again, referring to Rubens's *Assumption of the Virgin* (Plate 1), each of these factors has been used. Because of Rubens's skill, the brightness of the yellow color surrounding the face of the Virgin fixes our attention not on the color, but on the Virgin's face. So, in a subtle way, the artist has used both color and encirclement to draw us to the central focus of the painting. There is, however, additional use of encirclement in the oval of angels around the holy personage. Finally, throughout the picture, line established by the sweep of color edges and gestures of the people leads us to the Virgin. Color and encirclement draw the eye to the face of Kerry James Marshall's *Den Mother* (Figure 2.12).

A sculptor's task with regard to focal areas is much more complicated when dealing with three dimensions. In that case, a sculptor may have little control over the direction from which the viewer will first perceive the piece:

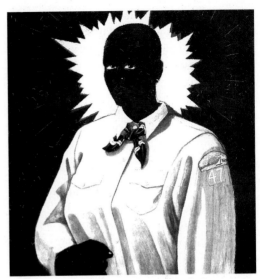

Figure 2.12 Kerry James Marshall, *Den Mother* (1996). Acrylic on paper mounted on wood, 41" × 40". Collection of General Mills Corporation, Minneapolis, Minnesota. The Jack Shainman Gallery, New York.

The entire 360-degree view may comprise the experience. Nonetheless, converging lines, encirclement, and color work for the sculptor in exactly the same way they do for artists working in two dimensions.

Another device is, however, available to the sculptor: movement. Sculptors have the option of placing moving objects in their work. Such objects immediately become focal points. A mobile, for example, like that of Alexander Calder's *Spring Blossoms* (Figure 4.3), presents many ephemeral patterns of focus as it turns at the whim of the breeze.

WHAT OTHER FACTORS AFFECT US?

In addition to composition, there are several other factors that help us analyze works of art more effectively. These include perspective,

subject matter, articulation, charoscuro, dynamics, Trompe l'oeil, and juxtaposition.

Perspective

Perspective is a tool for indicating spatial relationships. This is primarily a tool in two-dimensional design, but it also can occur in relief sculpture (see Chapter 4). Perspective is based on the phenomenon of distant objects appearing smaller and less distinct than objects in the foreground. In a moment we will discuss three types of perspective, but first we should note perspective's effects. In artworks with lifelike content, perspective may indicate concerns of the artist. For example, when perspective relationships are rational—that is,

the relationships of the objects appear as they would in normal life—there appears a concern for coherent order and mathematical representation. The ancient Greeks (see Chapter 7) displayed such concerns, as did the artists of the Renaissance (see Chapter 8), who codified perspective scientifically. During the Middle Ages, however, when spirituality was of great concern, rational perspective took a back seat. To post-Renaissance, western-acculturated eyes, lack of rational perspective effects a somewhat strange picture because, although background objects might be rendered smaller than foreground objects, the positioning does not seem logical. We can see this to a certain extent in Figure 2.13, St. Mark from the Gospel Book of St. Medard.

Figure 2.13 St. Mark from the Gospel Book of St. Medard of Soissons, France (early ninth century). Paint on vellum, 14⅜″ × 10¼″. Cliche Bibliothèque Nationale de France—Paris.

The lines forming the sides of the base of the platform on which St. Mark's chair rests do not come closer together as they recede from the frontal plane. In fact, just the opposite occurs. If the perspective were rational, the lines would converge slightly as they recede. If they were extended, they would join each other at a point established by the artist on the imaginary viewer's eye level or horizon line.

As noted earlier, there are a number of types of perspective that artists use to create a sense of "space"—that is, the illusion of depth in a work. We will discuss three: linear, atmospheric, and shifting perspective.

Linear Perspective

Linear perspective is characterized by the phenomenon of standing on railroad tracks and watching the two rails apparently come together at the horizon (known as the vanishing point) (Figure 2.14). Very simply, linear perspective is the creation of the illusion of distance in a two-dimensional artwork through the convention of line and foreshortening—that is, the illusion that parallel lines come together in the distance. Linear perspective is also called scientific, mathematical, one-point and multiple point, and, sometimes,

Renaissance perspective and was codified in fifteenth-century Italy (see Chapter 8). It uses mathematical formulas to construct illusionistic images in which all the elements are shaped by imaginary lines called *orthogonals* that converge in one or more vanishing points on a horizon line. Linear perspective is the system most people in the Euro-American cultures think of as perspective, because it is the visual code they are accustomed to seeing.

Atmospheric Perspective

Atmospheric perspective indicates distance through the use of light and atmosphere. For example, mountains or buildings in the background of a picture are made to appear distant by being painted in less detail; they seem hazy. In Giovanni Battista Vanni's painting *Holy Family with St. John* (Plate 6), a distant castle appears in the upper left corner. We know it is distant because, first, it is small; but, second, it is also hazy. Its details are less distinct than the objects in the foreground. The same set of circumstances occurs in Jean-Baptiste-Camille Corot's painting *A View Near Volterra* (Figure 1.6).

Shifting Perspective

This form of perspective is found especially in Chinese landscapes and is affected by additional factors of culture and convention. In *Buddhist Retreat by Stream and Mountains*, attributed to the artist Juran (zhoo-RAHN; Figure 2.15), the artist divides the picture into two basic units: foreground and background. The foreground of the painting consists of details reaching back toward the middle ground. At that point a division occurs, so that the background and the foreground are separated by openness in what might have been a deep middle ground. The foreground represents the nearby, and its rich details cause us to pause and ponder on numerous elements, including the artist's use of brush stroke in creating

Figure 2.14 Linear perspective.

Figure 2.15 *Buddhist Retreat by Stream and Mountains.* Hanging scroll, ink on silk, height 185.4cm × 57.5cm. Attributed to Juran, Chinese, active c. 960–980 C.E., northern Song dynasty. © 2001, The Cleveland Museum of Art. Gift of Katherine Holden Thayer (1959.348).

foliage, rocks, and water. Then there is a break, and the background appears to loom up or be suspended, almost as if it were a separate entity. Although the foreground gives us a sense of depth—of space receding from the front plane of the painting—the background seems flat, a factor that serves to enhance further the sense of height of the mountain. What causes the perspective to "shift," however, is the attitude that truth to natural appearance should not be at the expense of a pictorial examination of how nature works. The viewer is invited to enter the painting and examine its various parts, but not to take a panoramic view from a single position. Rather, each part is revealed as though the viewer were walking through the landscape. Shifting perspective allows for a personal journey and for a strong personal, spiritual impact on the viewer.

Content

Arguably, all works of art pursue verisimilitude, and they do so with a variety of treatments of content. We can regard treatment of content as ranging from naturalism to stylization. Included are such concepts as abstract, representational, and non-objective (see Glossary). The word *verisimilitude* comes from the Latin *verisimilitudo*, and it means plausibility. Aristotle, in his *Poetics*, insisted that art should reflect nature—for example, that even highly idealized representations should possess recognizable qualities, and that what was probable should take precedence over what was merely possible. What this has come to mean in art is that the search for a portrayal of truth can sometimes mean a distortion of what we observe around us in favor of an image that, while perhaps not lifelike, better speaks to the underlying truth of human existence than mere lifelikeness. So, what is verisimilar, whether lifelike or not, is what is acceptable or convincing according to the respondent's own experience or knowledge. In some cases, this means

Naturalism

Naturalism is a theory (and a style related to that theory) that art should conform exactly to nature and depict every appearance of the subject that comes to the artist's attention. Specifically, it emphasizes the role of heredity and environment on human life and character development. Naturalism aims at a faithful, unselective representation of reality, presented without moral judgment. Naturalism differs from realism in its assumption of scientific determinism, which emphasizes the accidental, physiological nature of humans, rather than moral or rational characteristics. One of naturalism's dilemmas is that accuracy often dwells on morbid details—and without a subjective slant, that depiction can become mere illustration rather than an artful insight into the human condition.

Stylization

Stylization, on the other hand, pursues verisimilitude (vair-ih-sih-MIHL-ih-tood) by changing the surface appearance of the subject in order to achieve or to communicate a deeper insight into the essence of human nature or the subject. Although as respondents we often dismiss the nonlifelike portrayal as a lack of talent on the part of the artist, we should look deeper to allow the work to communicate beyond the simply illustrative.

enticing the respondent into suspending disbelief and accepting improbability within the framework of the work of art.

Articulation

As the eye views a work of art, it scans the objects by going from one element to the next. That scanning movement is called *articulation*. In human speech, as an example, sentences, phrases, and individual words are nothing more than sound syllables (vowels) articulated (that is, joined together) by consonants. Understanding what someone says results because that individual articulates as he or she speaks. Putting the five vowel sounds side by side—*Eh-Ee-Ah-Oh-OO*—does not create a sentence. But when those vowels are articulated with consonants, meaning occurs: "Say, she must go too." The nature of an artwork depends on how the artist has repeated, varied, harmonized, and related its parts and how he or she has articulated the movement from one part to another—that is, how the artist indicates where one stops and the other begins.

Chiaroscuro

Chiaroscuro (kee-ahr-oh-SKOO-roh), from the Italian word meaning "light and shade," is the suggestion of three-dimensional forms via light and shadow without the use of outline. It is a device used by artists to make their forms appear plastic—that is, three-dimensional. Making two-dimensional objects appear three-dimensional depends on an artist's ability to render highlight and shadow effectively. Without them, all forms are two-dimensional in appearance.

Use of chiaroscuro gives a picture much of its character. For example, the dynamic and dramatic treatment of light and shade in Jan Vermeer's *Girl with the Red Hat* (Plate 4) gives this painting a quality quite different from what would have resulted had the artist

chosen to give full, flat, front light to the face. The highlights, falling as they do, create not only a dramatic effect but also a compositional triangle (extending from shoulder to cheek, down to the hand, and then across the sleeve and back to the shoulder) that organizes the work and helps give it unity. Consider the substantial change in character in Vanni's *Holy Family with St. John* (Plate 6) had highlight and shadow been executed there in the flat manner used by Picasso in *Girl Before a Mirror* (Plate 5).

In contrast, works that do not employ chiaroscuro have a two-dimensional quality. This can be seen in Van Gogh's *The Starry Night* (Figure 1.8), Picasso's *Girl Before a Mirror* (Plate 5), and Picasso's *Guernica* (Figure 2.16). An interesting variation on chiaroscuro is the challenge of an artist's treatment and portrayal of flesh. Some flesh is treated harshly and appears like stone. Other flesh appears soft, warm, and true to life. Our response to either treatment is tactile; we want to touch it, believing that we know how the flesh as rendered would feel.

Dynamics

Although most artworks are motionless, they can effectively stimulate a sense of movement and activity. They can also create a sense of stable solidity. An artist stimulates these sensations by using certain compositional devices. Composition that is principally vertical can express, for example, a sense of dignity and grandeur as does Giorgio di Chirico's (KEE-ree-koh) *The Nostalgia of the Infinite* (Plate 3) and Grant Wood's *American Gothic* (Figure 1.4). A picture that is horizontal can elicit a sense of stability and placidity, as in Masaccio's (mah-ZAH-koh or mah-ZAHT-choh) *Tribute Money* (Figure 2.17). The triangle is a most interesting form in engineering because of its structural qualities. It is also interesting in art because of its psychological qualities. A triangle whose base forms the

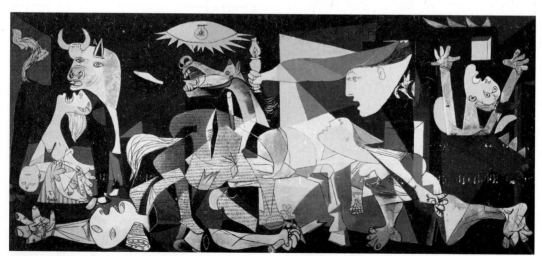

Figure 2.16 Pablo Picasso, *Guernica* (mural) (1937). Oil on canvas, 11'6" × 25'8". Museo Nacional Centro de Arte Reina Sophia, Madrid. © 2002, Estate of Pablo Picasso/Artists Rights Society (ARS), New York.

Figure 2.17 Masaccio, *The Tribute Money* (c. 1427). Santa Maria del Carmine, Florence. Heato-Sessions, Stone Ridge, New York.

bottom of a picture creates a sense of solidarity and immovability (Figure 2.18). If that triangle were a pyramid sitting on a level plane, a great deal of effort would be required to tip it over. On the other hand, a triangle inverted so that it balances on its apex creates a sensation of instability (Figure 2.19)

The use of line also affects dynamics. Figure 2.20 illustrates how the use of curved lines can elicit a sense of relaxation. The broken line in Figure 2.21 creates a more dynamic and violent sensation. We can also sense that the upright triangle in Figure 2.18, although solid and stable, has some activity because of

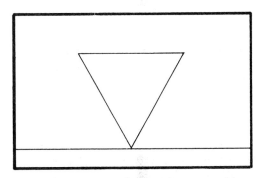

Figure 2.19 Inverted triangular composition.

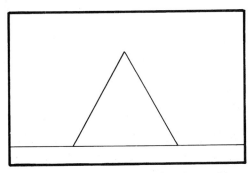

Figure 2.18 Upright triangular composition.

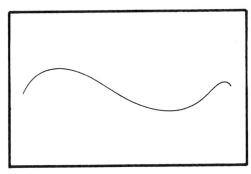

Figure 2.20 Curved line.

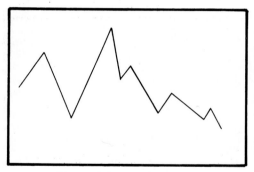

Figure 2.21 Broken line.

the diagonal line of its sides. Precision of linear execution also can create sharply defined forms or soft, fuzzy images, as we noted in the style exercise in the Introduction. In a final example, the painter Piet Mondrian finds in straight lines and right angles the basic principles of life itself. To him, vertical lines signify vitality and life; horizontal lines signify tranquility and death. The intersection of vertical and horizontal lines represents life's tensions (Figure 2.22).

Trompe l'Oeil

Trompe l'oeil (trawmp-LYUH), or "trick the eye," gives the artist a varied set of stimuli by which to affect our sensory response. It is a form of illusionist painting that attempts to represent an object as existing in three dimensions at the surface of a painting, accounting, also, for the point of view of the observer, for example, Masaccio's *Holy Trinity with the Virgin, Saint John the Evangelist, and Donors.*

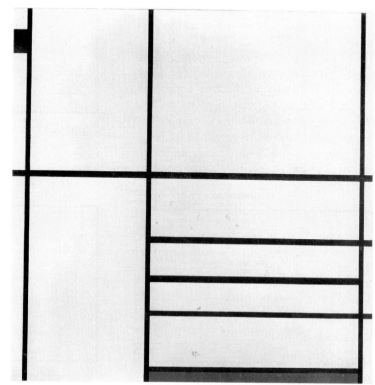

Figure 2.22 Piet Mondrian, *Composition in White, Black, and Red* (1936). Oil on canvas, 102.2cm × 104.1cm (40¼" × 41"). The Museum of Modern Art, New York. Gift of the Advisory Committee. © 2000, Artists Rights Society (ARS), New York/Beeldrecht, Amsterdam. Photograph. © 2001, The Museum of Modern Art, New York.

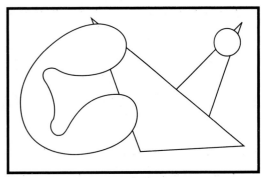

Figure 2.23 Juxtaposition.

Juxtaposition

Simply put, juxtaposition is placement of things side by side. Artists juxtapose colors, forms, and lines for specific effect. For example, dissimilar forms and curved and straight lines can cause a sense of dissonance or consonance. Figure 2.23 illustrates the juxtaposing of inharmonious forms to create instability and uncertainty. Picasso's *Girl Before a Mirror* (Plate 5) juxtaposes curvilinear and rectilinear items to strong effect.

Can We See in Two Dimensions?

Drawing, Painting, and Printmaking

What's in This Chapter?

Pictures of family, friends, rock and sports stars, copies of artistic masterpieces, and original paintings and prints adorn our personal spaces. Walls seem coldly empty and depersonalized without pictures of some kind. Pictures have always been important to humankind. For instance, people of the Paleolithic period, more than 20,000 years ago, drew pictures on the walls of caves. This chapter discusses three media of two-dimensional art: drawing, painting, and printmaking, as well as some technical aspects of their execution and some general factors of how they affect us. At the end of the chapter is an outline for developing a basic analysis of two-dimensional works of art. The purpose of this material is to enhance understanding, deepen confidence in approaching artworks, and enliven ability to communicate about them.

Drawings, paintings, and prints are pictures, differing primarily in the technique of their ex-ecution. They are two dimensional, and their subjects might be landscapes, seascapes, portraits, religious, still lifes, nonobjective, abstract, or something else. Usually, one's initial reaction to a picture is to its content, which can prove to be a powerful device for effecting intellectual and emotional response. It would seem logical for individuals to respond intellectually to nonobjective pictures, because the content, being nonrecognizable, should be neutral. However, quite often just the opposite occurs. When asked if they feel more comfortable with the treatment of subject matter in a life-like manner or in a nonobjective manner, most people prefer the lifelike. That leaves us to ponder several important questions. Does an explicit appeal cause a more profound response? Or, does the stimulation provided by the unfamiliar (i.e., the nonobjective) cause us to think more deeply and respond more fully because our imagination is left free to wander? When considering which artworks appeal most readily to us, a good question to ask is, Why?

Let us begin to answer these questions by exploring the various choices of medium in which a two-dimensional work of art may be produced. We start with drawing, followed by painting and printmaking. Questions may arise concerning what medium is or how we should discuss computer-generated art; we will address those issues in Chapter 11 (p. 202) and omit them here.

DRAWING IS THE BASIS

Drawing is considered the foundation of two-dimensional art, and it can be done with a wide variety of materials. Drawing materials are traditionally divided into two groups: dry media and wet media. In the discussion that follows, we will examine the dry media of chalk, charcoal, graphite, metalpoint, and pastel, and the wet media of ink and wash and brush.

Dry Media

Chalk

Chalk had developed as a drawing medium by the middle of the sixteenth century. Artists first used them in their natural state, derived from ocher hematite, white soapstone, and black carbonaceous shale, placing them in a holder and sharpening them to a point. Chalk is a fairly flexible medium. A wide variety of tonal areas can be created, with extremely subtle transitions between areas. Chalk can be applied with a heavy or light pressure and worked with the fingers once it is on the paper to create the exact image the artist desires.

Charcoal

Charcoal, a burnt wood product (preferably hardwood), is like chalk in that it requires a paper with a relatively rough surface—tooth—in order for the medium to adhere. Charcoal has a tendency to smudge easily, and that dampened its early use as a drawing medium. It found wide use, however, as a means of drawing details (for example, on walls) for murals that were eventually painted or frescoed. Today, resin fixatives can be sprayed over charcoal drawings to eliminate the tendency to smudge, and charcoal has become a popular medium because artists find it extremely expressive. Like chalk, charcoal can achieve a variety of tonalities, and the medium can be manufactured in a variety of shapes and densities, for example, in sharpened sticks that work like pencils and hard or soft.

CYBER EXAMPLE

Charcoal

Georgia O'Keeffe, *The Shell* (National Gallery of Art, Washington, DC)

http://www.nga.gov/cgi-bin
/pinfo?Object=56395+0+none

Graphite

Graphite is a form of carbon, like coal. We know it best in its use as a pencil lead. As a drawing medium it can be manufactured in various degrees of hardness. The harder the lead, the lighter and more delicate its mark.

CYBER EXAMPLE

Chalk

Alberti Cherubino, *Prudence* (National Gallery of Art, Washington, DC)

http://www.nga.gov/cgi-bin
/pinfo?Object=72239+0+none

CYBER EXAMPLE

Graphite

Oscar F. Bluemner, *Study for a Painting* (National Gallery of Art, Washington, DC)

http://www.nga.gov/cgi-bin
/pinfo?Object=56861+0+none

Mary Cassatt, *Margot Leaning Against Reine's Knee* (National Gallery of Art, Washington, DC)

http://www.nga.gov/cgi-bin
/pinfo?Object=73108+0+none

Metalpoint

Metalpoint was one of the most common tools used for drawing in the late fifteenth and early sixteenth centuries. It consists of a stylus, or point, made of gold, silver, or some other metal. In order to draw with the stylus, an artist must use a specially prepared paper. When the stylus is silver, the medium is called silverpoint. The dominant characteristic of metalpoint is its extremely delicate, pale gray line. To make lines of differing thickness, artists must use different styli. As is the case with all linear media, shadows, for example, are created by careful hatching—that is, by a succession of parallel lines. Cross-hatching is a series of parallel lines that cross each other.

CYBER EXAMPLE

Metalpoint

Raphael, *Paul Rending His Garments* (Getty Museum of Art, Pasadena, California)

http://www.getty.edu/art/collections
/objects/o105.html

When highlights are desired in metalpoint, the artist applies an opaque white to the drawing after the metalpoint lines have been made.

Pastel

Pastel is essentially a chalk medium in which colored pigment and a nongreasy binder have been combined. Typically, pastels come in sticks that are approximately the diameter of a finger, and are available in a variety of hardnesses: soft, medium, hard. Hardness is increased by adding more binder, with the result that the harder the stick, the less intense is its color. In fact, the word pastel implies pale, light colors. Soft pastels are quite difficult to work with, although they must be used if any intense colors are desired. A special ribbed paper helps to grab the powdery pastel, and the final drawing is sprayed with a fixative to hold the powder in place permanently on the paper. Beverly Buchanan's *Monroe County House with Yellow Datura* (Figure 3.1) illustrates not only the breadth of color intensity possible with pastels, but also the intricacy with which they can be applied by a skilled hand.

Liquid Media

Pen and Ink

Pen and ink is a fairly flexible medium compared to metalpoint and graphite, for example. Although linear, pen and ink does give the artist the possibility of variation in line and texture. Shading, for example, can be achieved by diluting the ink, and the overall quality of the drawing achieves fluidity and expressiveness.

Wash and Brush

When ink is diluted with water and applied with a brush it creates a wash that is similar in characteristics to watercolor, which we discuss

Figure 3.1 Beverly Buchanan, *Monroe County House with Yellow Datura* (1994). Oil pastel on paper, 60" × 79". Photo by Adam Reich. Collection of Bernice and Harold Steinbaum. Courtesy of Steinbaum Krauss Gallery, New York.

CYBER EXAMPLE

Pen and Ink

Rembrandt, *Lot and His Family Leaving Sodom* (National Gallery of Art, Washington, DC)

http://www.nga.gov/cgi-bin/pinfo?Object=1854+0+none

Agnes Martin, *Water Flower* (National Gallery of Art, Washington, DC)

http://www.nga.gov/cgi-bin/pinfo?Object=55750+0+none

in the next section on painting media. It is difficult to control, yet its effects are nearly impossible to achieve in any other medium. Because it must be worked quickly and freely, it has a spontaneous and appealing quality, as suggested in Zhu Da's *Lotus* (Figure 3.2).

In addition to the media we have just described (and which may be combined in infinite variety) there exists a wide range of possibilities of an experimental and innovative nature. These include the computer, which can be used as an electronic sketch pad.

Figure 3.2 Zhu Da (Bada Shanren) (Chinese, 1625–c.1705) , *Lotus* (1705). Ink on paper, 61½″ × 28″. Palmer Museum of Art, Pennsylvania State University (77.15).

PAINTING IS THE DOMINANT FORM

Arguably, perhaps, over the centuries painting has been the dominant visual art form—to the point where it is nearly synonymous with "art." Like drawing media, painting media each have their own particular characteristics, and, to a great extent, this dictates what the artist can or cannot achieve as an end result. In the following section we will examine five painting media: oils, watercolor, tempera, acrylics, and fresco.

Oils

Oils, developed near the beginning of the fifteenth century, offer painters many opportunities, including a wide range of color possibilities. Oils dry slowly, they can be reworked, they present many options for textural manipulation, and they are durable. If we compare two oils, van Gogh's *The Starry Night* (Figure 3.3) and Giovanni Vanni's *The Holy Family with Saint John* (Plate 6), the medium shows its importance to the final effect of the works. Vanni creates light and shade in the baroque tradition (see Chapter 8), and his chiaroscuro depends on the capacity of the medium to blend smoothly among color areas. Van Gogh, in contrast, requires a medium that will stand up to form obvious brush strokes. Vanni demands the paint to be flesh and cloth. Van Gogh demands the paint to be paint *and* to be stars and sky, but also to call attention to itself.

Oil paint is tremendously flexible. When thinned with turpentine it can become almost transparent. When applied without a thinner, it can be applied and shaped with a palette knife to form three-dimensional surfaces in a technique known as impasto.

Watercolor

Watercolor is a broad category that includes any color medium that uses water as a thinner. However, the term has traditionally referred to a transparent paint usually applied to paper. Because watercolors are transparent, artists must be very careful to control them. If one

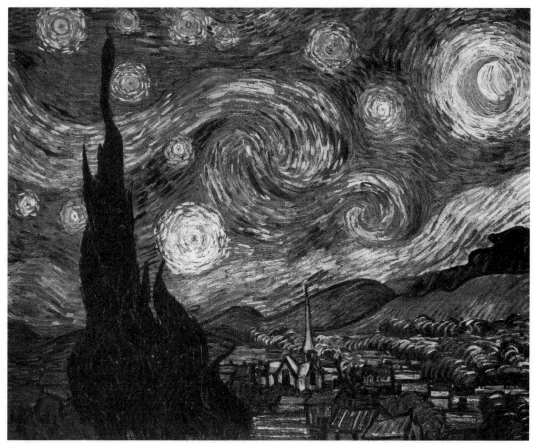

Figure 3.3 Vincent van Gogh, *The Starry Night* (1889). Oil on canvas, 73.7cm × 92.1cm (29" × 36¼"). The Museum of Modern Art, New York. Acquired through the Lillie P. Bliss Bequest. Photograph. © 2001, The Museum of Modern Art, New York.

area of color overlaps another, the overlap will show as a third area combining the previous hues. Yet, one of the major appeals and popularity of watercolors is that their transparency offers a delicacy that cannot be produced in any other medium. We see this quality in William Blake's *Evening* (Figure 3.4), in which the monochromatic image appears to blend with the surface on which it is painted. Gouache is a watercolor medium in which gum is added to ground opaque colors mixed with water. Transparent watercolors can be made into gouache by adding Chinese white to them, a special, opaque, water-soluble paint.

The final product, in contrast to watercolor, is opaque.

Tempera

Tempera is an opaque watercolor medium whose use spans recorded history. It was employed by the ancient Egyptians and is still used by artists today. *Tempera* refers to ground pigments and their color binders, such as gum or glue, and is best known for its egg tempera form. It is a fast-drying medium that virtually eliminates brush strokes and gives extremely sharp and precise detail. Colors in tempera

Figure 3.4 William Blake (British, 1757–1827), *Evening* (c. 1820/1825). Watercolor and chalk on wood, 0.918cm × 0.297cm (36⁷⁄₁₆″ × 11¾″); framed: 1.011m × 0.387m × 0.057m (39¹³⁄₁₆″ × 15¼″ × 2¼″). National Gallery of Art, Washington, DC. Gift of Mr. and Mrs. Gordon Hanes, in Honor of the fiftieth Anniversary of the National Gallery of Art. Photograph. © 2001, Board of Trustees, National Gallery of Art, Washington, DC.

paintings appear almost gemlike in their clarity and brilliance. *The Adoration of the Magi* by Fra Angelico (frah ahn-JAY-lee-coh) and Filippo Lippi (fee-LEE-poh LEE-pee) illustrates this medium (Figure 3.5).

Acrylics

Acrylics, in contrast with tempera, are modern synthetic products. Most acrylics are water soluble (that is, they dissolve in water), and the binding agent for the pigment is an acrylic polymer. Acrylics are flexible media offering artists a wide range of possibilities in both color and technique. An acrylic paint can be either opaque or transparent, depending on dilution. It is fast drying, thin, and resistant to cracking under temperature and humidity extremes. It is perhaps less permanent than some other media but adheres to a wider variety of surfaces. It will not darken or yellow with age, as will oil. Gene Davis's *Narcissus III* (Figure 3.6) illustrates this quality.

Fresco

Fresco is a wall-painting technique in which pigments suspended in water are applied to plaster. When this is done with fresh wet plaster, the technique is called *buon fresco* (bwohn frayz-koh or frehs-koh; Italian for "good" or "true" fresco). Because the end result becomes part of the plaster wall itself rather than just being painted on it, fresco provides a long-lasting work. However, it is an extremely difficult process, and once the pigments are applied, no changes can be made without replastering an entire section of the wall. The best example of fresco is Michelangelo's Sistine Chapel ceiling (Figures 3.7 and 3.8). If the pigment is applied to hardened or dry plaster, the technique is called *fresco secco* (frayz-koh zay-koh or frehs-koh seh-koh; "dry fresco"). In this technique, the artist may work at leisure, but the disadvantage lies in the fact that moisture can get

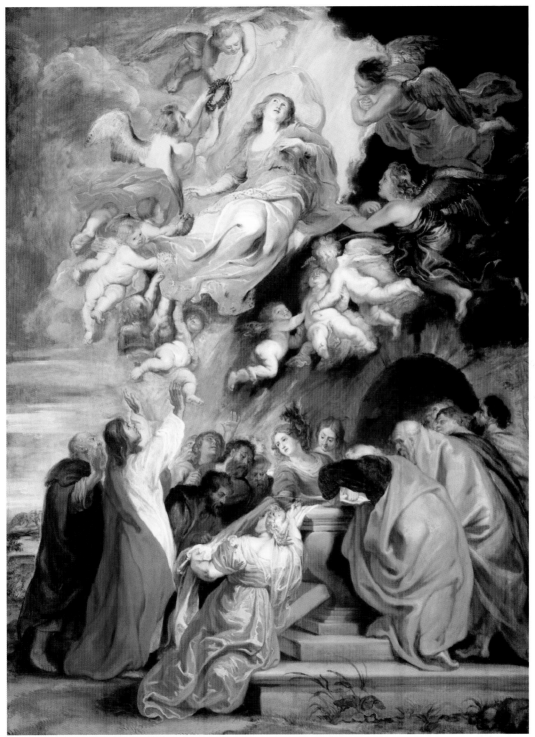

Plate 1 Sir Peter Paul Rubens (Flemish, 1577–1640), *The Assumption of the Virgin* (c. 1626). Oil on panel, 1.254m × 0.942m (49³⁄₈″ × 37¹⁄₈″); framed: 1.575m × 1.257m × 0.082m (62″ × 49¹⁄₂″ × 3¹⁄₄″). National Gallery of Art, Washington, DC. Samuel H. Kress Collection.

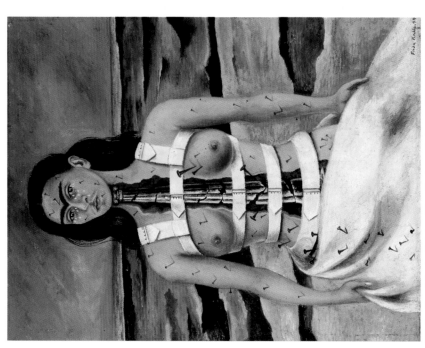

Plate 4 Johannes Vermeer (Dutch, 1632–1675), *Girl with the Red Hat* (c. 1660). Oil on panel, unframed (painted surface): 0.228m × 0.180m (9″ × 7¹/₁₆″); framed, 0.445m × 0.394m × 0.083m (17½″ × 15½″ × 3¼″). National Gallery of Art, Washington, DC. Andrew W. Mellon Collection. Photo by Richard Carafelli.

Plate 5 Pablo Picasso, *Girl Before a Mirror* (Boisegeloup, March 1932). Oil on canvas, 162.3cm × 130.2cm (64″ × 51¼″). The Museum of Modern Art, New York. Gift of Mrs. Simon Guggenheim. Photograph 1996, The Museum of Modern Art, New York. © 1999, Estate of Pablo Picasso/Artists Rights Society (ARS), New York.

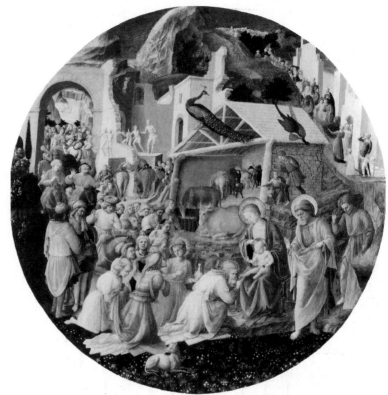

Figure 3.5 Fra Angelico and Fra Filippo Lippi (Florentine) *The Adoration of the Magi* (c. 1445). Tempera on panel; diameter: 1.372m (54″), framed; 1.880m × 1.715m × 0.127m (74″ × 67½″ × 5″). Samuel H. Kress Collection. Photograph. © 2001, Board of Trustees, National Gallery of Art, Washington, DC.

between the plaster and the pigment, causing the painting to peel away from the wall, as occurred with Leonardo da Vinci's *Last Supper* (Figure 8.4).

PRINTS OFFER MULTIPLE OPPORTUNITIES

Prints fall generally into three main categories, based essentially on the nature of the printing surface. The first category would be relief printing, such as woodcut, wood engraving, collograph, and linoleum cut. The second category consists of intaglio, which includes etching, and aquatint. And the third category is the planographic process, which includes lithography, serigraphy (seh-RIHG-ruh-fee; silkscreen), and other forms of stenciling, and monoprints or monotypes. In addition, printmakers also use other combinations and processes.

There are two main reasons artists choose to produce an original work of art as a print. The first reason is to obtain a number of identical copies. The motive for this reason may be to create pictures as multiple images or to reinterpret an original drawing or painting in print form. The fact is that prints sell less expensively than unique objects and thus are more accessible to individuals who may not normally invest in art. The second reason

Figure 3.6 Gene Davis (American, b. 1920) *Narcissus III* (1975). Acrylic on canvas, 2.441m × 2.899m (96⅛″ × 114⅛″). Anonymous Gift. Photograph. © 2001, Board of Trustees, National Gallery of Art, Washington, DC.

to choose to produce a print is that each printmaking process produces characteristic visual qualities that are distinctly different from those of paintings and drawings.

Many prints have a number written on them. On some prints the number may appear as a fraction—for example, 36/100. The denominator indicates how many prints were produced from the plate or block. This number is called the issue number. The numerator indicates where in the series the individual print was produced. If only a single number

appears, such as 500 (also called an issue number), it simply indicates the total number of prints in the series. Printmakers are beginning to eliminate the former kind of numbering because of the misconception that the relationship of the numerator to the issue total has a bearing on the print's value, monetarily or qualitatively. The issue number does have some value in comparing, for example, an issue of 25 with one of 500, and usually is reflected in the price of a print. However, the edition number is not the sole factor in

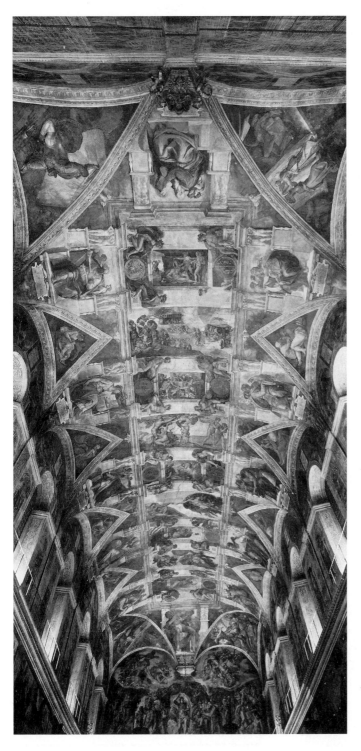

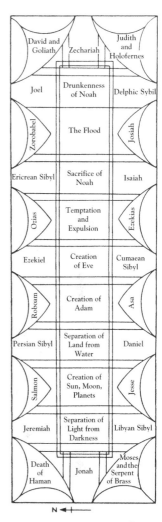

Figure 3.8 Diagram of scenes from the Sistine Chapel ceiling.

Figure 3.7 Michelangelo Buonarroti, View of the Sistine Chapel, Rome, showing the ceiling (1508–1512) and *Last Judgment* (1534–1541). Sistine Chapel, Vatican Palace, Vatican State. Scala/Art Resource, New York.

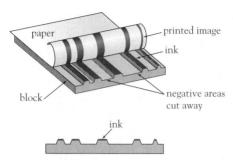

Figure 3.9 Relief printing technique.

determining the value of a print. The quality of the print and the reputation of the artist are more important considerations.

Relief Printing

In relief printing, as diagrammed in Figure 3.9, the image is transferred to the paper by cutting away nonimage areas and inking the surface that remains. Therefore, the image protrudes, in relief, from the block or plate and produces a picture that is reversed from the image carved by the artist. This reversal is characteristic of all printmaking media. Woodcuts and wood engravings are two popular techniques. A woodcut, one of the oldest techniques, is cut into the plank of the grain, while a wood engraving is cut into the butt of

Figure 3.10 Wood plank and butt.

the grain (Figure 3.10). Albrecht Dürer's (duhr-uhr) woodcut *Lamentation* (Figure 3.11) illustrates the linear essence of the woodcut and shows the precision and delicacy possible in this medium in the hands of a master.

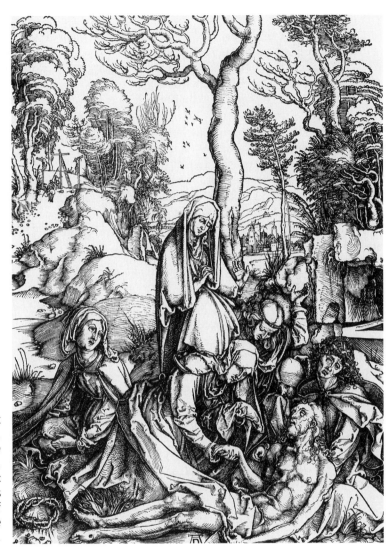

Figure 3.11 Albrecht Dürer (German, 1471–1528), *Lamentation* (c. 1497–1500). Woodcut, 39.3cm × 28.5cm (15½″ × 11¼″). Gift of the Friends of the Palmer Museum of Art, Pennsylvania State University (75.5).

Collograph

Collograph, or collage block, is a method of relief printing that provides an artist the opportunity to produce interesting and varied printed images without use of specialist tools or materials. Here, the basic principle of relief printing—that is, printing from raised areas on a printing block, in contrast to the negative, or cut-away, sections—can be adapted to handmade blocks constructed from a variety of materials. These materials, which can include paper, cardboard, fabric, string, bottle tops, and so on are attached to a flat base in order to form a printing block. The image results from inking the materials whose high spots transfer the ink to paper.

Linocut

Linocut, or linoleum cut, is a relatively simple process that does not require a press to transfer its image to paper. In this technique, the image is cut into a piece of linoleum, a corky composite sheet material with a burlap backing. The design is marked out in pencil, marker, or India ink (in reverse). The artist then cuts around the image, depending on whether he or she desires the image to appear as a positive or negative. The block may then be "proofed"—that is, a thin piece of paper is laid over the block and rubbed with a graphite pencil. When the image appears as the artist desires it, the block is inked and applied to paper.

Intaglio

The intaglio (ihn-TAHG-lee-oh) process is the opposite of relief printing. The ink is transferred to the paper not from raised areas but, rather, from grooves cut into a metal plate (Figure 3.12). Line engraving, etching, and aquatint are some of the methods of intaglio.

Line Engraving

Line engraving involves cutting grooves into a metal plate with special sharp tools. It requires great muscular control on the part of the artist, because the pressure must be continuous and constant if the grooves are to produce the desired image. The print resulting from the line engraving process is very sharp and precise. This form of intaglio is the most difficult and demanding. The distinct character of the result can be seen in Albrecht Dürer's *Angel with the Key to the Bottomless Pit.*

CYBER EXAMPLE

Line Engraving

Albrecht Dürer, *Angel with the Key to the Bottomless Pit*

http://sunsite.auc.dk/cgfa/durer /p-durer5.htm

Etching

In the etching process, the artist removes the surface of the plate by exposing it to an acid bath. First the plate is covered with a thin, waxlike, acid-resistant substance called a ground. Then the artist scratches away the ground to produce the desired lines. The plate is then immersed in the acid, which burns away the exposed areas. The longer a plate is left in the acid, the deeper the resulting etches; the deeper the etch, the darker the final image. Artists wishing to produce lines or areas of differing darkness must cover the lines they do not want to be more deeply cut before further immersions in the acid. Repetition of the process yields a plate that produces a print with the desired differences in light and dark lines. All the details of Figure 3.13

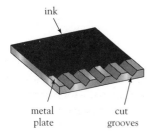
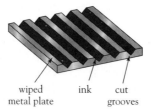
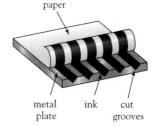

Figure 3.12 Intaglio processes.

Figure 3.13 Daniel Hopfer (German, 1493–1536), *Ceiling Ornaments.* Etching, 10" × 8¾". Palmer Museum of Art, Pennsylvania State University (76.9).

consist of individual lines, either single or in combination. The lighter lines required less time in the acid than the darker ones. Because of the clarity and precision of the lines, it would be difficult to determine, without knowing in advance, whether this print is an etching or an engraving. Drypoint, in contrast, produces lines with less sharp edges.

Drypoint

Drypoint is a technique in which the surface of the metal plate is scratched with a needle. Unlike line engraving, which results in a clean, sharp line, drypoint technique leaves a ridge, called a burr, on either side of the groove, resulting in a somewhat fuzzy line.

Aquatint

The aquatint process enables an artist to create both areas of solid tone on an etching plate and gradations of tone from white through a range of grays to black. The aquatint process is usually combined with line etching to create an image of greater weight and modeling, but it can be used as a primary technique as well. The intaglio methods noted thus far consist of various means of cutting lines into a metal plate. There are, however, effects—such as solid tones and shading—that cannot be produced effectively with lines. Therefore, the artist dusts the plate with a resin substance. The plate is then heated, which affixes the resin, and then it is put into the acid bath. The result yields a plate with a rough surface texture, like sandpaper, and a print whose tonal areas reflect that texture.

Once the plate is prepared, whether by line engraving, etching, drypoint, aquatint, or a combination of methods, the artist is ready for the printing process. The plate is placed in a press and a special dampened paper is laid over it. Padding is placed on the paper and then a roller is passed over it, forcing the plate and the paper together with great pressure. The ink, which has been carefully applied to the plate (*note:* The plate itself has been wiped carefully as well, so that the ink remains in the grooves), transfers as the paper is forced into the grooves by the roller of the press. Even if no ink had been applied to the plate, the paper would still receive an image. This embossing effect, called *blind embossing,* marks an intaglio process in which the three-dimensional plate-mark is very obvious.

Planographic Processes

In a planographic process, the artist prints from a plane surface (neither relief nor intaglio), as illustrated in Figure 3.14.

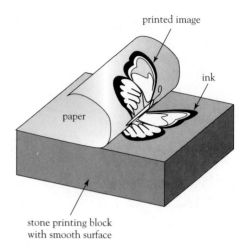

Figure 3.14 Planographic process.

Lithography

Lithography (literally "stone writing") rests on the principle that water and grease do not mix. To create a lithograph, artists begin with a stone, usually limestone, and grind one side until absolutely smooth. They then draw an image on the stone with a greasy substance. Artists can vary the darkness of the final image by the amount of grease they use (i.e., the more grease applied, the darker the image). After artists have drawn the image, they treat the stone with gum arabic and nitric acid and then rinse it with a petroleum product that removes the image. However, the water, gum, and acid have impressed the grease on the stone, and when the stone is wetted it absorbs water (limestone being porous) only in those areas that were not previously greased. Finally, a grease-based ink is applied to the stone. It, in turn, will not adhere to the water-soaked areas. As a result, with ink adhering only to the areas on which the artist has drawn, the stone can be placed in a press and the image transferred to the waiting paper. Lithographs often have a crayon-drawing appearance, as illustrated in Thomas Hart Benton's *Cradling*

Wheat (Figure 3.15) and Charles Sheeler's *Delmonico Building* (Figure 3.16), because the lithographer usually draws with a crayonlike material on the stone. Another example of lithograph is Robert Indiana's *South Bend.*

CYBER EXAMPLE

Robert Indiana, *South Bend* (National Gallery of Art, Washington, DC)

http://www.nga.gov/cgi-bin /pinfo?object=56441+0+none

Serigraphy

The serigraphic process (serigraphy), or silkscreening, is the most common of the stenciling processes. Silkscreens are made from a wooden frame covered with a finely meshed silk fabric. The nonimage areas are blocked out by a variety of methods including glue or cut paper. The stencil is placed in the frame and ink applied. By means of a rubber instrument called a squeegee, the ink is forced through the openings of the stencil, through the screen, and onto the paper below. This

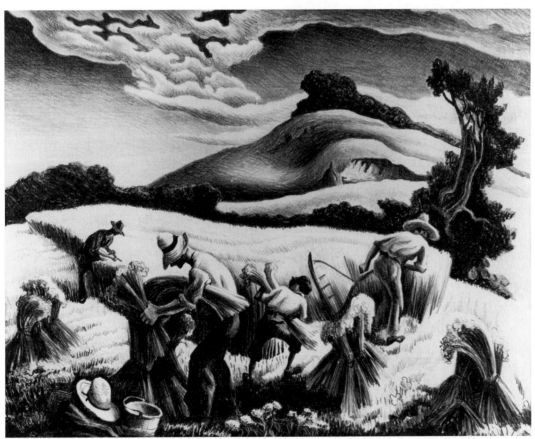

Figure 3.15 Thomas Hart Benton (American, 1889–1974), *Cradling Wheat* (1938). Lithograph, 9½″ × 12″. Palmer Museum of Art, Pennsylvania State University. Gift of Carolyn Wose Hull (73.1).

Figure 3.16 Charles Sheeler, *Delmonico Building* (1926). Lithograph, 10″ × 7⅛″. Palmer Museum of Art, Pennsylvania State University.

technique allows the printmaker to achieve large, flat, uniform color areas such as we see in Nancy McIntyre's serigraph *Barbershop Mirror* (Figure 3.17).

Monotype

A monotype or monoprint, as its name implies, is a unique impression made by applying printing ink to a flat surface and transferring it to paper. The method, however, excludes one of the usual main purposes of printmaking, which is to obtain multiple copies of a single image. The marks and textures of the monotype are characteristically different from those drawn or painted directly on paper. Monoprint is of particular interest to many

[handwritten margin note: what you use paint canvas]

because no presses or studio equipment are needed.

It is not always possible to discern the technique used in executing a print, and some prints reflect a combination of techniques. However, in seeking the method of execution, we add another layer of potential response to a work of art.

BUILDING A BASIC ANALYSIS

You can do a basic analysis of a drawing, painting, or print by using the following outline of concepts from the text as a guide and answering the questions. These questions, and those that follow in Chapters 4 through 7, are designed to assist in focusing your response to any work of art you may encounter by emphasizing as a point of departure the concepts discussed in the chapter. There are other specific reasons and methods for analyzing works of art, and we will discuss these in detail at the conclusion of the text.

- Reaction. What is your emotional and intellectual response to the work, and what do you think causes that response? How do the elements discussed in the chapter combine to create a reaction in you? In other words, what draws your attention?
- Medium. What medium has the artist used? What particular qualities does the medium itself impart to the work?
- Line. How has the artist employed the various qualities of line? How does use of implied line, outline, and/or color edges affect the dynamic workings of the piece?

Figure 3.17 Nancy McIntyre (American), *Barbershop Mirror* (1976). Serigraph, 67.3cm × 48.3cm (26½″ × 19″). Palmer Museum of Art, Pennsylvania State University (76.124).

- Form. What forms appear in the work? Are they representational or non-objective? How does the artist's use of form contribute to the work's meaning?
- Color. How do hue, value, and contrast contribute to the overall palette employed in the work?
- Repetition. How do rhythm, harmony, and variation appear in the work?
- Balance. What kind(s) of balance has the artist used, and what factors—for example, line,

form, and color—contribute significantly to achieving balance?

- Focal area. What parts of the eye draw your attention, and how is your eye drawn from one part of the work to another?
- Deep space. In what ways has the artist attempted to create a sense of depth of space in the work, if at all? How do the factors of linear and atmospheric perspective contribute to the work's sense of space?

perspective 36

use title

convince her

Can We Handle Three Dimensions?

Sculpture and Decorative Arts and Crafts

What's in This Chapter?

In this chapter, we will examine sculpture and the decorative arts. These are objects in three dimensions, but with different purposes, if you will recall our discussion on the differences between "fine art" and "applied art" (see p. 10). With regard to sculpture, we will look at (1) dimensionality, (2) methods of execution, and (3) a few factors that influence our response. The section on decorative arts and crafts will explain more about these media and illustrate some of the basic techniques. The chapter ends with another outline to assist you in developing a basic analysis of three-dimensional works.

SCULPTURE—WHAT'S IN A FORM?

Sculpture, in contrast to pictures, seems less personal and more public. In fact, we are most likely to find works of sculpture in public spaces. Outside city halls and in parks and corporate office buildings we find statues of local dignitaries, and constructions of wood, stone, and metal that appear to represent nothing at all. We might even wonder why our tax dollars were spent to buy them. Today, as through history, sculpture (and other forms of art) are often the subject of public pride and controversy. Because of its permanence, sculpture often represents the only artifact of entire civilizations. In this chapter, we'll not only see how sculpture is made and how it works, but our examples also will reveal ideas of artists from ancient history, contemporary times, and many cultures.

Sculpture is a three-dimensional art. It may take the form of whatever it seeks to represent, from pure, or nonobjective, form to lifelike depiction of people or any other entity. Sometimes sculpture, because of its three-dimensionality, comes very close to reality in its depiction. Duane Hanson and John DeAndrea, for example, use plastics to render the human form so realistically that the viewer might approach the

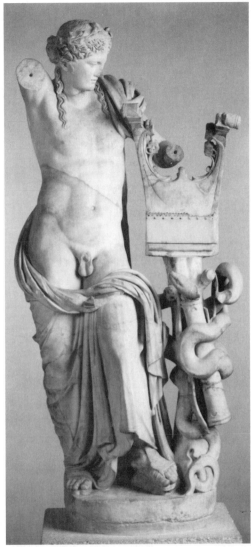

Figure 4.1 Apollo Playing the Lyre. Roman copy of a Greek statue, from the Temple of Apollo at Cyrene (first century B.C.E.). Marble, over life size. © The British Museum, London.

artwork and examine it closely before realizing that it is not a real person.

Dimensionality

Sculptures may be full round, relief, or linear. Full round (or "in the round") works are free-standing and fully three dimensional (Figure 4.1). A work that can be viewed only from one side—that is, one that projects from a background—is said to be in relief (Figure 4.2). A work utilizing narrow, elongated materials is called linear (Figure 4.3). A sculptor's choice of full round, relief, or linearity as a mode of expression dictates to a large extent what he or she can and cannot do, both aesthetically and practically. We now look in greater detail at each of these types of dimensionality.

Full Round

Sculptural works that explore full three-dimensionality and intend viewing from any angle are called full round. Some subjects and styles pose certain constraints in this regard, however. Painters and printmakers have virtually unlimited choice of subject matter and compositional arrangements. Full-round sculptures dealing with such subjects as clouds, oceans, and panoramic landscapes are problematic for the sculptor. Because sculpture occupies real space, the use of perspective, for example, to increase spatial relationships poses obvious problems. In addition, because full-round sculpture is freestanding and three dimensional, sculptors must concern themselves with the practicalities of engineering and gravity. For example, they cannot create a work with great mass at the top unless they can find a way

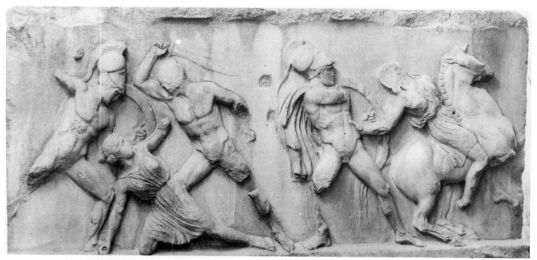

Figure 4.2 East Frieze, Halicarnassus. © The British Museum, London.

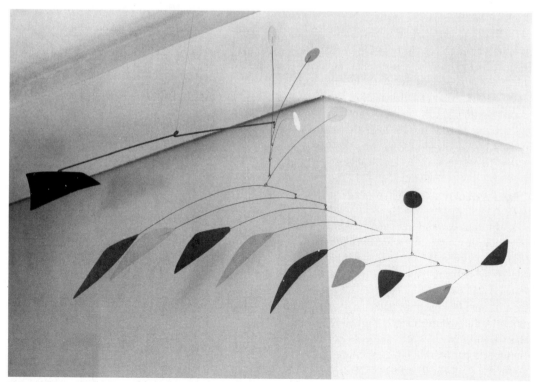

Figure 4.3 Alexander Calder (American, 1898–1976), *Spring Blossoms* (1965). Painted metal and heavy wire, extends 52″ × 102″. Palmer Museum of Art, Pennsylvania State University. Gift of the class of 1965 (6.51). © 1999, Estate of Alexander Calder/Artists Rights Society (ARS), New York.

(within the bounds of acceptable composition) to keep the statue from falling over. In the sculpture Apollo Playing the Lyre (Figure 4.1), as in numerous full-round works—especially of stone—sculptors often use small animals, branches, tree stumps, rocks, and other devices as additional support to give practical stability to a work.

CYBER EXAMPLE

Sculpture in the Round

Deborah Brown, *Cock Bob*

http://www.decordova.org/decordova
/sculp_park/brown.html

Relief

Sculptors who create works in relief do not have quite so many restrictions, because their work is attached to a background. Clouds, seas, and perspective landscapes are within relief sculptors' reach because their work needs only to be viewed from one side. Relief sculpture, then is three-dimensional. However, because it protrudes from a background, as does the frieze from Halicarnassus (Figure 4.2), it maintains a two-dimensional quality, as compared to full-round sculpture. There are, of course, cases in which relief sculpture can almost reach the point of full-roundness, as the jamb statues from the west portal of Chartres Cathedral in France illustrate (Figure 4.11). Later jamb statues from another portal of the same cathedral (Figure 7.18) exhibit an even greater sense of emergence from their background. Relief sculptures that project only a small distance from their base, such as the Halicarnassus frieze, are called *low relief*. Sculptures such as those from Chartres Cathedral that project by at least half their depth are termed *high relief*. The French terms *bas-relief*, for the former, and *haut-relief*, for the latter, are also used.

Linear

The third category of sculptural dimensionality, linear sculpture, emphasizes construction with thin, elongated items such as wire or neon tubing. We see a good example of this type of dimensionality in Calder's mobile *Spring Blossoms* (Figure 4.3). Artworks using linear materials and occupying three-dimensional space will occasionally puzzle us as we consider or try to decide whether they are really linear or full round. Here, absolute definition is less important than the process of analysis and our own aesthetic experience and response.

We now move to examine the methods of execution that a sculptor can use in creating a work.

Methods of Execution

In general, we may say that sculpture is executed using additive, subtractive, substitute, or manipulative techniques. A fifth category, called *found sculpture*, may or may not be considered a method of execution, as we see later.

Subtraction

Carved works are said to be subtractive. That is, the sculptor begins with a large block, usually wood or stone, and cuts away (subtracts) the unwanted material. In previous eras, and to some extent today, sculptors have had to work with whatever materials were at hand. Wood carvings emanated from forested regions, soapstone carvings came from the Eskimos, and great works of marble came from the regions surrounding the quarries of the Mediterranean. Anything that can yield to the carver's tools can be formed into a work of sculpture. However, stone, with its promise of immortality, has proven to be the most popular material.

Three types of rock hold potential for the carver. Igneous rock, of which granite is an example, is very hard and potentially long lasting. However, it is difficult to carve and therefore not popular. Sedimentary rock such as limestone is relatively long lasting, easy to carve, and polishable. Beautifully smooth and lustrous surfaces are possible with sedimentary rock. Metamorphic rock, including marble, seems to be the sculptor's ideal. It is long lasting, a pleasure to carve, and exists in a broad range of colors. Whatever the artist's choice, one requirement must be met: The material to be carved, whether wood, stone, or a bar of soap, must be free of flaws.

A sculptor who sets about to carve a work does not begin by simply imagining a *Samson Slaying a Philistine* (Figure 4.4) and then attacking the stone. He or she first creates a model, usually smaller than the intended sculpture. The model is made of clay, plaster, wax, or some other material and completed in precise detail—a miniature of the final product.

Once the likeness of the model has been enlarged and transferred, the artist begins to rough out the actual image ("knocking away the waste material," as Michelangelo put it). In this step of the sculpting process, the artist carves to within two or three inches of what is to be the finished area, using specific tools designed for the purpose. Then, using a different set of carving tools, he carefully takes the material down to the precise detail. Finishing work and polishing follow. The result can transform cold stone into form that nearly breathes, as in Michelangelo's masterwork, *David* (Figure 4.10).

Addition

In contrast to the method of carving from a large block of material, the sculptor using an additive process starts with raw material and adds element to element until the work is finished. The term *built sculpture* often is used to

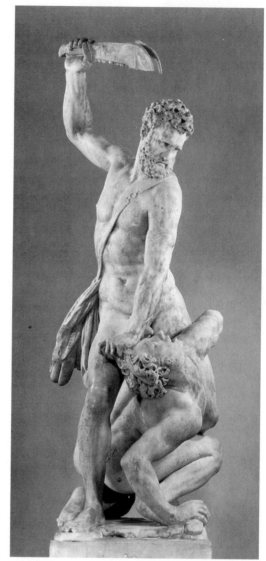

Figure 4.4 Giambologna (Italian, 1529–1608), *Samson Slaying a Philistine* (c. 1567). Marble. Courtesy of the Board of Trustees of the Victoria and Albert Museum, London. V&A Picture Library.

describe materials executed in an additive technique. The materials employed in this process can be plastics, metals such as aluminum or steel, terracottas (clay), epoxy resins, or

PROFILE

Michelangelo (1475–1564)

Sculptor, painter, architect, and poet, Michelangelo was one of the world's greatest artists. Born Michelangelo Buonarroti, he came from a respectable Florentine family, and when he was twelve years old he was apprenticed to the Florentine painter Domenico Ghirlandaio. Even before his apprenticeship had ended, Michelangelo turned away from painting to sculpture, and he gained the attention of Florence's ruler Lorenzo de' Medici, the Magnificent, who invited the young Michelangelo to stay at his palace. During these early years, Michelangelo became a master of anatomy.

After the Medici fell from power, Michelangelo traveled. He spent five years in Rome and enjoyed his first success as a sculptor. He carved his magnificent pietà—that is, the dead Christ in the lap of his mother—when he was twenty-three years old, and his larger-than-lifesize work established him as a leading sculptor of his time.

After four years in Florence, he returned to Rome in 1505 and began a series of grand, large-scale works under the patronage of Pope Julius II. Later, when the Medici returned to power, Michelangelo returned to Florence for nearly twenty years.

During the last years of his life, Michelangelo's religious faith deepened, and he produced not only the complicated and somber frescoes of the Pauline Chapel in the Vatican but also a considerable amount of poetry. Among the few sculptural works attempted in his late years was a pietà, which he designed for his own tomb. After his death in 1564, his body was returned to Florence for burial.

Michelangelo's ideal was the full realization of individuality—a reflection of his own unique genius. He epitomized the quality of *terribilità,* a supreme confidence that allows a person to accept no authority but his or her own genius. Critical of his own work, he was jealous of other artists and clashed constantly with his patrons, yet in his letters he expresses a real sympathy and concern for those close to him. His works reveal a deep understanding of humanity. They capture the idea of potential energy, imprisoned in the earthly body, and he believed that the image from the artist's hand must spring from the idea in his or her mind. The idea is the reality, and it is revealed by the genius of the artist. The artist does not create the ideas, but finds them in the natural world, which reflects the absolute idea: beauty. Thus, to Michelangelo, when art imitates nature, it reveals truths hidden within nature.

wood. Many times, materials are combined, as the Bakota ancestor figure from Gabon, Africa (Figure 4.5) illustrates. It is not uncommon for sculptors to combine constructional methods as well. For example, built sections of metal or plastic may be combined with carved sections of stone.

CYBER EXAMPLE
Built Sculpture
Mary Mead, *Advancing Slowly*
http://www.decordova.org/decordova /sculp_park/mead.html

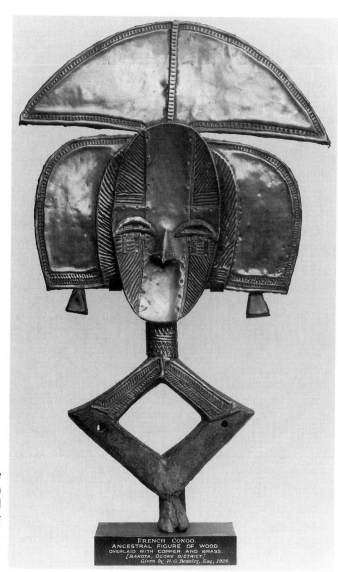

Figure 4.5 Bakota ancestor figure from Gabon, Africa, late nineteenth century, French Congo. Ancestral figure of wood. Overlaid with copper and brass. Given by H. G. Beasley, Esq., 1924. The British Museum, London.

Substitution

Any material that can be transformed from a plastic, molten, or fluid state into a solid state can be molded or cast into a work of sculpture. The creation of a piece of cast sculpture always involves the use of a mold. First, the artist creates an identically sized model of the intended sculpture. This is called a positive. He or she then covers the positive with a material, such as plaster of paris, that when hardened and removed will retain the surface configurations of the positive. This form is called a negative and becomes the mold for the actual sculpture. The molten or fluid material is poured into the negative and allowed to solidify. When the mold is removed, the work of sculpture emerges. Surface polishing, if desired, brings the work to its final form. Ronald J. Bennet's cast bronze sculpture *Landscape #3* (Figure 4.6), Henry Moore's *Two Large Forms* (Figure 4.7), and Alberto Giacometti's *Man Pointing* (Figure 4.13) illustrate the technique and show the degrees of complexity and variety achievable through casting.

CYBER EXAMPLE

Cast Sculpture

Magdalena Abakanowicz, *Puellae* (Girls) (National Gallery of Art, Washington, DC)

http://www.nga.gov/cgi-bin /pinfo?Object=108121+0+none

The lost-wax technique, sometimes known by the French term *cire-perdue*, is a method of casting sculpture in which the basic mold is created by using a wax model, which is then melted to leave the desired spaces in the mold. The technique probably began in Egypt. By 200 B.C.E., the technique was used in China and ancient Mesopotamia, and it was used soon after that by the Benin people of Africa. It spread to Greece sometime in the late sixth century B.C.E.

The drawings in Figure 4.8 illustrate the steps that Benin sculptors would have utilized. A heat-resistant "core" of clay—approximately

Figure 4.6 Ronald J. Bennet (American, b. 1941), *Landscape #3* (1969). Cast bronze, 8″ high × 10″ wide × 7″ deep. Palmer Museum of Art, Pennsylvania State University. Gift of the Class of 1975 (76.60).

Figure 4.7 Henry Moore, *Two Large Forms* (1969). The Serpentine, Hyde Park, London. Reproduced by permission of the Henry Moore Foundation.

the shape of the sculpture—was covered by a layer of wax approximately the thickness of the final work. The sculptor carved the details in the wax. Rods and a pouring cup made of wax were attached to the model, and then the model, rods, and cup were covered with thick layers of clay. When the clay was dry, the mold was heated to melt the wax. Molten metal could then be poured into the mold. When the molten metal had dried, the clay mold was bro-

ken and removed, which meant that the sculpture could not be duplicated.

Very often sculpture is cast so it is hollow. This method, of course, is less expensive because it requires less material. It also results in a work less prone to crack, since it is less susceptible to expansion and contraction resulting from changes in temperature. Finally, hollow sculpture is, naturally, lighter, and thus more easily shipped and handled.

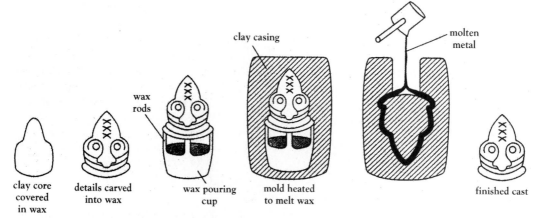

clay core covered in wax

details carved into wax

wax rods

wax pouring cup

clay casing

mold heated to melt wax

molten metal

finished cast

Figure 4.8 Lost-wax process.

Manipulation

In this technique, materials such as clay are shaped by skilled use of the hands. A term of similar meaning is *modeling*. The difference between this technique and addition is clear when we watch an artist take a single lump of clay and skillfully transform it, as it turns on a potter's wheel, into a final shape.

Found

This category of sculpture is exactly what its name implies. Often natural objects, whether shaped by human hands or otherwise, are discovered that for some reason have taken on characteristics that stimulate aesthetic responses. They become objects of art (objets d'art), not because an artist put them together (although an artist may combine found objects to create a work), but because an artist chose to take them from their original surroundings and hold them up to the rest of us as vehicles for aesthetic communication. In other words, an artist decided that such an object said something aesthetically, and chose to present it in that vein.

Some may have concern about such a category, however, because it removes *techne* (TEK-nay), or skill, from the artistic process. As a result, objects such as driftwood and interesting rocks can assume perhaps an unwarranted place as art products or objects. This is a touchy area. However, if a found object is altered in some way to produce an artwork, then the process, arguably, would probably fall under one of the previously noted methods, and the product could be termed an artwork in the fullest sense of the word.

Ephemeral

Ephemeral, or temporary, art has many different expressions and includes the school of artists called *conceptualists*, who insist that the idea is the most important aspect of the work. In fact, the idea drives the art, and what the art looks like is not particularly important. Designed to be transitory, ephemeral art makes its statement and then, eventually, ceases to exist. Undoubtedly the largest work of sculpture ever designed was based on that concept. Christo and Jeanne-Claude's *Running Fence* (Figure 4.9) was an event and a process, as well as a sculptural work. At the end of a two-week viewing period, *Running Fence, Sonoma and Marin Counties, California* (1972–1976) was removed entirely and materials were recycled.

Environmental Art

This is a category that may or may not be a "type" of sculpture such as we are discussing here. Because of the way in which it is assembled, it might be thought of as a combination of the other types we have noted. It, arguably, also might be considered a "style" or "movement." In any case, we discuss this particular topic in Chapter 11 (p. 198).

Factors Influencing Response

Each of a sculpture's characteristics in some way influences response to it. The compositional elements and principles and other factors discussed in Chapter 2 are factors a sculptor manipulates and makes choices about in order to create a work that "says" what the artist desires. In fact, a convenient outline for analyzing a sculptural work is a list of those factors, asking how each contributes to how the work appears and how it stimulates response. Here are some additional thoughts on responding to sculptures.

Color

Perhaps color does not seem particularly important when we relate it to sculpture. We tend

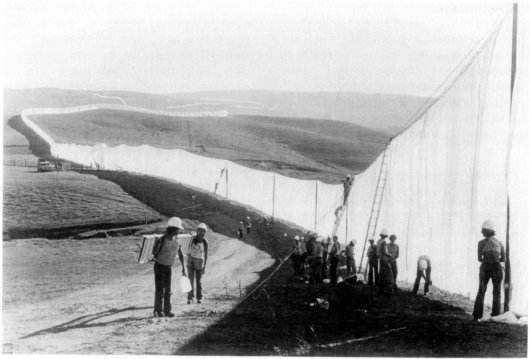

Figure 4.9 Christo and Jeanne-Claude. *Running Fence, Sonoma and Marin Counties, California* (1972–1976). Woven nylon fabric and steel cables, height 5.8m (18′), length 35.5km (24½ miles). Copyright Christo, 1976. Photograph: Wolfgang Volz.

to see ancient sculpture as white (even though, originally, it may well have been painted) and modern sculpture as natural wood or rusty iron. Nevertheless, color is as important to the sculptor as to the painter. In some cases, the material itself may be chosen because of its color; in others, the sculpture may be painted. Still other materials may be chosen or treated so that nature will provide the final color through oxidation or weathering.

Color in sculpture creates its effects by utilizing the same universal symbols as it does in two-dimensional art. To reiterate, reds, oranges, and yellows stimulate sensations of warmth; blues and greens, sensations of coolness. In sculpture, color can result from the conscious choice of the artist, either in the selection of material or in the selection of pigment with

which the material is painted. Or, as indicated earlier, color may result from the artist's choice to let nature color the work through wind, water, sun, and so forth.

Proportion

Proportion is the relative relationship of shapes to one another. Just as we have a seemingly innate sense of balance, so we have a feeling of proportion. That feeling tells us that each form in the sculpture is in proper relationship to the others. However, proportion—or the ideal of relationships—has varied from one civilization or culture to another. For example, such a seemingly obvious proportion as the human body has varied greatly in its proportions as sculptors over the

centuries have depicted it. Study the differences in proportion in the human body among Michelangelo's *David* (Figure 4.10), the Chartres sculptures (Figure 4.11), an ancient Greek Kouros figure (*kouros*—KOO-rohs—means, simply, "male youth"; its plural is *kouroy*—KOO-roy; *Kore*—KOH-ray—is the feminine, meaning "maiden," and its plural is

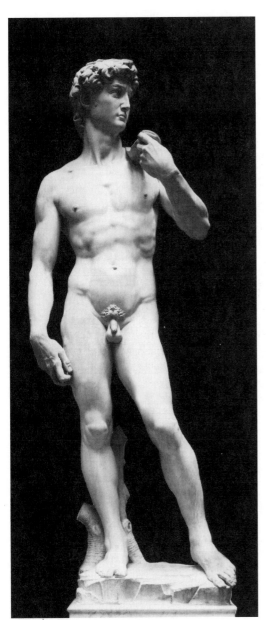

Figure 4.10 Michelangelo, *David* (1501–1504) Marble, 13'5". Academy, Florence.

Figure 4.11 Jamb Statues, west portal, Chartres Cathedral (begun 1145). Lauros-Giraudon/Art Resource, New York.

korai) (Figure 4.12), and Giacometti's *Man Pointing* (Figure 4.13). Each depicts the human form, but with differing proportions. The differences in proportion help transmit the artists' messages about the subject and (usually) have little to do with the ability to make a lifelike figure.

Figure 4.12 Statue of Kouros Island figure. Marble. Greek, sixth century B.C., C. 600 B.C. The Metropolitan Museum of Art, New York. Fletcher Fund, 1932. (32.11.1).

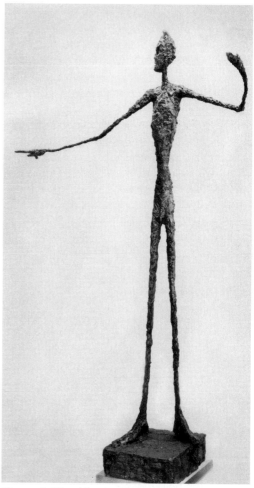

Figure 4.13 Alberto Giacometti, *Man Pointing* (1947). Bronze, 179cm × 103.4cm × 41.5cm (70½″ × 40¾″ × 16⅜″), at base 12″ × 13¼″. The Museum of Modern Art, New York. Gift of Mrs. John D. Rockefeller 3d. Photograph. © 2001, The Museum of Modern art, New York.

Repetition

As we noted in Chapter 2, rhythm, harmony, and variation constitute repetition in works of art. Reducing sculpture to its components of line and form, we find rhythmic patterns emerging, and these can be either regular or irregular. In the frieze from Halicarnassus (Figure 4.2), for example, these patterns are fairly regular, moving the eye from figure to figure and from leg to leg of the figures. The harmony of these patterns is, as we noted earlier, relatively dissonant as a result of the juxtaposition of strong triangles in the stances and groupings with the softened curves of the human body. On the other hand, a more consonant series of relationships occurs in the Indian tree spirit of Figure 4.15. Lastly, in contrast with variation on a triangular theme seen in the Halicarnassus frieze, variation on a circular theme occurs in William Zorach's *Child with Cat* (Figure 4.14). Here, the artist uses the oval as a motif and varies it among the child's face, upper arm, hand, and face of the cat.

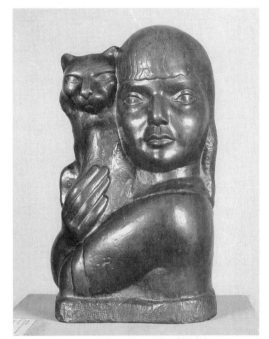

Figure 4.14 William Zorach (American, 1887–1996), *Child with Cat* (1926). Bronze, 17½″ × 10″ × 7½″. Palmer Museum of Art, Pennsylvania State University (77.16).

Material and Age

In Chapter 2, we spoke of glyptic sculpture—that is, sculpture that draws attention to its material. Marble polished to look like skin or wood polished to appear like fabric can change the appearance of the mass of a sculpture and significantly affect our response to it.

Part of our response to a work is consideration of the purpose of disguising material. For example, does the detailing of the sculpture reflect a formal concern for design, or does it reflect a concern for greater lifelikeness? Examine the cloth represented in Figures 4.1 and 4.15. In both cases, the sculptor has disguised the material by making stone appear to be cloth. In Figure 4.1, the cloth is detailed naturalistically. It drapes as real cloth would drape, and as a result its effect in the composition depends on the subtlety of line characteristic of draped cloth. In Figure 4.15, however, the sculptor has depicted cloth in such a way that its effect in the design is not dependent on how the cloth drapes, but rather on the decorative function of line as the sculptor wishes to use it compositionally. Real cloth cannot drape as the sculptor has depicted it. Nor, probably, did the sculptor care. The main concern here was for decoration, for using line (that looks like cloth) to emphasize the rhythm of the work.

Lighting and Environment

One final factor that significantly influences our response to a sculpture, a factor we often do not consider and is outside the control of the artist unless he or she personally supervises every exhibition in which the work is displayed, is that of lighting and environment.

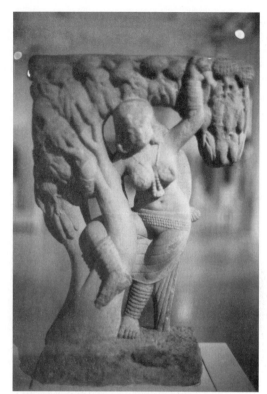

Figure 4.15 Tree Spirit (Bracket Figure), central India (first century C.E.). © The British Museum, London.

Light plays a fundamental role in our perception of—and thereby our response to—three-dimensional objects. The direction and number of sources of light striking a three-dimensional work can change the entire perception of that work. Whether the work is displayed outdoors or indoors, the method of lighting affects the overall presentation. Diffuse room lighting allows us to see all aspects of a sculpture without external influence. However, if the work is placed in a darkened room and illuminated from particular directions by spotlights, it becomes much more dramatic, and our response is affected accordingly. The differences in illumination between that of the crucifix in Figure 4.16 and that of the Egyptian sculpture in

Figure 4.17 illustrate the point. The diffuse, general lighting of the Egyptian work gives its presentation a stark neutrality, whereas the side lighting of the crucifix enhances its three-dimensionality and drama.

WHAT ARE DECORATIVE ARTS AND CRAFTS?

People began to consider the decorative, or applied arts, arts as a separate category of art at the beginning of the Industrial Revolution in the mid-nineteenth century. It quickly extended to such products as Josiah Wedgwood's stoneware and the entire field of mechanically produced minor arts. A precise definition is somewhat elusive, as we noted, and recently the term "decorative arts" has been increasingly applied to those objects that are of a relatively practical and useful nature and that exhibit a high degree of fine craftsmanship and artistic integrity.

In addition to Art Deco (see Glossary), the most significant historical decorative arts movement came in the mid- to late nineteenth century: the Arts and Crafts movement, centered in Great Britain, and led by William Morris, a poet, artist, and socialist. Morris's decorating firm produced a full range of medieval-inspired objects, including cloth. His object was to renew English design through the renewal of the medieval, handmade craft tradition. He had two purposes in this. First, he believed that mass manufacturing processes alienated workers from their labor; second, he missed the quality of handmade items. He believed that industrial workers had no stake in what they made and, therefore, no pride in it. The result, for Morris, was shoddy work and unhappy workers. Typical of Morris's fabric designs is flattened motifs on organic subjects, such as illustrated in the Cyber Example. Overall, the purpose of the Arts and Crafts movement was to provide relief from modern

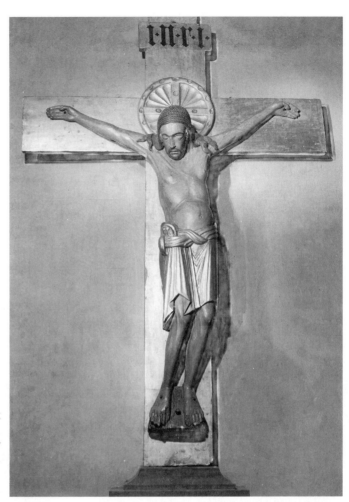

Figure 4.16 Gero Crucifix (c. 975–1000 C.E.). Oak crucifix, 6'2". Cologne Cathedral. Courtesy of Heaton Sessions, Stone Ridge, New York. Rheinisches Bildarchiv. Photograph.

CYBER EXAMPLES

Josiah Wedgwood stoneware

http://www.comptons.com /encyclopedia/captions /20003009_p.html

William Morris design

http://www.netcentral.co.uk/steveb /types/jasper.htm

urban existence and the sorry aesthetic state of mass-produced goods at the time. Associated with the Arts and Crafts movement is the style called Art Nouveau, which we discuss in Chapter 9 (p. 170).

We understand clearly how artistry and craftsmanship can blend in utilitarian objects when we examine two works. The first is an example of cabinetry from the nineteenth century (Figure 4.18). In this coin cabinet attributed to

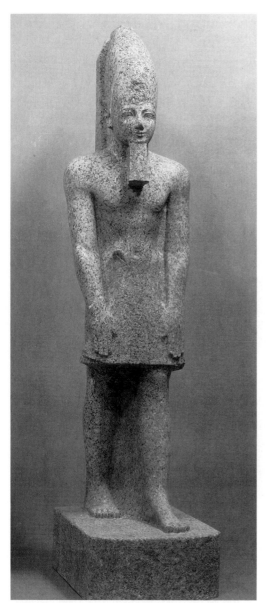

François-Honoré-Georges Jacob-Desmalter, the sides of the object slope inward as it rises from base to top, and then flair dramatically outward in a flourish reminiscent of a column capital. To give a sense of solidity to the cabinet, it is wrapped with a terminal accent of wooden banding around the bottom. The flat trapezoidal sides are highlighted with silver mounts that relieve the solid planes of the sides and add a sense of lightness because of the delicacy of their tracery. The design for the top section of the cabinet was taken from drawings made by Dominique Vivant-Denon, who accompanied Napoleon on his Egyptian campaign. The

Figure 4.17 Statue of King Thutmose III, red granite. From the temple of Montu at Medamud. Egyptian, eighteenth dynasty (1501–1447 B.C.E.). The Metropolitan Museum of Art, New York. Gift of Edward S. Harkness, 1914 (14.7.15).

Figure 4.18 François-Honoré-Georges Jacob-Desmalter (1770–1841). Coin Cabinet. Decorations after drawings by Baron Dominique Vivant-Denon. Made in Paris, France. Mahogony, silver. 90.2cm × 50.2cm × 37.5cm (35½″ × 19¾″ × 14¾″). The Metropolitan Museum of Art, New York. Bequest of Collis P. Huntington, 1900 (26.168.77).

drawings were modeled on the pylon at Ghoos, in Upper Egypt. There are twenty-two drawers on each side of the cabinet, all inlaid with a silver bee. One wing is hinged to provide a pull.

The second example proves that the most common of objects can have artistic flair and, as a consequence, provide pleasure and interest to daily life. An example of industrial design, the juice extractor (Figure 4.19), offers a

Figure 4.19 Designer unknown. (West Germany), Juice Extractor Multipresse (1950–1958). Plastic, aluminum, rubber, zinc. Produced by Braun AG. 18.5 × 27.6 × 19.2 cm. Montreal Museum of Fine Arts, Liliane and David M. Stewart Collection, gift of the American Friends of Canada through the generosity of Barry Friedman and Patricia Pastor. Photo: Giles Rivest (Montreal).

sense of pleasantry to a rather mundane chore. Its two-part plastic body sits on colored rubber feet and reminds us, perhaps, of a futuristic robot not unlike something from *Star Wars*. Its cream and brown colors are soft and warm, comfortable rather than cold and utilitarian. There is a friendly humor in its plumpness, and we could imagine talking to this little device as an amicable companion rather than regarding it as a mere machine.

BUILDING A BASIC ANALYSIS

You can make a basic analysis of a three-dimensional work of art by following this outline of concepts from the text and answering the questions:

- Reaction. What is your emotional and intellectual response to the work, and what do you think causes those responses? How do the following elements from the text combine to create a reaction in you? In other words, what draws your attention?
- Dimensionality. What is the dimensionality of the work? How does dimensionality contribute to the work's overall design and effect?
- Method of Execution. What method of execution is employed? How do the method of execution and materials create a final effect?
- Mass. In what ways does the mass of the work contribute to its overall effect?
- Line and Form. How does the artist's use of line and form contribute to overall composition and effect?
- Texture. In what ways does the texture of the work create an intellectual or emotional appeal to the viewer?
- Repetition. How do rhythm, harmony, and variety contribute to composition and effect?
- Articulation. How has the artist articulated the various parts of the work to create movement from one part to another?
- Focal areas. What elements has the artist used to create areas of interest? Which ones are primary and which are secondary?

5

Getting Next to Structures

Architecture

What's in This Chapter?

Every street in every town represents a museum of ideas and engineering. The houses, churches, and commercial buildings we pass every day reflect appearances and techniques that may be as old as the human race itself. We go in and out of these buildings, often without notice, and yet they engage us and frequently dictate actions we can or cannot take.

In this chapter we will examine the technical and aesthetic properties of the art of architecture. We begin with a brief statement on what architecture is. Then we will discuss technical elements: how buildings are put together—that is, the elements that architects address and that we can see when confronting a work of architecture. We will conclude with some comments on how we actually relate to works of architecture and with another model outline for analyzing works of architecture.

In approaching architecture as an art, it is virtually impossible to separate aesthetic properties from practical or functional properties. The principal concern that architects have is to achieve a practical function in their buildings. The aesthetics of the building are important, but they must be tailored to overall practical considerations. For example, when an architect designs a 110-story skyscraper, he or she is locked into a vertical form, rather than a horizontal one. He or she may attempt to counter verticality with strong horizontal elements, but the physical fact that the building will be taller than it is wide is the basis from which the architect must work. The structural design must take into account all the practical needs implicit in the building's use. Nonetheless, considerable room for aesthetics remains. Treatment of space, texture, line, and proportion can give us buildings of unique style and character or buildings of unimaginative sameness.

Architecture often is described as the art of sheltering, using this term very broadly. Obviously there are types of architecture within

which people do not dwell and under which they cannot escape the rain. Architecture encompasses more than buildings. We can, however, consider architecture as the art of sheltering if we consider both physical and spiritual sheltering from the raw elements of the natural world.

In a larger sense, architecture is the design of three-dimensional space to create practical enclosure. Its basic forms are residences, churches, commercial buildings, bridges, walls, and monuments. Each of these forms can take innumerable shapes, from modest single-family houses to ornate palaces of kings and high-rise condominiums; from convenience marts to skyscrapers.

CYBER EXAMPLE

Rebecca L. Binder, Ackerman Student Union, UCLA

http://www.bluffton.edu/~sullivanm /binderucla/binderucla.html

HOW IS ARCHITECTURE PUT TOGETHER?

In examining how a work of architecture is put together technically, we limit ourselves to some fundamental elements: structure systems, materials, line, repetition, and balance, scale, proportion, context, space, and climate.

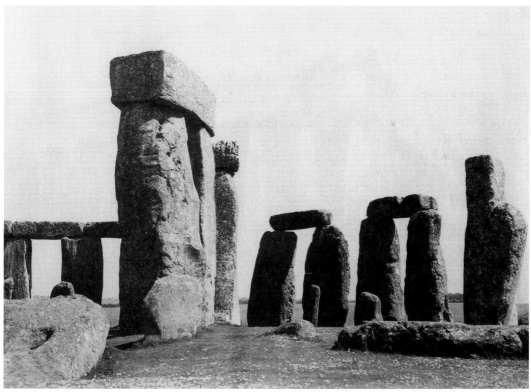

Figure 5.1 Stonehenge, Salisbury Plain, England (c. 1800–1400 B.C.E.)/British Information Services photo.

Structure Systems

Many systems of construction exist for supporting a building. Let us examine a few of the most prominent: post and lintel, arch, cantilever, bearing-wall, and skeleton frame.

Post and Lintel

Post and lintel structure (Figures 5.1–5.2) consists of horizontal beams (lintels) laid across the open spaces between vertical supports (posts). In this architectural system, the traditional material is stone. Historically, perhaps the most easily recognizable examples of post and lintel structure occurred in the ancient Greek orders illustrated in Figure 5.3. Post and lintel structures are similar to post and beam structures, in which horizontal members, traditionally of wood, join vertical posts. Nails or pegs fasten the members of post and beam structures.

Because stone lacks tensile strength (the ability to withstand twisting and stretching), post and lintel structure has a limited ability to create open space. If we lay a slab of stone across an open space and support it only at each end, we can span only a narrow gap before the slab cracks in the middle. However, stone has great compressive strength—that is, the ability to withstand crushing. Thus, fairly slender columns of stone can support massive lintels.

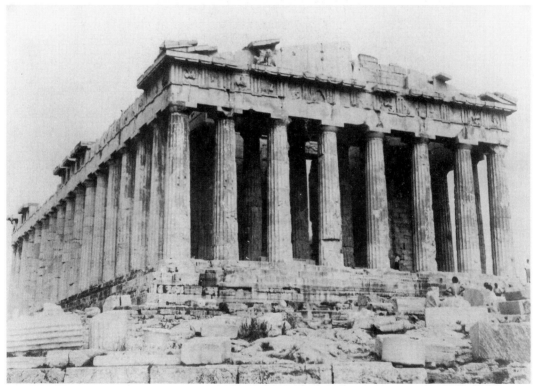

Figure 5.2 Ictinos and Calicrates. The Parthenon, Acropolis, Athens (449–432 B.C.E.). Marble. AC&R RELATIONS photo.

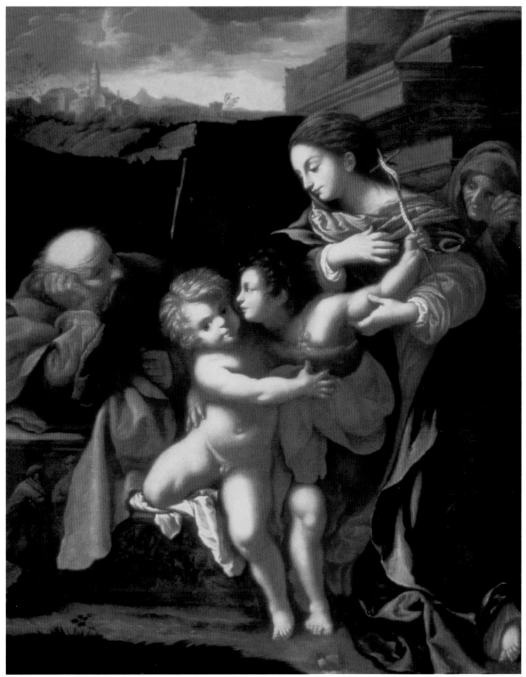

Plate 6 Giovanni Battista Vanni (Italian, 1599–1660), *Holy Family with Saint John* 1630–1660).
Oil on canvas, 70″ × 58″. Palmer Museum of Art, Pennsylvania State University (73.118).

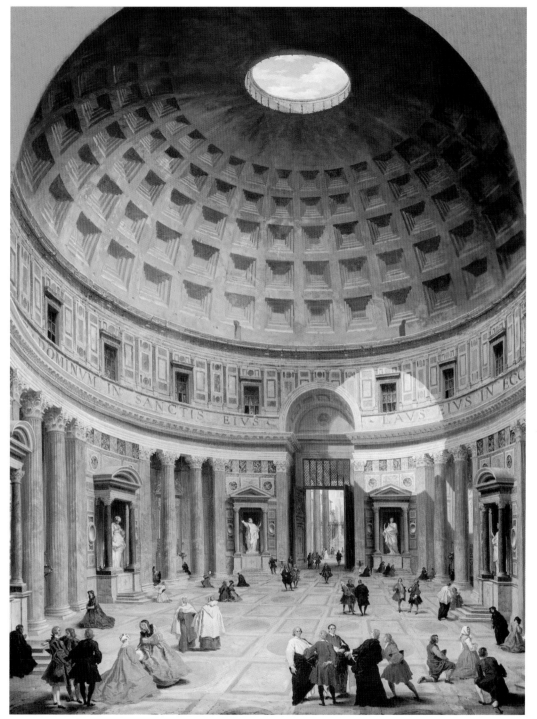

Plate 8 Giovanni Paolo Panini (Roman, 1691–1765), *Interior of the Pantheon, Rome* (c. 1734). Oil on canvas, 1.280m × 0.990m (50½″ × 39″); framed: 1.441m × 1.143m (56¾″ × 45″). Samuel H. Kress Collection. Photograph © 2001, Board of Trustees, National Gallery of Art, Washington, DC. (1939.1.24.[135])/PA. Photo by Richard Carafelli.

Plate 9 Renzo Piano and Richard Rogers, Pompidou Center, Paris (1971–1978). Charles Kennard/Stock Boston.

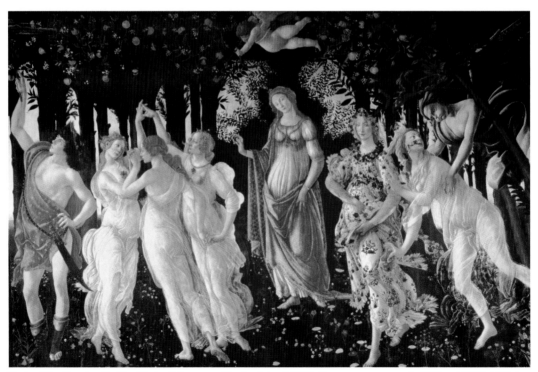

Plate 10 Sandro Botticelli, *La Primavera* (Spring) (c. 1478). Tempera on panel, 6′8″ × 10′4″. Uffizi Gallery, Florence, Italy. Fototeca Storica Nazionale/PhotoDisc, Inc.

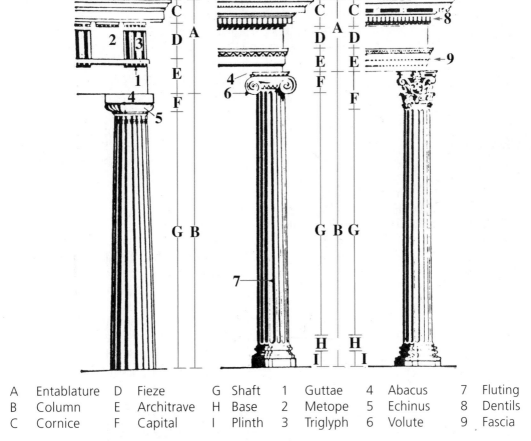

A	Entablature	D	Fieze	G	Shaft	1	Guttae	4	Abacus	7	Fluting
B	Column	E	Architrave	H	Base	2	Metope	5	Echinus	8	Dentils
C	Cornice	F	Capital	I	Plinth	3	Triglyph	6	Volute	9	Fascia

Figure 5.3 Greek columns and capitals (Greek orders): Doric (left), Ionic (center), Corinthian (right). Calmann and King Ltd.

A primitive example of post and lintel structure is Stonehenge, that ancient and mysterious religious configuration of giant stones on Salisbury Plain in southern England (Figure 5.1). The ancient Greeks refined this system to high elegance; the most familiar of their post and lintel creations is the Parthenon (Figure 5.2). Another example of this type of structure can be seen in Figure 7.7.

The Greek refinement of post and lintel structure is a prototype for buildings throughout the world and across the centuries. So it makes sense to pause to examine the Greek style in more detail. One of the more interesting aspects of the style is the treatment of columns and capitals. Figure 5.3 shows the three basic Greek orders: Doric, Ionic, and Corinthian. These, of course, are not the only orders. Column capitals can be as varied as the imagination of the architect who designed them. Their primary purpose is to act as a transition for the eye as it moves from post to lintel. Columns may express a variety of detail—as, for example, in Figures 5.4 and 5.5. A final element, present in some columns, is fluting—vertical ridges cut into the column (Figure 5.2).

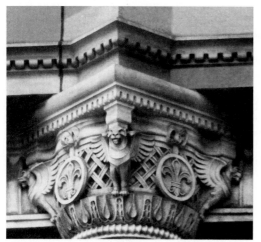

Figure 5.4 Column capital, central portal, Westminster Cathedral, London.

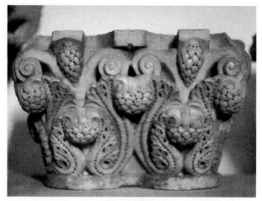

Figure 5.5 Column capital, Egypt (eighth century c.e.). © The British Museum, London.

Arch

The arch, in contrast to post and lintel structure, can define large open spaces because its stresses are transferred outward from its center (the keystone) to its legs. Thus, it does not depend on the tensile strength of its materials.

There are many different kinds and styles of arches, some of which are illustrated in Figure 5.6. The characteristics of different arches may have structural as well as decorative functions.

The transfer of stress from the center of an arch outward to its legs dictates the need for a

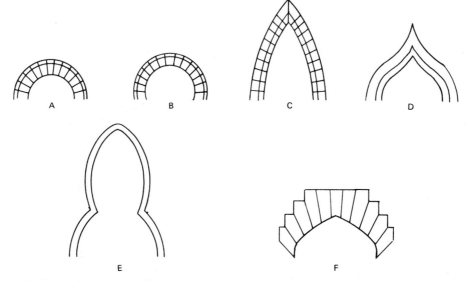

Figure 5.6 The arch. A. Round (Roman) arch. B. Horseshoe (Moorish) arch. C. Lancet (pointed, Gothic) arch. D. Ogee arch. E. Trefoil arch. F. Tudor arch.

strong support to keep the legs from caving outward. Such a refinement is called a *buttress* (Figure 5.7). The designers of Gothic cathedrals sought to achieve a sense of lightness. Because stone was their basic building material, they recognized the need for a system that would overcome the bulk of a stone buttress. Therefore, they developed a system of buttresses that accomplished structural ends but were light in appearance. These structures are called *flying buttresses* (Figure 5.8).

Arches placed back to back to enclose space form a *tunnel vault* (Figure 5.9). Several arches placed side by side form an *arcade* (Figure 5.10). When two tunnel vaults intercept at right angles, they form a *groin vault* (Figure 5.11). The protruding masonry indicating diagonal juncture of arches is *rib vaulting* (Figure 5.12).

When arches are joined at the top with their legs forming a circle, the result is a *dome* (Figure 5.13). The dome, through its intersecting arches, allows for more expansive,

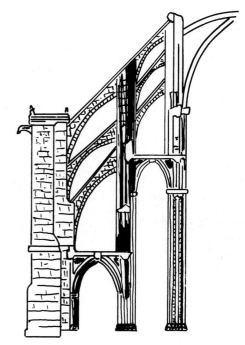

Figure 5.8 Flying buttresses.

freer space within the structure. However, if the structures supporting the dome form a circle, the result would be a circular building such as the Pantheon (color insert, Plate 8). To permit squared space beneath a dome the architect can transfer weight and stress through the use of pendentives (Figure 5.14).

Figure 5.7 Buttress.

Figure 5.9 Tunnel vault.

Figure 5.10 Arcade.

Cantilever

A cantilever is an overhanging beam or floor supported only at one end (Figure 5.15). Perhaps the simplest example of a cantilever is a diving board. Although not a twentieth-century innovation—many nineteenth-century barns in the central and eastern parts of the United States employed it—the most dramatic uses of cantilever have emerged with the introduction of modern materials such as steel beams and prestressed concrete (Figure 5.16).

Bearing Wall

In the bearing-wall system, the wall supports itself, the floors, and the roof. Log cabins are examples of bearing-wall construction; so

are solid masonry buildings in which the walls are the structure. In variations of bearing-wall such as poured concrete (Figure 5.28), the wall material is continuous—that is, not jointed or pieced together. This variation is called *monolithic construction*.

Skeleton Frame

When a skeleton frame is used, a framework supports the building; the walls are attached to the frame, thus forming an exterior skin. When skeleton framing utilizes wood, as in traditional home construction, the technique is called *balloon construction*. When metal forms the frame, as in skyscrapers, the technique is known as *steel cage construction*.

Figure 5.11 Groin vault.

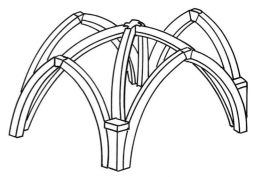

Figure 5.12 Ribbed vault.

Figure 5.13 Dome. Sir Christopher Wren, St. Paul's Cathedral, London (1675–1710)/British Tourist Authority.

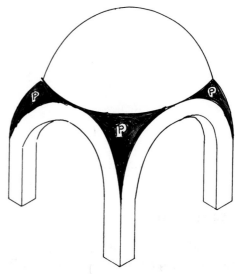

Figure 5.14 Dome with pendentives (P).

Building Materials

Historic and contemporary architectural practices and traditions often center on specific materials. To understand architecture in more depth, we will discuss several of these materials.

Stone

The use of stone as a material leads us back to post and lintel systems and the structures shown in Figures 5.1 and 5.2. When stone is used with mortar, for example, in arch construction, that combination is called *masonry*

construction. The most obvious example of masonry is the brick wall. Stones, bricks, or blocks are joined together with mortar, one on top of the other, to provide basic, structural, weight-bearing walls of a building, a bridge, and so forth (Figure 5.17). There is a limit to what can be accomplished with masonry because of the pressures that play on the joints between blocks and mortar and the foundation on which they rest. However, when one considers that Chicago's Monadnock Building (Figure 5.18), an early skyscraper, has a

Figure 5.15 Cantilever.

Figure 5.16 Eduardo Torroja. Grandstand, Zarzuela Race Track, Madrid (1935).

completely masonry structure (there are no hidden steel reinforcements in the walls), it becomes obvious that much is possible with this elemental combination of stone and mortar.

Concrete

Although the use of concrete is widely recognized as central to much contemporary architectural practice, it was also significant as far back in history as ancient Rome. One of Rome's great buildings, the Pantheon (Plate 8), comprises a masterful structure of concrete with a massive concrete dome, 143 feet in diameter, resting on concrete walls twenty feet thick. In contemporary architecture, we find precast concrete, which is concrete cast in place using wooden forms around a steel framework. We also find ferroconcrete or reinforced concrete, which utilizes metal

Figure 5.17 Masonry wall.

CYBER EXAMPLE

Reinforced Concrete

Julia Morgan, El Campanil, Mills College, Oakland, CA

http://www.bluffton.edu/~sullivanm /jmmills/jmcampanil.html

Figure 5.18 Burnam and Root, Monadnock Building, Chicago, Illinois (1891).

reinforcing embedded in the concrete. Such a technique combines the tensile strength of metal with the compressive strength of the concrete. Prestressed and post-tensioned concrete use metal rods and wires under stress or tension to cause structural forces to flow in predetermined directions. Both comprise extremely versatile building materials.

Wood

Whether in balloon framing or in laminated beaming, wood has played a pivotal role in the building industry, especially in the United States. As new technologies emerge in making engineered beams from what once was scrap wood, wood's continuation as a viable

PROFILE

Frank Lloyd Wright (1867–1959)

Frank Lloyd Wright pioneered ideas in architecture far ahead of his time and became probably the most influential architect of the twentieth century.

In 1887, Wright took a job as a draftsman in Chicago and, the next year, joined the firm of Adler and Sullivan. In short order, Wright became Louis Sullivan's (see p. 185) chief assistant. As Sullivan's assistant, Wright handled most of the firm's designing of houses. Deep in debt, Wright moonlighted by designing for private clients on his own. When Sullivan objected, Wright left the firm to set up his own practice. As an independent architect, Wright led the way in a style of architecture called the prairie school (see p. 185). Houses designed in this style have low-pitched roofs and strong horizontal lines reflecting the flat landscape of the American prairie. These houses also reflect Wright's philosophy that interior and exterior spaces should blend together.

The Great Depression of the 1930s greatly curtailed building projects, and Wright spent his time writing and lecturing. In 1932, he established the Taliesin Fellowship (the name "Taliesin" came from his grandfather's farm and means "shining brow" in Welsh), a school in which students learned by working with building materials and problems of design and construction.

Wright's work was always controversial, and he lived a flamboyant life full of personal tragedy and financial difficulty. Married three times, he had seven children. He died in Phoenix, Arizona, on April 9, 1959.

building product will probably remain—with less negative impact on the environment.

Steel

The use of steel comprises nearly endless variation and almost limitless possibilities for construction. Its introduction into the nineteenth-century industrial age forever changed style and scale in architecture. We discussed steel cage construction and cantilever earlier. Suspension construction in bridges, superdomes, aerial walkways, and so on has carried architects to the limits of space expansion. The geodesic dome (Figure 5.19) is a unique use of materials invented by an American architect, R. Buckminster Fuller. Consisting of a network of metal rods and hexagonal plates, the dome is a light, inexpensive, yet strong and easily assembled building. Although it has no apparent size limit (Fuller claimed he could roof New York City, given the funds), its potential for variation and aesthetic expressiveness seems somewhat limited.

Line, Repetition, and Balance

Line and repetition perform the same compositional functions in architecture as in painting and sculpture. In his Marin County Courthouse (Figure 5.20), Frank Lloyd Wright takes a single motif, the arc, varies only its

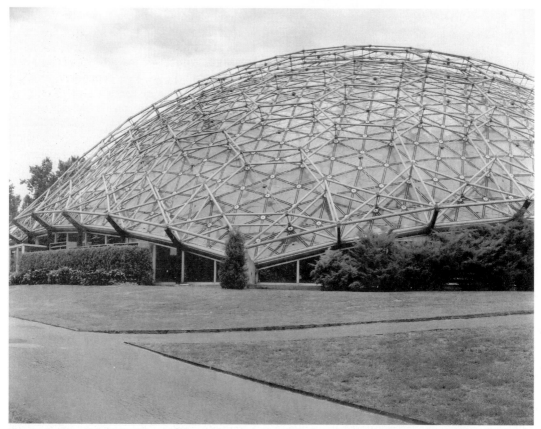

Figure 5.19 Geodesic Dome. R. Buckminster Fuller, Climatron, St. Louis, Missouri (1959). Wayne Andrews/Esto Photographics, Inc.

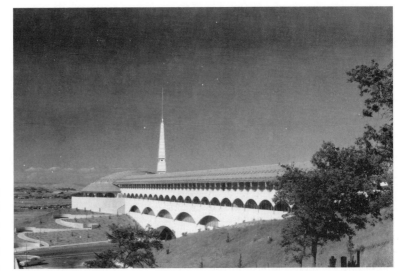

Figure 5.20 Frank Lloyd Wright, Marin County Courthouse, California (1957–1963). Ezra Stoller/Esto Photographics, Inc.

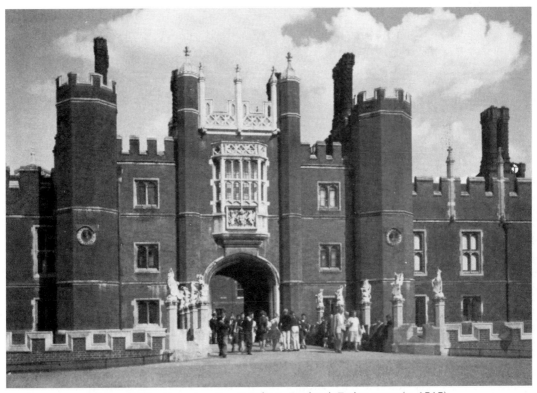

Figure 5.21 Hampton Court Palace, England. Tudor entry (c. 1515).

size, and repeats it almost endlessly. The result, rather than being monotonous, is dynamic and fascinating.

Let's look at three other buildings. The main gate of Hampton Court Palace (Figure 5.21), built in the English Tudor style around 1515 for Thomas Wolsey, achieves bilateral symmetry—that is the architect balanced identical items on each side of the centerline. In addition, line and form give Hampton Court Palace the appearance of a substantial castle.

Figure 5.22 is the same Hampton Court Palace. Figure 5.21 reflects the style and taste of England during the reign of Henry VIII (who appropriated the palace from its original owner, Cardinal Wolsey). Later monarchs found the cumbersome and primitive appearance unsuited to their tastes, and Sir Christopher Wren, the architect of St. Paul's Cathedral (Figure 5.13), was commissioned to plan a new palace. In 1689, in the reign of William and Mary, renovation of the palace began. The result was a new and classically oriented facade in the style of the English baroque.

As we can see in Figure 5.22, Wren has designed a sophisticated and overlapping system of repetition and balance. Note first that the facade is balanced symmetrically. The outward wing at the far left of the photograph is duplicated at the right (but not shown in the photo). In the center of the building are four attached columns surrounding three windows. The middle window forms the exact center of the design, with mirror-image repetition on each side. Next, note that above the main windows is a series of relief sculptures, pediments (triangular casings), and circular windows. Returning to the main row of windows

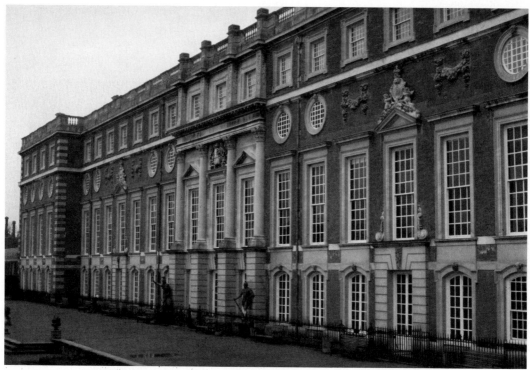

Figure 5.22 Hampton Court Palace, England. Wren façade (1689).

at the left border of the photo, count toward the center. The outer wing contains four windows; then seven windows; then the central three; then seven; and finally, the four of the unseen wing. Wren has established a pattern of four in the outer wing, three in the center, and then repeated the pattern within each of the seven-window groups to create additional patterns of three. He creates four patterns of three using only seven windows by using forms to group windows together. We can follow his organization with careful observation. First, locate the center window of the seven. It has a pediment and a relief sculpture above it. On each side of this window are three windows (a total of six) without pediments. So, there are two groupings of three windows each. Above each of the outside four windows is a circular window. The window on each side of the center window does not have a circular window above it. Rather, it has a relief sculpture, the presence of which joins these two windows

with the center window to give a third grouping of three. Line, repetition, and balance in this facade form a challenging perceptual exercise and experience.

Buckingham Palace (Figure 5.23) and the Palace of Versailles (Figure 5.24) illustrate different treatments of line and repetition. Buckingham Palace uses straight line exclusively, with repetition of rectilinear and triangular form. Like Hampton Court Palace, it exhibits fenestration (window opening) groupings of threes and sevens (the grouping of threes, fours, and sevens popular in early architecture often refers to the holy trinity, the four gospels, and the seven deadly sins), and the building is symmetrically balanced and divided by three pedimented, porticolike protrusions (porches). Notice how the predominantly horizontal line of the building is broken by the three major pediments and given interest and contrast across its full length by the window pediments and the verticality of the attached columns.

Figure 5.23 Buckingham Palace, London (1703); Remodeled by John Nash (1825)/British Tourist Authority.

Figure 5.24 Louis LeVau and Jules Hardouin-Mansart, Palace of Versailles, France (1669–1685)/Pan American Airways Corp.

Compare Buckingham Palace to the Palace of Versailles, in which repetition occurs in groupings of threes and fives. Contrast is provided by juxtaposition and repetition of curvilinear line in the arched windows and baroque statuary of the Palace of Versailles. Notice how the horizontal line of the building, despite

CYBER EXAMPLE

Fenestration

Denise Scott Brown (Venturi, Scott Brown, and Associates), Addition to the Allen Memorial Art Museum, Oberlin College, Oberlin, OH

http://www.bluffton.edu/~sullivanm /venturi/add.html

three porticoes, remains virtually undisturbed, in contrast with Buckingham Palace.

Scale and Proportion

Scale in architecture refers to a building's size and the relationship of the building and its decorative elements to the human form. Proportion, or the relationship of individual elements to each other, also plays an important role in a building's visual effect. Perhaps nothing suggests the dynamics of technological achievement more than the overwhelming scale of the skyscraper. Also, nothing symbolizes the subordination of humans to their technology more than the scale of the Sears Tower, once the world's tallest building (Figure 5.25). Proportion and scale are tools with which the architect can create relationships that may be

Figure 5.25 Skidmore, Owings, and Merrill. Sears Tower, Chicago, Illinois (1971)/Sears Roebuck & Co. photo.

two, one to three, and so on. Discovering such relationships in a building is one of the fascinating challenges that face us whenever we encounter a work of architecture.

Context

An architectural design usually takes into account its context, or environment. In many cases, context is essential to the statement made by the design. Throughout Europe we find cathedrals sitting at the center of, and on the highest point in, a city. Their placement in that particular location had a purpose for the medieval artisans and clerics responsible for their design. The centrality of the cathedral to the community was an essential statement of the centrality of the church to the life of the medieval community. Context also has a psychological bearing on scale. A skyscraper in the midst of skyscrapers has great mass but does not appear as massive in scale when overshadowed by another, taller, skyscraper. A cathedral, when compared to a skyscraper, is relatively small in scale. However, when standing in the center of a community of small houses, it appears quite large.

Two additional aspects of context concern the shapes and textures of the physical environment and their reflection in a building. On one hand, the environment can be shaped according to the compositional qualities of the building. Perhaps the best illustration of that principle is Louis XIV's palace at Versailles, whose formal symmetry is reflected in the design of thousands of acres around it.

In contrast, a building may be designed to reflect the natural characteristics of its environment. Frank Lloyd Wright's Falling Water (Figure 10.11) illustrates this principle. Such an idea has been advanced by many architects and can be seen especially in residences in which large expanses of glass allow us to feel a part of the outside while we are inside. The interior decoration of such houses often adopts

straightforward or deceptive. We must decide how these elements are used, and to what effect. In addition, proportion in many buildings is mathematical: The relationships of one part to another (as in the high chest in Figure 1.11) often are based on ratios of three to two, one to

the theme of colors, textures, lines, and forms in the environment surrounding the home. Natural fibers, earth tones, delicate wooden furniture, pictures that reflect the surroundings, large open spaces—together these form the core of the design, selection, and placement of nearly every item in the home, from walls to furniture to silverware. Sometimes a building seems at odds with its context. For example, situated in the middle of historic Paris near the old marketplace, Les Halles, resides the Pompidou Center (Plate 9), an art museum whose brightly painted infrastructure, which appears on the outside of the building, seems out of place beside its older neighbors.

Space

It seems almost absurdly logical to state that architecture must concern space—for what else, by definition, is architecture? However, the world is overwhelmed with examples of architectural design that have not met that need. Design of space essentially means the design and flow of contiguous spaces relative to function. *Traffic flow* is another term often used to describe this concept. Take, for example, a sports arena. Of primary concern is the space necessary for the sports intended to occupy the building. Will it play host to basketball, hockey, track, football, and/or baseball? Each of these sports restricts the architectural design, and curious results can occur when functions not intended by the design are forced into its parameters. For example, when the Brooklyn Dodgers first moved to Los Angeles, they played for a time in the Los Angeles Coliseum, a facility designed for the Olympic Games and for track and field events, and reasonably suited for football (although spectators in the peristyle end zone seats may not have agreed). However, as a venue for baseball, it strained credulity. The left-field fence was only slightly more than 200 feet from home plate!

In addition to the requirements of the game, a sports arena must also accommodate the requirements of the spectators. Pillars that obstruct spectators' views do not create good will nor stimulate the sale of tickets. The same may be said for seats that lack sufficient legroom. Determining where to draw the line between more seats (and more dollars) and fan comfort is not easy. The now-demolished old Montreal Forum, in which anyone taller than five feet two inches was forced to sit with knees rubbing their chin, did not prove deleterious to the sale of tickets for the Montreal Canadian's hockey team. Such a design of space, however, might be disastrous for a franchise in a less hockey-oriented city.

Finally, the design of space must concern the relationship of various needs peripheral to the primary function of the building. Again, in a sports arena the sport and its access to the spectator are primary. In addition, the relationship of access to spaces such as restrooms and concession stands must also be considered. I once had season basketball tickets in an arena seating 14,000 people in which access to the two concession stands required standing in a line that, because of spatial design, intersected the line to the rest room. If the effect was not chaotic, it certainly was confusing, especially during halftime of an exciting game.

Climate

Climate always has been a factor in architectural design in zones of severe temperature, either hot or cold. As the world's energy supplies diminish, this factor will grow in importance. In the temperate climate of much of the United States, systems and designs that make use of the sun and earth are common. These are passive systems; that is, their design accommodates natural phenomena rather than adding technological devices such as solar collectors. For example, in the colder regions of the

United States, a building can be made energy efficient by using design that eliminates or minimizes glass on the north-facing side. Windows facing south can be covered or uncovered to catch existing sunlight, which even in mid-winter provides considerable warmth. Houses built into the sides of hills or below ground require less heating or cooling than those standing fully exposed—regardless of climate extremes—because space as shallow as four feet below the ground maintains a temperature of fifty degrees.

HOW CAN WE RESPOND TO ARCHITECTURE?

As should be clear at this point, our response to a work of art is a composite experience. Individual characteristics of the work are the stimulation for our response. Architecture is not different from painting, sculpture, or any other visual art in that regard. Even color plays its role, in some cases in exotic ways—for example, in the Pompidou Center (Plate 9).

Controlled Vision and Symbolism

The Gothic cathedral has been described as the perfect synthesis of intellect, spirituality, and engineering. The upward, striving line of the Gothic arch makes a simple yet powerful statement of medieval peoples' striving to understand their earthly relation to the spiritual unknown. Today, the simplicity and grace of that design effects those who view a Gothic cathedral. Chartres Cathedral (Figures 5.26 and 5.27), unlike most other Gothic churches, has an asymmetrical design, arising from the replacement of one of its spires because of fire. The new spire reflects a later and more complex Gothic style, and as a result impedes the eye as it progresses upward. Only after some pause does the eye reach the tip of the spire, the point of which symbolizes the individual's escape

Figure 5.26 Exterior, Chartres Cathedral, France (1145–1220). Photo. Lauros/Giraudon, Art Resource, New York.

from the earthly known to the unknown. Included in this grandeur of simple vertical line is an ethereal lightness that defies the material from which the cathedral is constructed. The medieval architect has created in stone not the heavy yet elegant composition of the early Greeks, which focused on treatment of stone, but rather a treatment of stone that focuses on space—the ultimate mystery. Inside the cathedral, the design of stained glass kept high above the worshipers' heads so controls the light entering the cathedral that the overwhelming effect is, again, one of mystery. Line, form, scale, color, structure, balance, proportion, context, and space combine to form a unified composition that has stood for more than seven hundred years as an example and symbol of the Christian experience.

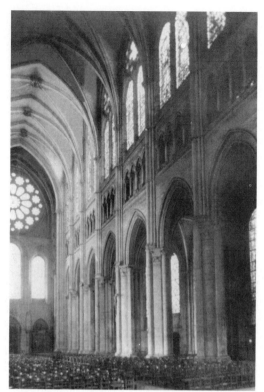

Figure 5.27 Chartres Cathedral (1145–1220). Interior, France.

Style

The Christian experience is also the denominator of the design of the Church of the Holy Family (Figure 5.28). However, despite the clarity of line and the upward striving power of its composition, this church suggests modern sophistication through its style, perhaps speaking more of our own conception of space, which seems less unknowable and more conquerable than it seemed to our medieval predecessors. The juxtaposing of rectilinear and curvilinear line creates an active and dynamic response, one that prompts a sense of abruptness rather than mystery. The composition is cool, and its material calls attention to itself—to its starkness and to its lack of decoration.

Each part of the church is distinct and is not quite subordinate to the totality of the design. This building perhaps represents a philosophy intermediate between the philosophy underlying Chartres Cathedral, whose entire design can be reduced to a single motif—the Gothic arch—and the philosophy such as the baroque style, as seen in the Hall of Mirrors of the Palace of Versailles (Figure 5.29). No single part of the design of this hall epitomizes the whole, yet each part is subordinate to the whole. Our response to the hall is shaped by its ornate complexity, which calls for detachment and investigation and intends to overwhelm us with its opulence.

In many cases, the expression and the stimuli reflect the patron. Chartres Cathedral reflects the medieval church; the Church of the Holy Family, the contemporary church; and Versailles, King Louis XIV. Versailles is complex, highly active, and yet warm. The richness of its textures, the warmth of its colors, and its curvilinear softness create a certain kind of comfort despite its scale and formality.

In the U.S. Capitol, a neoclassic house of government (Figure 5.30), formality creates a four-square, solid response. The symmetry of its design, the weight of its material, and its coldness elicit a sense of impersonal power, which is heightened by the crushing weight of the dome. Rather than the upward-striving spiritual release of the Gothic arch, or even the powerful elegance of the Greek post and lintel, the Capitol building, based on a Roman prototype, elicits a sense of struggle, achieved through upward columnar thrust (enhanced by the height of Capitol Hill) and downward thrust (of the dome) focused toward the interior of the building.

Apparent Function

The architect Louis Sullivan, of whom Frank Lloyd Wright was a pupil, is credited with the concept that "form follows function." To a

Figure 5.28 Conrad and Fleishman, The Church of the Holy Family, Parma, Ohio (1965).

degree, we have seen that concept in the previous examples, even though, with the exception of the Church of the Holy Family, they all predate Sullivan. A worthy question concerning the Guggenheim Museum (Figure 5.31) might be how well Wright followed his teacher's philosophy. There is a story that Wright came to hate New York City because of his unpleasant experiences with the city fathers during previous projects. As a result, the Guggenheim, done late in his life, became a symbol of revenge. This center of contemporary culture and art, with its single, circular ramp from street level to roof was built (so the story goes) from the unused plans for a parking garage. Be that as it may, the line and form of this building create a simple, smoothly flowing, leisurely upward movement juxtaposed against a stark and dynamic rectilinear form. The building's line and

color, and the feeling they produce, are contemporary statements appropriate to the contemporary art the museum houses. The modern design of the Guggenheim is quite in contrast with the classical proportions of the Metropolitan Museum, just down the street, which houses great works of ancient and modern art. The Guggenheim's interior design is outwardly expressed in the ramp, and one can speculate that the slowly curving, unbroken line of the ramp is highly appropriate to the leisurely pace that one should follow when going through a museum.

Dynamics

Leisurely progress through the Guggenheim is diametrically opposite to the sensation stimulated by the cantilevered roof of the grandstand

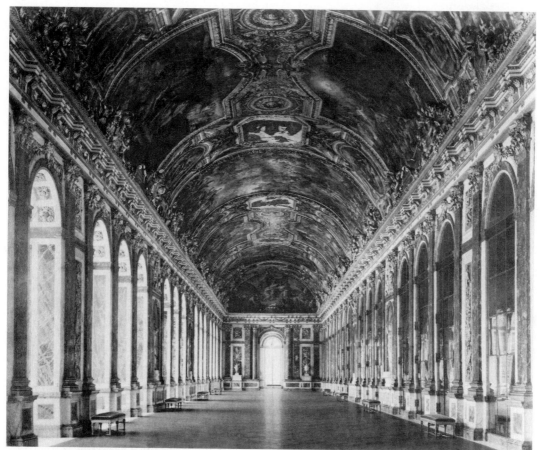

Figure 5.29 Jules Hardouin-Mansart and Charles LeBrun, Hall of Mirrors, Palace of Versailles, France (1680)/French Government Tourist Office.

at Zarzuela Race Track in Madrid, Spain (Figure 5.16). Speed, power, and flight are its preeminent concerns. The sense of dynamic instability inherent in the structural form—that is, cantilever, and this particular application of that form—mirror the dynamic instability and forward power of the race horse at full speed. However, despite the form and the strong diagonals of this design, it is not out of control; the architect has unified the design through repetition of the track-level arcade in the arched line of the cantilevered roof. The design is dynamic and yet

humanized in the softness of its curves and the control of its scale.

BUILDING A BASIC ANALYSIS

You can do a basic analysis of a work of architecture using the following outline of concepts from the text as a guide and answering the questions:

• Reaction. What is your emotional and intellectual response to the work, and what causes

Figure 5.30 United States Capitol Building (1792–1856)/Washington DC Convention and Visitors Association photo.

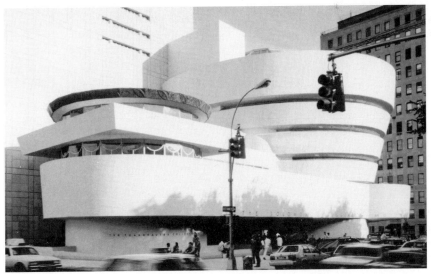

Figure 5.31 Frank Lloyd Wright, Guggenheim Museum, New York City (1942–1959). David Heald/The Solomon R. Guggenheim Museum.

that response? How do the following elements combine to create a reaction in you? In other words, what draws your attention?

- Structure. What is the structure of the example? How does the exterior suggest its supports?

- Materials. What materials have been used, and how have they been combined for structure and decoration?

- Scale and proportion. How does the size of the example relate to the human form? What emotions does this create? How do each of the elements of the example relate to each other in terms of proportions?

- Context. How does the example explore its context? What is the context of the example? Does the example harmonize or conflict with its context?

- Climate. What accommodation to climate does the building make?

6

The Flicker of Camera Art
Photography and Cinema

What's in This Chapter?

This chapter details the arts of the camera. We begin with photography, detailing three general topics: photography as art, photography as documentary, and photographic techniques. The second part of the chapter covers the art of cinema, once more in three topics: basic cinema types, basic cinema techniques, and some other factors. The chapter ends with yet another model analysis outline to assist in developing a basic critique of camera art.

PHOTOGRAPHY—CAPTURING IMAGES THROUGH A LENS

Photography as Art

Photographic images (and images of its subsequent developments—motion pictures and video) are primarily informational. Cameras record the world; but, in addition, through editing, a photographer can take the camera's image and change the reality of life as we see it to a reality of the imagination. In one sense, photography is a simplification of reality that substitutes two-dimensional images for the three-dimensional images of life. It also can be an amplification of reality when a photographer takes a snapshot of one moment in time and transforms it by altering the photographic image and/or artificially emphasizing one of its parts.

In some cases, photography is merely a matter of personal record executed with equipment of varying degrees of expense and sophistication (Figure 6.1). Certainly, photography as a matter of pictorial record, or even as photojournalism, may lack the qualities we believe are requisite to art. A photograph of a baseball player sliding into second base or of Aunt Mabel cooking hamburgers at the family reunion may trigger expressive responses, but it is doubtful that the photographers had aesthetic communication in mind when they snapped

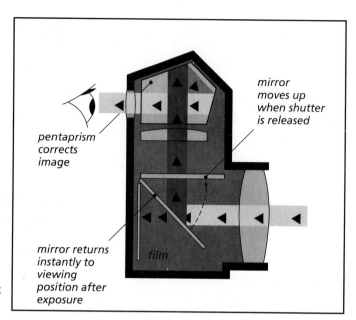

mirror
moves up
when shutter
is released

pentaprism
corrects
image

mirror returns
instantly to
viewing
position after
exposure

film

Figure 6.1 The single-lens reflex (SLR) camera.

the shutter. But a carefully composed and sensitively designed and executed photograph can contain every attribute of human expression possible in any art form.

Ansel Adams believed the photographer to be an interpretive artist; he likened a photographic negative to a musical score, and the print to a performance. Despite all the choices an artist may make in committing an image to film, these are only the beginning of the artistic process. A photographer still has the choice of size, texture, and value contrast or tonality. A photo of the grain of a piece of wood, for example, can have an enormous range of aesthetic possibilities, depending on

how an artist employs and combines these three elements.

Consequently, the question "Is it art?" may have a cogent application to photography. However, the quality of our aesthetic repayment from the photographic experience is higher if we view photography in the same vein as we do the other arts—as a visualization of reality expressed through a technique and resulting in an aesthetic effect.

After World War I, as photography entered its second century, significant aesthetic changes occurred. Early explorations of photography as an art form tended to employ darkroom techniques, tricks, and manipulation that created works appearing to be staged and imitative of sentimental, moralistic paintings. The followers of such an aesthetic believed that for photography to be art, it must look like "art."

During the early years of the twentieth century, however, a new generation of photographers arose who determined to take photography away from the previous pictorial style

CYBER EXAMPLE

Ansel Adams, *North Dome*

http://nmaa-ryder.si.edu/images/1994
/1994.91.1_1b.jpg

and its soft focus, and toward a more direct, unmanipulated, and sharply focused approach. Called straight photography, it expressed what its adherents believed was photography's unique vision. The principal American force behind the recognition of photography as a fine art was Alfred Stieglitz (STEEG-lits; 1864–1946). His own work gained recognition for his clarity of image and reality shots, especially of clouds and New York City architecture. In 1902, he formed the Photo-Secessionist group and opened a gallery referred to as 291 because of its address at 291 Fifth Avenue in New York City. In addition to showcasing photography, Stieglitz's efforts promoted many visual artists, including the woman who would become his wife, Georgia O'Keeffe (see p. 177). He also promoted photography as a fine art in the pages of his illustrated quarterly, *Camera Work*.

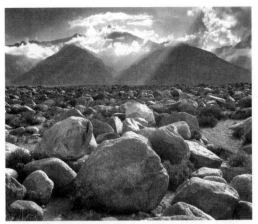

Figure 6.2 Ansel Adams, *Mount Williamson in the Sierra Nevada* (1945)/CORBIS.

CYBER EXAMPLE

Alfred Stieglitz, *The Terminal*

http://www.artsmia.org/get-the-picture/stieglitz/frame04.html

Among the most famous adherents of straight photography was Ansel Adams (1902–1984), who became a recognized leader of modern photography through his sharp, poetic landscape photographs of the American West—for example, his photograph *Mount Williamson in the Sierra Nevada* (Figure 6.2). He was well known as a technical innovator and was a pioneer in the movement to preserve the wilderness. His work did much to elevate photography to the level of art. It emphasized sharp focus and subtle variety in light and texture, with rich detail and brilliant tonal differences. In 1941, he began making photomurals for the United States

Department of the Interior, a project that forced him to master techniques for photographing the light and space of immense landscapes. He developed what he called the zone system, a means for determining the final tone of each part of the landscape.

Photography as Documentary

Since the late nineteenth century, photographers had used photography to document social problems. During the Great Depression, a large-scale program in documentary photography began in the United States. Among the photographers using this approach, Dorothea Lange (1895–1965) helped develop an unsurpassed portrait of the nation. Noted for her ability to make strangers seem like familiar acquaintances, her work for the Farm Security Administration, including *Migrant Mother, Nipomo, California* (Figure 6.3), graphically detailed the erosion of the land and the people of rural America during the Great Depression. Her work brought the plight of the poor to national attention. Her photographs of California's migrant workers, captioned with their

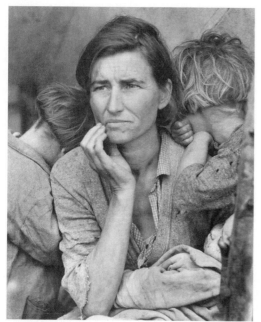

Figure 6.3 Dorothea Lange, *Migrant Mother, Nipoma, California* (1936). Library of Congress, Washington, DC/CORBIS.

own words, were so effective that the state established migrant worker camps to alleviate the suffering.

Photographic Techniques

The word *camera* means "room" in Latin; in the sixteenth century, artists used a darkened room, called a camera obscura, to copy nature accurately. Remarkably, the camera obscura utilized the same device used by today's cameras. Specifically, a small hole on one side of the light-free room admitted a ray of light that projected the scene outside onto a semitransparent scrim cloth. The camera obscura illustrated in Figure 6.4 actually has holes in two walls. The early camera obscuras were also portable, which allowed artists to set them up to project any subject matter. Of course, the camera obscura could not preserve the image it projected, and photography could not emerge until that technological problem had been solved.

The technology of photography was invented in England in 1839 by William Henry Fox Talbot, who achieved a process for fixing negative images on a paper coated with light-sensitive

Figure 6.4 Camera Obscura. Engraving. © Bettmann/CORBIS.

chemicals. His process was called a photogenic drawing. In France, at about the same time, two inventors, Louis Jacques Mandé Daguerre (dah-GAIR) and Joseph Nicéphore Niépce (nee-APE-suh) produced a process in which a positive image could be affixed to a metal plate. Niépce died in 1833, and Daguerre perfected the process, which now bears his name: daguerreotype (dah-GAIR-oh-tipe).

Unfortunately, the image on the daguerreotype could not be reproduced, while the photogenic image, on paper, could. Fox Talbot realized that the negative image of the photogenic drawing could be reversed by covering it with sensitized paper and exposing the two papers to sunlight. Then the latent image on the second paper was developed by dipping the paper in gallic acid, a process called *calotype*.

The early technical developments of Fox Talbot were followed in 1850 by another Englishman, Frederick Archer, who, in a darkened room, poured a viscous chemical solution, liquid collodion, over a glass plate bathed in silver nitrate. Although the process required preparing, exposing, and developing the plate within a span of fifteen minutes, the results were universally accepted within the next five years, and the wet-plate collodion photographic process became standard.

Dorothea Lange
Migrant Mother

In this poignant photograph, Florence Thompson, a thirty-two-year-old widow with ten children, looks past the viewer with a preoccupied, worried expression. With her furrowed brow and prematurely aged face, she captures the fears of an entire population of disenfranchised people. Two of her children lean on her for support, their faces buried disconsolately in their mother's shoulders. Lange consciously avoided including all of Thompson's children in the photograph because she did not wish to contribute to the widespread resentment among wealthier people in America regarding overpopulation among the poor.

CINEMATOGRAPHY— LIKE LIFE IN A CAN

Like theater, but without the spontaneity of "live" performers, *cinematography* (the art of the motion picture) uses the camera to portray life nearly as graphically as it is found on the streets. On the other hand, through the magic of sophisticated special effects, movies can create new worlds plausibly in ways open to no other form of art.

Cinematography is usually accepted casually, and yet all its elements come carefully crafted from editing techniques, camera usage, juxtaposition of image, and structural rhythms. As a result, cinema (film) can rise from the realm of mere entertainment to the level of serious art. George Bernard Shaw, the Irish playwright once observed that "Details are important; they make comments." It may not be as easy as it might seem to perceive the details of a film because, while the search proceeds, the entertainment elements of the film draw attention away from the search. In terse terms, cinema is aesthetic communication through the design of time and three-dimensional space compressed into a two-dimensional image.

A strip of film is only a series of still pictures running the length of the strip. Each of these pictures, or frames, is about $\frac{4}{5}''$ (twenty-two mm) wide and $\frac{3}{5}''$ (sixteen mm) high. The frames, in relation to each other, each seem to show almost exactly the same scene. However, the position of the objects in each frame is slightly different. Film also contains sixteen frames per foot (thirty mm). When it runs on a projecting device and passes before a light source at the rate of twenty-four frames per second (sixteen to eighteen frames per second for silent films), a magnifying lens enlarges the frames. Projected on a screen, the images appear to move. However, the motion picture, as cinema is popularly called, does not really move but only seems to. This is caused by an optical phenomenon called *persistence of vision*, which, according to legend, was discovered by the astronomer Ptolemy in the second century C.E. The theory behind persistence of vision asserts that the eyes take a fraction of a second to record an impression of an image and send it to the brain. Once the impression is received, the eye retains it on the retina for about one-tenth of a second after the actual image has disappeared.

A film projector pulls the film between a light source and a lens in a stop-and-go fashion, the film pausing long enough at each frame to let the eye take in the picture. Then a shutter on the projector closes, the retina retains the image, and the projection mechanism pulls the film ahead to the next frame. Perforations along the right-hand side of the filmstrip enable the teeth on the gear of the driving mechanism to grasp the film and not only move it along frame by frame but also hold it steady in the gate (the slot between the light source and the magnifying lens). This stop-and-go motion gives the impression of continuous movement. If the film did not pause at each frame, the eye would receive a blurred image.

PROFILE

D. W. Griffith

D. W. Griffith (1875–1948) was the first giant of the motion picture industry and a genius of film credited with making film an art form. As a director, D. W. Griffith never needed a script. He improvised new ways to use the camera and to cut the celluloid, which redefined the craft for the next generation of directors.

At age sixteen, Griffith quit school and worked in a bookstore, where he met some actors from a Louisville, Kentucky theater. This acquaintanceship led to work with amateur theater groups and to tours with stock companies. He tried play writing, but failed, and his first screenplay met the same result. While acting for New York studios, however, he did sell some scripts for one-reel films, and when the Biograph Company had an opening for a director in 1908, Griffith was hired.

During his years with Biograph, Griffith introduced or refined all the basic techniques of moviemaking. His innovations in cinematography included the close-up, the fade-in and fade-out, soft focus, high- and low-angle shots, and panning (moving the camera in panoramic long shots). In film editing, he invented the techniques of flashback and crosscutting (interweaving bits of scenes to give an impression of simultaneous action).

Griffith also expanded the horizon of film with social commentary. In 1919, Griffith formed a motion picture distribution company called United Artists. His stature within the Hollywood hierarchy was one of respect and integrity, although the modern reassessment of his contribution in the light of the Civil Rights movement and the racism perceived in his film *The Birth of a Nation* (1915) lent controversy to the yearly prestigious film award that bears his name.

The motion picture was originally invented as a device for recording and depicting motion, but the realization that cinema could record and present stories—in particular, stories that made use of the unique qualities of the medium—quickly followed. As cinema art emerged, it coalesced into three distinct genres: narrative film, documentary film, and absolute film.

Basic Cinema Types

Narrative Film

Narrative film tells a story. In many ways, it uses the techniques of theater. It follows the rules of literary construction in that it begins with expository material, adds levels of complication, builds to a climax, and ends with a resolution of the plot elements. As in theater, under the guidance of a director, actors portray the characters. The action takes place within a setting designed and constructed primarily for the story but allowing cameras to move freely. Many narrative films pursue genre subjects—for example westerns, detective stories, horror stories, and so on. In these films the story elements are so familiar that the audience usually knows the outcome of the plot before it begins. The final showdown between the "good guy" and the "bad guy," the destruction of a city, and the identification of a murderer by a detective are all familiar plot scenarios that have become clichés or stereotypes; their use fulfills audience expectations. Film versions of popular novels and stories written especially for the screen form part of the narrative-film form; but because film is a major part of the mass entertainment industry, the narrative presented is usually material that will attract a large audience and thus assure a profit. Narrative films may also include elements from documentary and absolute film.

Documentary Film

Documentary film is an attempt to record actuality using primarily either a sociological or a journalistic approach. It is normally not reenacted by professional actors and is often shot as the event occurs—at the same time and place as the occurrence. The film may use a narrative structure, and some of the events may be ordered or compressed for dramatic reasons, but its presentation gives the illusion of reality. Footage shown on the evening news, programming concerned with current events or problems, and television or film coverage of worldwide events such as the Olympics are all examples of documentary film. All convey a sense of reality as well as a recording of time and place. An excellent example is the work of the German filmmaker Leni Riefenstahl (LAY-nee REEF-en-shtahl).

CYBER EXAMPLE

Leni Riefenstahl

http://www.german-way.com/cinema/rief.html

Absolute Film

Absolute film exists for its own sake: for its record of movement or form. It ignores narrative techniques, although it occasionally employs documentary techniques. Created neither in the camera nor on location, absolute film is constructed carefully, piece by piece, on the editing table or through special effects and multiple-printing techniques. It

CYBER EXAMPLE

Historical perspective on experimental films and film history in general:

http://www.filmsite.org/filmh.html

tells no story but exists solely as movement or form. Absolute film is rarely longer than twelve minutes (one reel) in length, and usually is not created for commercial intent but only as an artistic experience.

Basic Cinema Techniques

Editing

A cinematic work is rarely recorded in the order of its final presentation. Rather, it is filmed in bits and pieces and put together, after all the photography is finished, as one puts together a jigsaw puzzle or builds a house. The force or strength of the final product depends upon the editing process, the manner in which the camera and the lighting are handled, and the movement of the actors. Perhaps the greatest difference between cinema and the other arts is plasticity—the quality of film that enables it to be cut, spliced, and ordered according to the needs of the film and the desires of the filmmaker. If twenty people were presented with all the footage shot of a presidential inauguration, for example, and asked to make a film commemorating the event, twenty different films would result.

The Shot

The shot is the basic unit of filmmaking, and several varieties are used. The *master shot* is a single, uninterrupted, shot of an entire piece of action, taken to facilitate the assembly of the component shots of which the scene will finally be composed. The *establishing shot* is a long shot (see below) introduced at the beginning of a scene to establish the interrelationship of details, time, or place. A *long shot* is taken with the camera a considerable distance from the subject; a *medium shot* is taken nearer to the subject; and a *close-up*, even nearer. A close-up of two people within a frame is called a *two-shot*, and a *bridging shot* is

one inserted in the editing of a scene to cover a brief break in continuity.

Cutting

Cutting is simply joining shots together during the editing process. A jump cut is a cut that breaks the continuity of time by moving forward from one part of the action to another that obviously is separated from the first by an interval of time, location, or camera position. A form cut jumps from one image to another—that is, from one object to a different one that has a similar shape or contour. Its purpose is to create a smooth transition from one shot to another. Montage can be considered the most aesthetic use of the cut in film. It is handled in two basic ways: first, as an indication of compression or elongation of time, and, second, as a rapid succession of images to illustrate an association of ideas. A series of stills from Fernand Léger's (lay-ZHAY) *Ballet Méchanique* (Figure 6.5) illustrates how images are juxtaposed to create comparisons. An additional example might be a man and a woman out on the town for an evening of dining and dancing. The film presents a rapid series of cuts of the pair—in a restaurant, then dancing, then driving to another spot, then drinking, and then dancing some more. In this way, the audience sees the couple's activities in an abridged manner. Elongation of time can be achieved in the same way. The second use of montage allows the filmmaker to depict complex ideas or draw a metaphor visually. Sergei Eisenstein (EYE-zen-stine), the Russian film director, presented a shot in one of his early films of a Russian army officer walking out of the room, his back to the camera and his hands crossed behind him. Eisenstein cuts immediately to a peacock strutting away from the camera and spreading its tail. These two images are juxtaposed, and the audience is allowed to make the association that the officer is as proud as a peacock.

Figure 6.5 *Ballet Méchanique* (1924). A film by Fernand Léger. © 1999 Artists Rights Society (ARS), New York/ADAGP, Paris.

Cutting within the frame is a method used to avoid the editing process altogether. It employs actor and/or camera movement and allows the scene to progress smoothly. For example, in a scene in John Ford's classic western *Stagecoach*, the coach and its passengers have just passed through hostile territory without being attacked; the driver and his passengers all express relief. Ford cuts to a long shot of the coach moving across the desert and pans, or follows, the coach from right to left across the screen. This movement of the camera suddenly reveals—in the foreground, and in close-up—the face of a hostile warrior watching the passage of the coach. In other words, the filmmaker has moved smoothly from a long shot to a close-up without needing the editing process. He has also established a spatial relationship.

Crosscutting constitutes an alternation between two separate actions related by theme, mood, or plot, but occurring at the same time. A classic western cliché illustrates this technique. A wagon train is under attack, and the valiant settlers are running out of ammunition. The hero has found a troop of cavalry, which rides frantically to effect a rescue. The film alternates between the pioneers fighting for their lives and the cavalry racing toward them. The film continues to cut back and forth between the two scenes, increasing in pace until the scene builds to a climax: The cavalry arrives in time to save the wagon train.

A subtle form of crosscutting called parallel development occurs in *The Godfather, Part I*. At the close of the film, Michael Corleone acts as godfather for his sister's son in church while, elsewhere, his men destroy their enemies. The film alternates between views of Michael at the religious service and sequences of violent death. The parallel construction draws ironic comparison, the juxtaposition of which lets audience members draw their own inferences. Meaning in the film is, thereby, deepened.

Dissolves

During the printing of a film negative, transitional devices can be worked into a scene. They are generally used to indicate the end of one scene and the beginning of another. The camera can cut to the next scene, but the transition is smoother if the scene fades out into black and the next scene fades in. This is called a *dissolve*. A *lap dissolve* occurs when the fade-out and the fade-in happen simultaneously, and the scenes momentarily overlap. A *wipe* is a form of transition in which an invisible line moves across the screen, eliminating one shot and revealing the next, much as a windshield wiper moves across the window of a car. Closing or opening the aperture of the lens creates an *iris-in* or *iris-out*. This technique is used effectively in *Star Wars*, Episode I: The Phantom Menace.

Focus

The manner in which the camera views a scene adds meaning to a film. If both near and distant objects appear clearly at the same time, the camera employs depth of focus. In this situation, actors can move without necessitating a change of camera position. If the main object of interest is photographed while the remainder of the scene is blurred or out of focus, the technique is called *rack* or *differential focus*. Filmmakers find this technique especially effective in channeling an audience's attention where the director wishes it.

Figure 6.6　Still from an unidentified, early black and white film.

Camera Movement

The movement of a camera as well as its position can add variety or impact to a shot or scene. Here are some of the possibilities for physical (as opposed to apparent) camera movements. The *track* is a shot taken as the camera moves in the same direction, at the same speed, and in the same place as the object photographed. A *pan* rotates the camera horizontally while keeping it fixed vertically. A *tilt* moves the camera vertically or diagonally. Moving the camera toward or away from the subject is called a *dolly shot.* Changing the focal length of the lens, as opposed to moving the camera is known as a *zoom shot.*

Other Factors

Lighting

Of course, the camera cannot photograph a scene without light, either natural or artificial. Most television productions photographed before a live audience require a flat, general illumination pattern. For close-ups, stronger and more definitively focused lights are required to highlight features, eliminate shadows, and add a feeling of depth to the shot. Cast shadows or atmospheric lighting (chiaroscuro) is often used to create a mood, particularly in films made without the use of color (Figure 6.6). Lighting at a particular angle can heighten the

Figure 6.7 Still photo from *The Birth of a Nation* (1915). Directed by D. W. Griffith. The Museum of Modern Art/Film Stills Archive.

feeling of texture, just as an extremely close shot can. These techniques add more visual variety to a sequence. Figure 6.7, a still taken from D. W. Griffith's controversial epic, *The Birth of a Nation*, illustrates how angles and shadows within a frame help create a feeling of excitement and variety.

If natural or outdoor lighting is used and the camera is handheld, an unsteadiness in movement results; this technique and effect is called *cinéma veritée* (veh-ree-TAY). This kind of camera work, along with natural lighting, is found more often in documentary films or in sequences photographed for newsreels or television news programming. It is one of the conventions of current events reporting and adds to the sense of reality necessary for this kind of film or video recording.

These techniques and many others are all used by filmmakers to ease some of the technical problems in making a film. They can be used to make the film smoother or more static, depending on the needs of the story line, or to add an element of commentary to the film. One school of cinematic thought believes that camera technique is best when it is not noticeable; another believes that the obviousness of all the technical aspects of cinema adds meaning to the work.

Direct Address

One method used to draw audience attention is direct address. It is a convention in most films that the actors rarely look at or talk directly to the audience. However, in *Tom Jones*, while Tom and his landlady are arguing over money, Tom suddenly turns directly to the camera and says to the audience, "You saw her take the money." That act focuses audience attention on the screen more strongly than before. This technique has been effectively adapted by television for use in commercial messages.

Silent films, of course, could not use this type of direct address; they had only the device of titles. However, some of the silent comedians felt they should have direct contact with their audience, and so they developed a camera look as a form of direct address. After an especially destructive moment in his films, Buster Keaton would look directly at the camera, his face immobile, and stare at the audience. When Charlie Chaplin achieved an adroit escape from catastrophe, he might turn toward the camera and wink. Stan Laurel would look at the camera and gesture helplessly (Figure 6.8), as if to say, "How did all this happen?" Oliver Hardy, after falling into an open manhole, would register disgust directly to the camera and the audience. These were all ways of commenting to the audience and letting them know the comedians knew they were there. Some sound comedies adapted this technique. In the *Road* pictures of Bob Hope and Bing Crosby, both stars (as well as camels, bears, fish, and anyone else who happened to be around) would comment on the film or the action directly to the audience. However, this style may have been equally based on the audience's familiarity with radio programs of the time, in which the performers usually spoke directly to the home audience.

BUILDING A BASIC ANALYSIS

To analyze a photograph, refer to the Basic Analysis list at the end of Chapter 3. You can do a basic analysis of a film by using the following outline of concepts from the text as a guide and answering the questions.

- Reaction. What is your emotional and intellectual response to the film, and what caused those reactions? How did the following elements combine to create a reaction in you? In other words, what drew your attention?
- Genres. What was the genre of the film? If it was a narrative film, how did story unfold?

Plate 11 Rembrandt van Rijn, *The Night Watch (The Company of Captain Frans Banning Cocq)* (1642). Oil on canvas, 12'2" × 14'7". Rijksmuseum, Amsterdam/SuperStock, Inc.

Plate 12 Antoine Watteau, *Embarkation for Cythera* (1717). Oil on canvas, 129cm × 194cm (4'3" × 6'4½"). Louvre, Paris, France. Bridgeman Art Library.

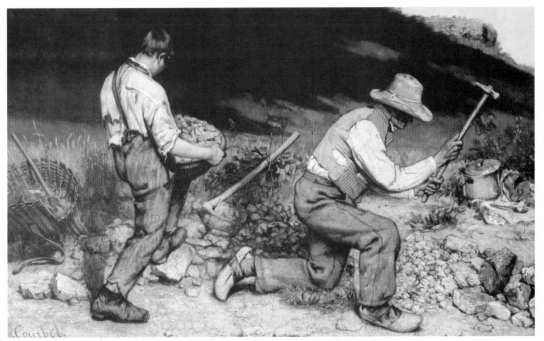

Plate 13 Gustave Courbet (1819–1877), *The Stone Breakers* (1851). Oil on canvas, 5'3" × 8'6". Formerly Gemäldegalerie, Dresden, Germany (destroyed 1945).

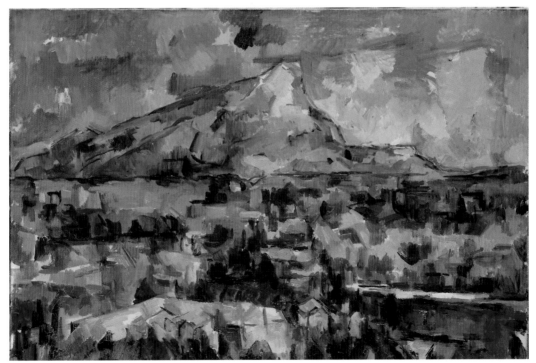

Plate 14 Paul Cézanne (French 1839–1906), *Mont Sainte-Victoire,* 1902–1904. Oil on canvas, 27½" × 35¼". Philadelphia Museum of Art. George W. Elkins Collection (Accession no.:E'36-1-1).

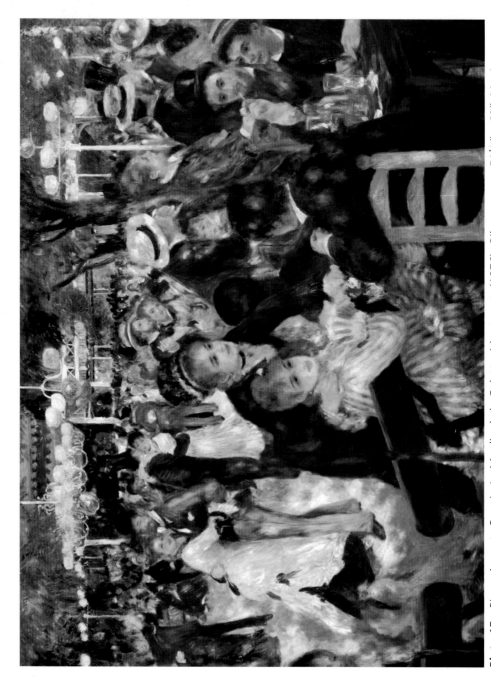

Plate 15 Pierre-Auguste Renoir, *Le Moulin de la Galette, Montmarte* (1876). Oil on canvas, 51½" × 69". Musée d'Orsay, Paris. Giraudon/Art Resource, New York.

Figure 6.8 *You're Darn Tootin'* (1928). A Hal Roach Production for Pathe Films. Directed by Edgar Kennedy.

Where were critical decisions made by the characters that forwarded the plot? If it was an absolute film, what artistic elements such as composition were present, and how did the filmmaker utilize them to create specific effects? If the film was a documentary, what characteristics of that genre did the filmmaker explore?

- Editing. What elements of editing were utilized, and how did those elements control viewer response or affect the rhythm and pace of the film?

- Shots. What shots did the filmmaker seem to emphasize? How did that emphasis create a basic sense of spectacle in the film?

- Cutting. How did the editor make use of cutting to create rhythmic flow in the film? What specific effects did the cutting techniques have on the mood, structure, and meaning of the film?

- Dissolves. Did the filmmaker utilize any particular type of dissolve for specific effects? What were they, and how did they work?

- Focus. How did the use of focus seek to control your attention? Was it successful? Why, or why not?

- Camera movement. In what ways did camera movement contribute to the overall effect of the film?

From Order and Restraint to Spirituality

Greek Classical, Hellenistic, Roman Classical,
Byzantine, Islamic, Romanesque, and
Gothic Art, c. 500 B.C.E.–c. 1400 C.E.

500 B.C.E.	350 B.C.E.	0	550 C.E.	1000	1100	1400
Greek classicism	Hellenism	Roman classicism	Byzantine	Romanesque	Gothic	

What's in This Chapter?

This chapter and the four that succeed it briefly outline the history of art in Western culture, beginning with its crucible, Greece, in the fifth century B.C.E. In the pages of this chapter, we will cover nearly two thousand years of history, and seven broad areas: (1) Greek classicism, (2) Hellenistic style, (3) imperial Roman classicism, (4) Byzantine styles, (5) Islamic tradition, (6) Romanesque style, and (7) Gothic style. We will witness here what many people describe as a swinging pendulum in Western art—that is, a movement from classicism (emphasis on form) to anti-classicism (emphasis on feeling). In this chapter we will see the pen-

dulum nearly at its extremes. The classicism of ancient Greece, the foundation of Western culture, is at one extreme. The spiritual emotionalism of Byzantine, Romanesque, and Gothic art is nearly to the other extreme. We should also be aware of the way that art served civic or religious objectives in ancient times—something quite different from the way art works in society today.

In what is ahead, we can only skim the surface of the major movements in Western art. Nonetheless, the text, illustrations, and cyber connections should present a fair introduction to what, as further individual study can reveal, is a tremendous reservoir of witness to the human condition.

GREEK CLASSICISM— A PREDOMINANCE OF FORM OVER FEELING

Under the ruler Pericles, classical Greek culture reached its zenith in the fifth century B.C.E. In the brief span of time between approximately 600 and 200 B.C.E., Greek influence and civilization spread throughout the Mediterranean world. At its widest, under Alexander the Great (356–323 B.C.E.), it stretched—during the span of a single lifetime—from Spain to the Indus River. All this was achieved by a people whose culture, at its height, took the human intellect as its measure. In society, as in the arts, rationality, clarity, and beauty of form were the aim. However, as the style we call Hellenistic developed in the fourth century B.C.E., artists increasingly sought to imbue their works with the expression of feeling.

Appeal to the intellect was the cornerstone of the classical style in art. Four characteristics reflect that appeal. First and foremost is an emphasis on form—on the formal organization of the whole into logical and structured parts. A second characteristic is idealization—an underlying purpose to portray things as better than they are, or to raise them above the level of common humanity. For example, the human figure is treated as a type rather than as an individual. A third characteristic is the use of convention, and a fourth is simplicity. Simplicity does not mean lack of sophistication. Rather, it implies freedom from unnecessary ornamentation and complexity.

Style is generally related to treatment of form rather than content or subject matter, but often form and content cannot be separated. When classicism was modified by a more individualized and lifelike treatment of form, its subject matter broadened to include the mundane, in addition to the heroic.

Such expression, particularly in painting, reflects a technical advance as well as a change in attitude. Many of the problems of foreshortening—the perceivable diminution of size as the object recedes in space—had been solved; as a result, figures were depicted with a new sense of depth. By the end of the fifth century the convention (typified in Egyptian and Mesopotamian art) of putting all the figures along the baseline on the frontal or picture plane of the design gave way to suggestions of depth. Some figures are occasionally placed higher than others. By the end of the fourth century the problems of depth and foreshortening were fully overcome. Impressions of lifelikeness were also heightened, in some cases, by the use of light and shadow.

Classical Painting

Some records imply that mural painters of the classical period were skillful in representation, but no examples have survived. What has come down to us is a wealth of vase painting. The restrictions inherent in the medium preclude assessment of the true level of skill and development of the two-dimensional art of this period.

Fifth-century Athenian painting in the classical style demonstrates the artists' concern for formal design—that is, logical, evident, and perfectly balanced organization of space. What separates classical painting from earlier styles is a new sense of idealized reality in figure depiction.

The idealism and dignity of the classical style are portrayed by such artists as the Achilles painter, whose work is seen in Figure 7.1. The portrayal of feet in the frontal position is a significant development, reflecting the new skill in depicting space.

Classical Sculpture

The fifth century B.C.E. saw many of the most talented artists turn to sculpture and architecture. The age of Greek classical style in sculpture probably begins with the sculptors Myron

Figure 7.1 Achilles painter, Ceramic white ground lekythos (oil bottle) from Gela (?), showing a woman and her maid (c. 440 B.C.). Height: 38.4cm (15¼″). Francis Bartlett Fund. Courtesy, Museum of Fine Arts, Boston. Reproduced with permission. © 2000, Museum of Fine Arts, Boston. All Rights Reserved.

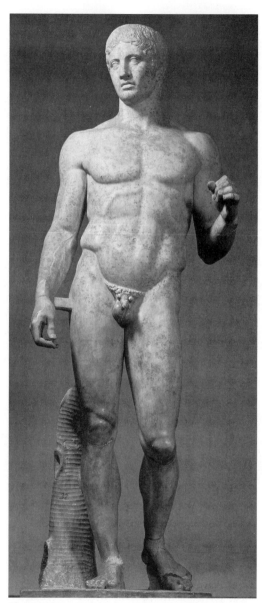

Figure 7.2 Polykleitos of Argos (fifth century B.C.E.), *Doryphoros* (Spearbearer), Roman copy of Greek original (c. 440 B.C.E.). Marble, height 6′6″. Museo Archeologico Nazionale, Naples, Italy. Scala/Art Resource, New York.

and Polykleitos (pah-lee-KLYE-tuhs) in the middle of the fifth century B.C.E. Both contributed to the development of cast sculpture. Polykleitos reportedly achieved the ideal proportions of the male athlete (Figure 7.2). Note

that the *Spearbearer* represents *the* male athlete, not *a* male athlete. In this work the body's weight rests on one leg in the *contrapposto* stance (see Glossary). This simple but important new posture, characteristic of Greek classical style (compare with the older style exhibited in the Kouros figure depicted in Figure 4.12), results in a sense of relaxation and controlled dynamics and a subtle play of curves.

Polykleitos developed a set of rules for constructing the ideal human figure that he laid out in his treatise *The Canon* (*kanon* is the Greek word for "rule" or "law"). The *Spearbearer* supposedly illustrates his theory, but because neither the treatise nor the original statue has survived, we do not know what set of proportions Polykleitos thought to be ideal. Probably, it was based on the ratios between some basic unit and the length of some body part or parts. Myron's best-known work is the *Discus Thrower* (Figure 7.3). It exemplifies the classical concern for restraint in its subdued vitality and subtle suggestion of movement coupled with balance. But it also expresses the sculptor's interest in the flesh of the idealized human form. The example pictured is, unfortunately, a much later marble copy. Myron's original was in bronze, a medium that allowed more flexibility of pose than marble.

Myron's representation of this young athlete contributes a sense of dynamism to Greek sculpture. Here Myron tackles a vexing problem for the sculptor: how to condense a series of movements into a single pose without making the sculpture appear static or frozen. His solution dramatically intersects two opposing arcs: one created by the downward sweep of the arms and shoulders, the other by the forward thrust of the thighs, torso, and head.

As is typical of Greek freestanding statues, The *Discus Thrower* is designed to be seen from one direction only. It is thus a sort of freestanding, three-dimensional "super-relief." The beginnings of classical style are represented by celebration of the powerful nude male figure. The suggestions of moral idealism,

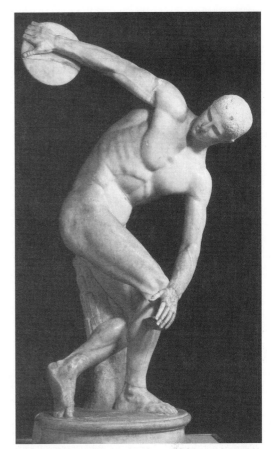

Figure 7.3 Myron of Athens (fifth century B.C.E.), *Lancillotti Discobolus* (Discus Thrower). Roman copy of a Greek bronze original (c. 450 B.C.E.) Marble, life-size. Museo Nazionale Romano del Terme, Rome, Italy. Scala/Art Resource, New York.

dignity, and self-control in the statue are all qualities inherent in classicism.

Architecture

The arts of the western world have returned over the past 2,500 years to the style of classical Greek architecture. Nothing brings it so clearly to mind as the Greek temple. Most people have an amazingly accurate concept of its structure and proportions. The art historian H. W. Janson suggests that the crystallization

of the characteristics of a Greek temple is so complete that when we think of one Greek temple, we basically think of all Greek temples. The classical Greek temple, exemplified by the Parthenon (Figure 7.4), has a structure of horizontal blocks of stone laid across vertical columns. This post and lintel construction is not unique to Greece, but certainly the Greeks refined it to its highest aesthetic level.

All the elements of the Parthenon are carefully adjusted. A great deal has been written about the "refinements" of the Parthenon—those features that seem to be intentional departures from strict geometric regularity. According to some, the slight bulge of the horizontal elements compensates for the eye's tendency to see a downward sagging when all elements are straight and parallel. Each column swells toward the middle by about seven inches, to compensate for the tendency of parallel vertical lines to appear to curve inward. This swelling is known as *entasis*. The columns also tilt inward slightly at the top, in order to appear perpendicular. The stylobate is raised toward the center so as not to appear to sag under the immense weight of the stone columns and roof. Even the white marble, which in other circumstances might appear stark, may have been chosen to reflect the intense Athenian sunlight.

Greek temples were of three orders: Doric, Ionic, and Corinthian (see Figure 5.3). These are not just decorative and elevational conventions, but systems of proportion. The earliest type, the Doric, has a massive appearance compared to the Ionic. The Ionic, with a round base, has a curved profile, which raises the column above the baseline of the building. The fluting (ridging) of the Ionic order, usually twenty-two per column, is deeper and separated by wider edges than is that of the Doric, giving the former a more delicate appearance. The Ionic capital is surrounded by a crown of hanging leaves, or *kymation*. The architrave—the section resting directly on the capitals—is divided into three parts, and each diminishes downward. This creates a much lighter impression than the more massive architrave of the Doric, which originated at a time earlier than the classical age. The Corintian order came later.

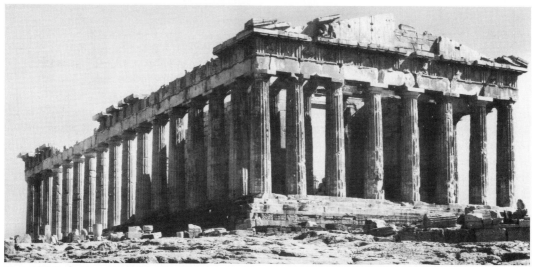

Figure 7.4 Ictinus and Callicrates, Parthenon, Acropolis, Athens, from the northwest (447–438 B.C.E.). Foto Marburg/Art Resources, New York.

In plan, the Parthenon is a peripteral temple—that is, columns surround the interior room, or *cella,* and the number of columns on the sides is twice the number across the front, plus one. Inside it is divided into two parts, and it would have housed the forty-foot-high ivory and gold statue of the goddess Athena Parthenos.

The Parthenon typifies every aspect of Greek classical style in architecture. It is Doric in character and geometric in configuration. Balance is achieved through symmetry, and the clean, simple line and plan hold the composition together perfectly.

HELLENISTIC STYLE—THE EMERGENCE OF FEELING

As the Age of Pericles gave way to the Hellenistic period (approximately 350 B.C.E. until the first century C.E.) the dominant characteristics of classicism were gradually modified to a less formal, more realistic, and more emotional style reflecting a diversity of approaches.

Sculpture

As time progressed, sculptural style changed to reflect an increasing interest in individual human differences. Hellenistic sculptors often turned to pathos, banality, trivia, and flights of individual virtuosity. The *Nike of Samothrace* (Figure 7.5), or *Winged Victory,* displays a dramatic, dynamic technical virtuosity. Symbolizing a triumph of one of Alexander the Great's successors, the victory figure brings an amazing strength, weight, and grace to sculpted marble. The sculptor has treated stone almost as if the work were a painting. As a result, the full, awesome reality of wind and sea becomes apparent.

The common Hellenistic theme of suffering is taken up explosively in the Laocoön (lay-AH-koh-ahn) group (Figure 7.6). The Trojan priest Laocoön and his sons are depicted being strangled by sea serpents. Based on Greek myth, the subject is Laocoön's punishment for defying Poseidon, the god of the sea, and warning the Trojans of the strategy of the Trojan horse. Emotion and movement are freed from all restraint, and straining muscles and bulging veins are portrayed with stark realism.

Architecture

The Temple of the Olympian Zeus (Figure 7.7) illustrates the Hellenistic modification of classical style in architecture. Temple architecture in this style was designed to produce an overpowering emotional experience. Scale and complexity have increased, but order, balance, moderation, and consonant harmony are still present. In these huge ruins we can see a change in proportions from the Parthenon, and slender and ornate Corinthian columns replace the Doric ones. This is the first major Corinthian temple. The remaining ruins only vaguely suggest the scale and richness of the original building, which was surrounded by an immense, walled precinct.

IMPERIAL ROMAN CLASSICISM— EMULATION OF THE GREEKS

By 70 C.E., the Romans had destroyed the Temple of Solomon in Jerusalem and colonized most of present-day England and Wales, spreading their pragmatic and pluralistic version of Hellenistic Mediterranean civilization to peoples of the Iron Age in northern and western Europe. Under Augustus, the first Roman emperor (63 B.C.E.–14 C.E.), Roman culture turned again to Greek classicism, and in that spirit glorified Rome, the emperor, and the empire. Inventive and utilitarian, Roman culture created roads, fortifications, and viaducts—traces of which remain today—and instituted a

Figure 7.5 *The Nike of Samothrace (Winged Victory),* c. 190 B.C.E. Marble, height 8'. Louvre, Paris, France. Alinari/Art Resource, New York.

Figure 7.6 Hagesandrus, Polydorus, and Athenodorus, *Laocoön and his Two Sons,* first century C.E. The Laocoön group. Roman copy, perhaps after Agesander, Athenodorus, and Polydorus of Rhodes (present state, former restorations removed). Marble. Height: 2.1m (5'). Museo Pio Clementino, Vatican Museum, Vatican State, Scala/Art Resource, New York.

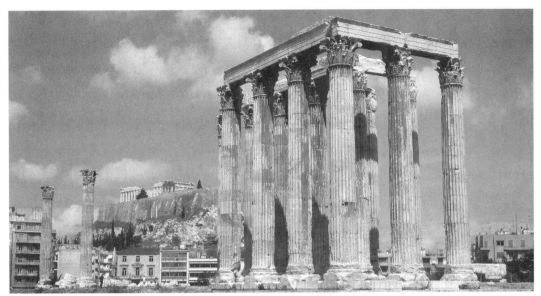

Figure 7.7 Temple of Olympian Zeus, Athens, 174 B.C.E.–130 C.E./SuperStock, Inc.

thorough administration and a sophisticated yet robust legal system.

Sculpture

After a period in which Roman emperors were raised to the status of gods, perhaps because a far-flung empire required assurances of stability and suprahuman characteristics in its leaders, the reality that men are men and not gods returned to Roman consciousness by the third century C.E. By that time, Roman sculpture exhibited an expressive starkness. In the fourth century a new and powerful emperor, Constantine the Great, took the throne, and his likeness (Figure 7.8)—part of a gigantic sculpture (the head is over eight feet tall)—shows an exaggerated, ill-proportioned intensity comparable with expressionist works of the early twentieth century (see p. 172). This work is not an actual likeness of Constantine. Instead, it is the artist's view of Constantine's perception of himself as emperor, and of the office of emperor itself.

Architecture

Given the practicality of the Roman viewpoint, it is not surprising that there is an immediately distinctive Roman style in architecture. The clear crystallization of form found in post and lintel structural system of the classical Greek temple is also apparent in the Roman arch.

The Colosseum (Figure 7.9), the best known of Roman buildings, and one of the most stylistically typical, combines an arcaded exterior with vaulted corridors. It seated 50,000 spectators and was a marvel of engineering. Its aesthetics are reminiscent of Greek classicism, but are fully Roman in style. The circular sweep of the building is carefully countered by the vertical line of engaged columns flanking every arch. Doric, Ionic, and Corinthian columns each mark one level, progressing upward from heavy to lighter orders. The Colosseum was a new type of building called an amphitheater, in which two "theaters," facing each other, were combined to form an arena surrounding

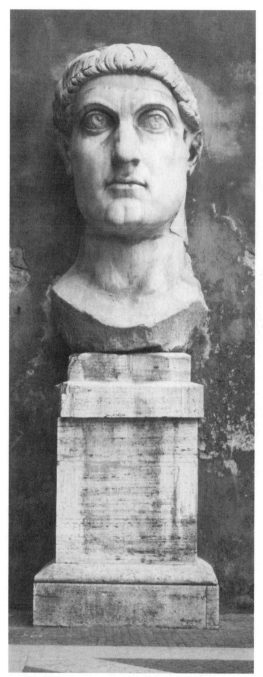

Figure 7.8 Head of Constantine the Great (part of an original colossal seated statue, 313 C.E.). Marble, height 8′6⅜″. © Vanni Archive/CORBIS.

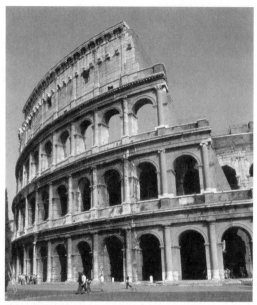

Figure 7.9 Colosseum, Rome (c. 70–82 C.E.)/ SuperStock, Inc.

an oval space. Placed in the center of the city of Rome, the Colosseum housed gladiatorial games, including the martyrdom of Christians by turning lions loose on them as a gruesome "spectator sport." Emperors competed with their predecessors to produce the most lavish spectacles here. Originally a series of poles and ropes supported awnings to provide shade for the spectators. The space below the arena contained animal enclosures, barracks for gladiators, and machines for raising and lowering scenery.

The Pantheon (Figure 7.10, Plate 8) fuses Roman engineering, practicality, and style in a domed temple of unprecedented scale, dedicated, as its name indicates, to all the gods. From the exterior we glimpse a cella comprising a simple unadorned cylinder capped by a gently curving dome. The entrance is a Hellenistic porch with huge Corinthian columns. Originally it was approached by a series of steps and attached to a rectangular forecourt, so today we see only part of a more complex design.

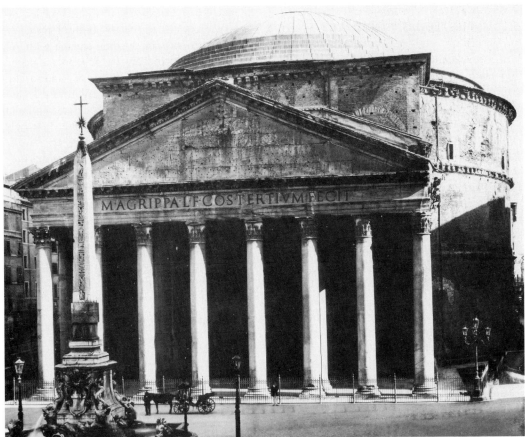

Figure 7.10 Pantheon, Rome (c. 118–128 C.E.). Archivi Alinari/Art Resource, New York.

Inside, the scale and detail are overwhelming. The drum and dome consist of solid monolithic concrete reinforced with bands of vitrified tile. The vertical gravity loads are collected and distributed to the drum by arches incorporated in the concrete. The wall of the twenty-foot-thick drum has alternating rectangular and curved niches cut into it, thus forming a series of massive radial buttresses. Originally, statues of the gods occupied these niches, which are carved out of the massive walls. Corinthian columns add grace and lightness to the lower level, and heavy horizontal moldings accentuate a feeling of open space made possible by the huge dome. It is 143 feet in both diameter and height (from the floor to the *oculus* [AH-kyoo-luhs; Latin for "eye"], the round opening at the top of the dome). The circular walls supporting the dome are twenty feet thick and seventy feet high. Recessed square coffers on the underside of the dome give an added sense of lightness and reflect the framework into which concrete was poured. Originally the ceiling was gilded to suggest the golden dome of heaven.

BYZANTINE STYLES—INFUSING SPIRITUALITY INTO ART

Astride the main land route from Europe to Asia and its riches, Byzantium possessed tremendous potential as a major metropolis. In addition, the city was a defensible deep-water port and controlled the passage between the Mediterranean and the Black Sea. Blessed with fertile agricultural surroundings, it formed the ideal "New Rome." For this was the objective of the emperor Constantine when he dedicated his new capital in 330 C.E. and changed its name to Constantinople (literally, "city of Constantine"). It prospered and became the center of Orthodox Christianity and mother to a unique and intense style in the visual arts and architecture. When Rome fell to the Goths in 476, it had long since handed the torch of civilization to Constantinople. Here the arts and learning of the classical world were preserved and nurtured, along with an eastern orientation, while western Europe underwent the turmoil and destruction of barbarian invasion.

A fundamental characteristic of Byzantine visual art is the concept that art has the potential to interpret as well as to represent. The content and purpose of Byzantine art was always religious, although the style of representation underwent numerous changes. The period of Justinian (reigned 527–565) marks an apparent deliberate break with the past. What is now described as Byzantine style, with its anti-naturalistic character, began to take shape in the fifth and sixth centuries, although the classical Hellenistic tradition seems to have survived.

By the eleventh century, Byzantine style had adopted a *hierarchical* (high-uhr-AHR-kih-kuhl) formula in wall paintings and mosaics. The church represented the kingdom of God: Moving up the hierarchy, figures changed in form from human to divine. Thus, placement in the composition depended upon religious, not spatial, relationships. A strictly two-dimen-sional, flat style appeared—elegant and decorative, without any perspective or illusionism.

Two general conclusions emerge with regard to Byzantine art (which encompassed nearly a thousand years of history and several shifts in style). The first conclusion is that the *content* of Byzantine art focuses on human figures of three main elements: (1) holy figures—Christ, the Virgin Mary, the saints, and the apostles, with bishops and angels portrayed in their company; (2) the emperor—believed divinely sanctioned by God; and (3) the classical heritage—images of cherubs, mythological heroes, gods and goddesses, and personifications of virtues. The second conclusion is that the *form* of Byzantine two-dimensional art increasingly reflected a consciously derived spirituality.

Mosaics

By about the year 500, the style known as *hieratic* (not to be confused with "hierarchical") was used in Byzantine art to present formalized, almost rigid depictions intended not so much to represent people as to inspire reverence and meditation. One formula of the hieratic style ordained that an individual should measure nine heads (seven heads would be our modern measurement). The hairline had to be a nose's length above the forehead. If the figure was naked, four nose lengths were needed for half its width. We see this style clearly in the mosaic *Emperor Justinian and His Court* (Figure 7.11). When the emperor was depicted in Byzantine art, any of several characteristics may be noted. The emperor may be shown in the presence of Christ to validate his supreme powers. In addition, one or several exclusive attributes of the emperor may be present, such as red shoes decorated with jewels; a long purple robe, over which is worn a scarf covered with jeweled patterns; a crown from which a strand of pearls is suspended on each side of the face (called a *pendulia*); or a scepter.

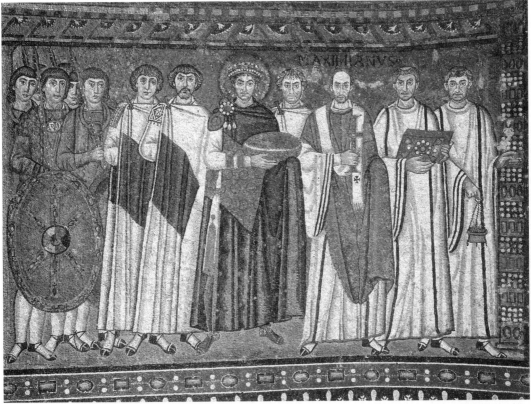

Figure 7.11 Emperor Justinian and His Court, San Vitale, Ravenna (c. 547 C.E.). Wall mosaic.
Scala/Art Resource, New York.

Architecture

The church of Hagia Sophia (Holy Wisdom)
(Figure 7.12) in Constantinople (modern Is-
tanbul) represents a crowning memorial of
Byzantine style in architecture. Characteristic
of Justinian Byzantine style, Hagia Sophia uses
Roman vaulting techniques with Hellenistic
design and geometry. The result is a richly col-
ored building in an eastern antique style. Basic
to the conception is the elevated central area
with its domed image of heaven and large,
open, and functional spaces.

Its architect, Anthemius, was a natural sci-
entist and geometer from Tralles in Asia Minor.
He built the church to replace an earlier

basilica. For a long time this was the largest
church in the world, yet it was completed in
only five years and ten months. Byzantine
masonry techniques were used, in which
courses of brick alternate with courses of
mortar equally thick as or thicker than the
bricks. Given the speed of construction, this
caused great weight to be placed on insuffi-
ciently dry mortar. As a result, arches buck-
led and buttresses had to be erected almost at
once. The eastern arch and part of the dome
fell in 557, after two earthquakes. No one
has since constructed such a large dome that
is so flat. Also remarkable is the delicate
proportioning of the vaults which support
such great weight. The building suggests an

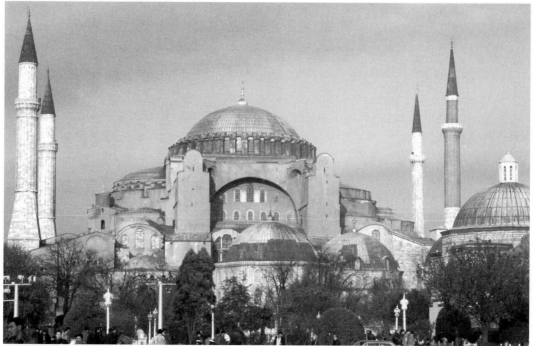

Figure 7.12 Anthemius of Tralles and Isidorus of Miletus, Hagia Sophia (532–537 C.E.). Francesco Venturi; Kea Publish/CORBIS.

intense spirituality and yet is capable of holding large numbers of worshippers. "It seemed as if the vault of heaven were suspended above one," wrote the sixth-century Byzantine historian Procopius.

ISLAMIC TRADITION— ART AS A HOLY PLACE

The Islamic tradition in art springs from the religion of Islam (meaning "submission"), of which Muhammad was the prophet. Adherents are called Muslims or Moslems. Muslims are those who submit to the will of God (*Allah* in Arabic). The latest of the three great monotheistic religions, it drew upon the other two—Judaism and Christianity. Abraham and Jesus are in the list of prophets preceding Muhammad. Muslims generally believe that Jesus will return as the Mahdi— Messiah—at the end of the world. They do not believe in the Trinity or the divinity of Jesus, however. Islam is based on the sacred book, the Koran (Qur'an), which Muslims believe was revealed by God to Muhammad. Five duties are prescribed for every Muslim; the last is a once-in-a-lifetime pilgrimage (Hajj) to Mecca. This has made the pilgrimage the greatest in the world and an important unifying force in Islam. In addition to the Koran, Islam accepts the Sunna—collections of moral sayings and anecdotes of Muhammad, collected as early as the ninth century. Islam spread rapidly in the seventh and eighth centuries and was soon dominant from Spain to India. It was a repository of great learning (including the arabic numbering system) and intermingled occasionally with western art.

Work on the first major example of Islamic architecture—the Dome of the Rock in Jerusalem (Figure 7.13)—began in 685 C.E. It was designated as a special holy place—not an ordinary mosque. Its location is revered by Jews as the tomb of Adam and the place where Abraham prepared to sacrifice Isaac. According to Muslim tradition, it also is the place from which Muhammad ascended into heaven. Written accounts suggest that was built to overshadow a sacred temple of similar construction on the other side of Jerusalem—the Holy Sepulchre. Caliph Abd al-Malik wanted a monument that would outshine the Christian churches of the area, and, perhaps, the Ka'ba in Mecca.

The Dome of the Rock is shaped as an octagon, and inside it contains two concentric ambulatories (walkways) surrounding a central space capped by the dome. The exterior was later decorated with the glazed blue tiles that give the façade its dazzling appearance; the interior glitters with gold, glass, and mother-of-pearl multicolored mosaics.

ROMANESQUE STYLE— ART IN SERVICE TO THE CHRISTIAN CHURCH

At its broadest, the Middle Ages is the name we have come to use for the thousand years from the fall of Rome to the Renaissance in Italy. In monasteries and convents throughout Europe, literacy, learning, and artistic creativity were nurtured. It was widely believed that the year 1000 would see the end of the world.

The later Middle Ages saw a spiritual and intellectual revival. In Christianity, emphasis shifted from a preoccupation with the wrath of God to an emphasis on the mercy and sweetness of the loving Savior and the Virgin Mary. The growth of towns and cities accelerated the pace of life, turning the focus of wealth and power away from the feudal countryside, and universities replaced monasteries as centers of learning.

At the beginning of the new millenium a new and radical style in architecture emerged. The Romanesque style took hold throughout

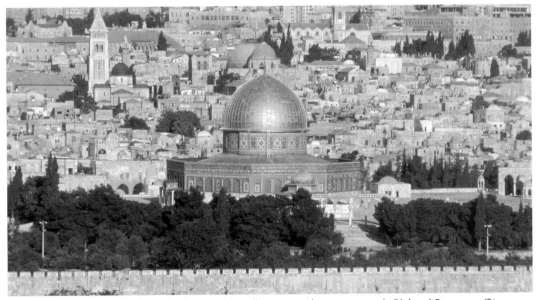

Figure 7.13 Dome of the Rock, Jerusalem (late seventh century C.E.). Richard Passmore/Stone.

Europe in a relatively short period. Originally meaning "debased Roman," it takes its name from the Roman-style round arches and columns of its doorways and windows. The term was coined in the early nineteenth century to describe medieval vaulted architecture that preceded the Gothic pointed arch. In addition to arched doorways and windows, characteristic of this style was a massive, static quality—a further reflection of the barricaded mentality and lifestyle generally associated with the Middle Ages.

The Romanesque style nonetheless exemplified the power and wealth of the Church Militant and Triumphant. If the style mirrored the social and intellectual system that produced it, it also reflected a new religious fervor and a turning of the church toward its growing flock. Romanesque churches were larger than their predecessors. Figure 7.14, St.-Sernin, gives some impression of their scale. An example of southern French Romanesque, St.-Sernin reflects a heavy elegance and complexity. The

Figure 7.14 St.-Sernin, Toulouse, France (c. 1080–1120). The top part of the tower was added in the thirteenth century. Scala/Art Resource, New York.

plan of the church is a Roman cross, and the side aisles extend beyond the crossing to create an ambulatory. Here pilgrims, who were mostly on their way to Spain, could walk around the altar without disturbing the service.

Significantly, the roof of this church is stone, whereas earlier buildings had wooden roofs. The stress of the tremendous weight and outward thrust of the central vault was diffused through a complex series of vaults and transferred to the ground, leaving a high and unencumbered central space.

In the case of sculpture, "Romanesque" refers more to an era than to a style. Examples are so diverse that if most sculptural works were not decorations attached to Romanesque architecture, they, arguably, probably could not be grouped under a stylistic label. However, some general conclusions about Romanesque sculpture can be drawn. First, it is associated with Romanesque architecture. Second, it is heavy and solid. Third, its medium is usually stone. Fourth, it is monumental. These last two characteristics represent a departure from previous sculptural style. Monumental stone sculpture had all but disappeared in the fifth century. Its reemergence across Europe in such a short time was remarkable, indicating at least a beginning of an outward dissemination of knowledge from the cloistered world of the monastery to the general populace—for it was applied to the exterior of the building, where it could appeal to the lay worshiper.

In the Last Judgment tympanum at Autun in France (Figure 7.15), the message is quite clear. In the center of the composition, framed by a Roman-style arch, is an awe-inspiring figure of Christ. Beside him are a series of disproportional figures. The inscription of the artist, Giselbertus (zhee-zehl-BAIR-toos), tells us that their purpose was "to let this horror appall those bound by earthly sin." Death was still central to medieval thought, and the devils share the stage, gleefully pushing the damned into the flaming pit.

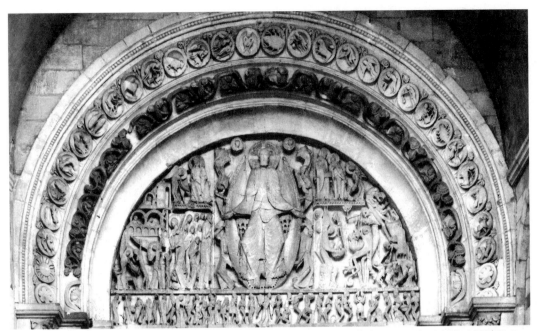

Figure 7.15 Giselbertus, Last Judgment tympanum, Autun Cathedral, France (c. 1130–1135)/Art Resource, New York.

GOTHIC STYLE— LETTING IN THE LIGHT

The term *Gothic* refers to a style of visual arts and culture that began with the ideas of the Abbot Suger and the redesign of the church of Saint Denis in the Île de France (eel duh Frahns), the area of France centering on Paris around the year 1140. What is now called "Gothic art" was originally called the "French style," and referred to architecture, which dominated the period. The Italians actually named the style. Preferring the classical, the Italians believed the style to be barbaric and associated it, derogatorily, with the most notorious of the barbarian tribes, the Goths.

Painting

During the twelfth to the fifteenth centuries, painting (in the form of frescoes and altar pieces) came into prominence, while manuscript illumination continued. The characteristics of Gothic style in painting include the beginning of three-dimensionality in figure representation and a striving to give figures mobility and life within three-dimensional space. Space is the essence of Gothic style. Gothic painters and illuminators had not mastered perspective, and their compositions do not have the spatial rationality of later works, but if we compare them with their predecessors of the earlier medieval eras, we discover that they have more or less broken free from the static, frozen two-dimensionality of earlier styles. Gothic painting also shows spirituality, lyricism, and a new humanism (emphasizing mercy, as opposed to the irrevocable judgment). It is less crowded and frantic.

The Gothic style of two-dimensional art also found expression in manuscript illumination. The courts of France and England produced some truly exquisite works. In the *David Harping* (Figure 7.16), the curious

Figure 7.16 David Harping, from the Oscott Psalter (c. 1270). 7½″ × 4½″. By permission of The British Library, London.

proportions of the face and hands of David, and the awkward linear draping of fabric juxtaposed against the curves of the harp and chair, create a sense of unease and nervous tension. There is almost a carelessness about the layout of the background screen. The upward curving arcs at the top are intended to be symmetrical, but their hand-drawn quality is reinforced by the imprecision of the repetition of diamond shapes. A touch of realism appears in the curved harp string that David is plucking, and rudimentary use of highlight and shadow gives basic three-dimensionality

to cloth and skin. While unbalanced in the interior space, the figure, nonetheless, does not appear to crowd the borders.

Architecture

Gothic style in architecture took many forms, but it is best exemplified in the Gothic cathedral. The cathedral, in its synthesis of intellect, spirituality, and engineering, perfectly expresses the medieval mind. Gothic architectural style developed initially in a very localized way on the Île de France in the late twelfth century and spread outward to the rest of Europe (Figs. 5.26 and 5.27). It had died as a style in some places before it was adopted in others.

Cathedrals were church buildings whose purpose was the service of God. However, civic pride as well as spirituality inspired their construction. Various local guilds contributed their services in financing or in the actual building work, and guilds were often memorialized in special chapels and stained-glass windows. Gothic cathedrals occupied the central, often elevated, area of the town or city. Their physical centrality and context symbolized the dominance of the universal church over human affairs, both spiritual and secular. Gothic cathedrals use refined, upward-striving line to symbolize humanity's striving to escape from earth into the mystery of space.

The pointed arch is the most easily identifiable characteristic of this style, and it represents not only a symbol of Gothic spirituality but also an engineering practicality. Compared to the round arch, it redistributes the thrust of downward force into more equal and controllable directions. In addition, the dimensions around a pointed arch can be adjusted to whatever practical and aesthetic parameters are desired.

Engineering advances implicit in the new form made possible larger clerestory (see Glossary), windows (hence more light), and more slender ribbing (hence a greater emphasis on space as opposed to mass). Outside, the practical

and aesthetic flying buttresses carry the outward thrust of the vaults through a delicate balance of ribs, vaults, and buttresses gracefully and comfortably to the ground (Figure 7.17).

Sculpture

Gothic sculpture again reveals the changes in attitude of the period. It portrays serenity and idealism. Like Gothic painting, it has a human quality. The vale of tears, death, and damnation typical of the earlier Middle Ages are replaced with conceptions of Christ as a benevolent teacher and God as beautiful. This style has a new order, symmetry, and clarity. Its visual images carry with distinctiveness over a distance. The figures of Gothic sculpture stand away from their backgrounds (Figure 4.11).

Schools of sculpture developed throughout France, and although individual stone carvers worked alone, their common training gave their works a unified character. Compositional unity changed from Early to Late Gothic. Early architectural sculpture was subordinate to the overall design of the building, but later work lost much of that integration as it gained in emotionalism (Figure 7.18)

The sculptures of Chartres Cathedral, which bracket nearly a century, illustrate clearly the transition from Early Gothic to Late Gothic. The attenuated figures of Figure 4.11 display a relaxed tranquility, idealization,

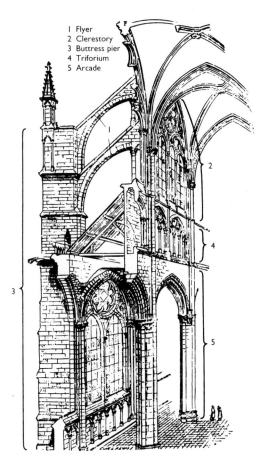

1 Flyer
2 Clerestory
3 Buttress pier
4 Triforium
5 Arcade

Figure 7.17 Principal features of a typical Gothic church.

Figure 7.18 Chartres Cathedral, jamb statues on south portal (c. 1215–1220). Craig Aurness/Art Resource, New York.

and simple realism. Although an integral part of the portal columns, they emerge from them, each statue in its own space. Detail is somewhat formalized and shallow, but we now see the human figure beneath the fabric—in contrast to previous uses of fabrics as mere compositional decoration.

Lifelikeness is even more pronounced in the figures of a hundred years later (Figure 7.18). Here we can see the characteristics of High Gothic style. Proportion is more lifelike, and the figures have only the most tenuous connection to the building. Figures are carved in subtle S curves rather than as rigid perpendicular columns. Fabric drapes are much more naturally depicted, with deeper and softer folds. These figures have the features of specific individuals.

The content of Gothic sculpture was designed to teach. Many of its lessons are straightforward and can be universally appreciated. Other lessons are more hidden, with specific conventions, codes, and sacred mathematics. For example, the numbers three, four, and seven symbolize, respectively, the Trinity, the Gospels, the sacraments, and the deadly sins. All this is consistent with the mysticism of the period, which held strong beliefs in allegorical and hidden meanings in holy sources.

CYBER EXAMPLES

Gothic Artists

http://www.artcyclopedia.com/history/gothic.html

Gothic Cathedrals

http://www.bc.edu/bc_org/avp/cas/fnart/arch/gothic_arch.html

CYBER SOURCES FOR ADDITIONAL STUDY

c. 500 B.C.E.–c. 300 C.E.

Rome and Hellenistic Greece

http://www.louvre.fr/img/photos/collec/ager/grande/ma2369.jpg

http://hyperion.advanced.org/12428/index1.html

c. 300–1400

The Middle Ages

http://www.artcyclopedia.com/history/byzantine.html

http://www.artcyclopedia.com/history/gothic.html

From Rebirth
to Rationalism

Renaissance to Enlightenment, c. 1400–c. 1800

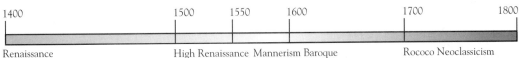

1400	1500	1550	1600	1700	1800

Renaissance High Renaissance Mannerism Baroque Rococo Neoclassicism

What's in This Chapter?

In this chapter we travel across a shorter time period than in the previous chapter. More, however, is happening to humanity as the Middle Ages gives birth to the Renaissance, whose characteristics we will examine momentarily. As we traverse the next four hundred years we will study three broad topics: (1) the Renaissance; (2) the baroque era; and (3) the Enlightenment. Each of these will have important subdivisions. For example, the Renaissance will include the Renaissance in Florence, Italy; the High Renaissance in Rome; and mannerism.

The Enlightenment will include such diverse styles as rococo and neoclassicism.

THE RENAISSANCE—
THE INDIVIDUAL REBORN

The Renaissance was seen by its leading exponents as a rebirth of our understanding of ourselves as social and creative beings. "Out of the sick Gothic night our eyes are opened to the glorious touch of the sun" was how the French humanist and satirist François Rabelais (1483–1553) expressed what most of his

educated contemporaries felt. At the center of Renaissance concerns were the visual arts, whose new ways of looking at the world soon had their counterparts in the performing arts as well. For the first time, it seemed possible not merely to emulate the works of the classical world, but to surpass them.

In just a few short years, however, the Reformation challenged institutional Christian faith and its authority. The proposal of a sun-centered universe knocked humankind from its previously assured place at the center of all things. Harmony seemed once more to be an unattainable ideal as Europe was riven by wars and as philosophers cast doubt on the certainties of the Renaissance. The modern age was in the making.

Renaissance Painting in Florence

It was in Italy, and more precisely in Florence, that the Renaissance found its early spark and heart in about 1400. Florence was a wealthy commercial center and, like Athens, leapt into a golden age on a soaring spirit of victory. The city successfully resisted the attempts of the Duke of Milan to subjugate it. The consequent outpouring of art made Florence the focal point of the early Italian Renaissance.

During the first two decades of the fifteenth century, sculpture reigned as the premier visual art of the time. Painters, for the most part, were kept busy painting altarpieces for Florentine churches—generally in a variation of Gothic style. Unlike sculpture, painting showed little concern for the human spirit or for the stylistic problems that occupied sculptors. But ideas were developing, and came to fruition in the work of Tommaso di Giovanni, better known as Masaccio (mah-ZAH-coh or mah-ZAHT-choh; 1401–1429). The hallmark of Masaccio's invention and development of a "new style" is the way he employs deep space and rational foreshortening or perspective in his figures. In collaboration with

the artist Masolin, Masaccio was summoned in 1425 to create a series of frescoes for the Brancacci Chapel of the Church of Santa Maria del Carmine in Florence.

Masaccio, *The Tribute Money*

The most famous of Masaccio's frescoes in the Brancacci family chapel is *The Tribute Money* (Figure 2.17). Its setting makes full use of the new discovery of linear perspective, as the rounded figures move freely in unencumbered deep space. It employs a technique called "continuous narration," unfolding a series of events across a single canvas—here the New Testament story from Matthew (17:24–27).

Botticelli, *Spring*

By the last third of the fifteenth century, most of the originators of Renaissance art were dead. The essences of the new art were well known and well established; it was a time for further exploration in other avenues. One of these turned inward toward the life of the spirit, and in its search created a lyrical expression, much more poetic than anything we have seen thus far. Outward reality was often ignored in favor of more abstract values. This tradition is best expressed in the paintings of Sandro Botticelli (bawt-tee-CHEL-lee) (Alessandro Filipepi, c. 1445–1510). The linear quality of *La Primavera*, or *Spring* (Plate 10), suggests an artist apparently unconcerned with deep space or subtle plasticity in light and shade. Rather, forms emerge through outline. The composition moves gently across the picture through a lyrical combination of undulating curved lines, with focal areas in each grouping. Mercury, the Three Graces, Venus, Flora, Spring, and Zephyrus—each part of this human, mythical composition carries its own emotion: contemplation, sadness, or happiness. Note the apparently classical and non-Christian subject

Masaccio
The Tribute Money

The figures in Masaccio's painting (Figure 2.17) are remarkably accomplished. In the first place, they are dressed in fabric that falls like real cloth. Next, weight and volume are depicted entirely differently from how they were in Gothic painting. Each figure is in classical *contrapposto* stance. The sense of motion is not particularly remarkable, but the accurate rendering of the feet makes these figures seem to stand on real ground. Masaccio uses light to reveal form and volume. The key is his establishment of a source for the light that strikes the figures and then renders the objects in the painting so that all highlights and shadows shadows occur as if caused by that single light source.

Masaccio's figures form a circular and three-dimensional grouping rather than a flat line across the surface of the work as in Botticelli's *La Primavera* (Plate 10). Even the haloes of the apostles appear in the new perspective and overlap at odd angles. Compositionally, the single vanishing point, by which the linear perspective is controlled, sits at the head of Christ—we will see this device for achieving focus again in Leonardo da Vinci's *The Last Supper* (Figure 8.4). In addition, Masaccio utilizes atmospheric perspective, in which distance is indicated through diminution of light and blurring of outlines.

matter. But, in fact, the painting is using allegory to equate Venus with the Virgin Mary. Beyond the immediate qualities, there is a deeper symbolism relating also to the Medici family, the patron rulers of Florence.

Anatomically, Botticelli's figures are quite simple. There is little concern with detailed musculature. Although the people are rendered three-dimensionally and shaded subtly, they seem almost weightless, floating in space without anatomical definition.

Renaissance Sculpture in Florence

An attempt to capture the essence of European sculpture in the early Renaissance can, again, best be served by looking to fifteenth-century Florence, where sculpture also enjoyed the patronage of the Medici. The early Renaissance sculptors developed the skills to create images of high lifelikeness. Their goal, however, was not the same as that of the Greeks, with their idealized reality of human form. Rather, Renaissance sculptors found their ideal in individualism. The ideal was the glorious—even if not quite perfect—individual. Sculpture of this style presented an uncompromising and stark view of humankind—complex, balanced, and full of action. Freestanding statuary, long out of favor, returned to dominance. The human form was built up layer by layer on its skeletal and muscular framework, reflecting scientific inquiry and interest in anatomy. Even when clothed, fifteenth-century sculpture revealed the body under the garments, quite unlike medieval works. And relief sculpture caught on to the new means of representing deep space through systematic, scientific perspective.

Notable and typical among fifteenth-century Italian sculptors were Lorenzo Ghiberti (gee-BAIR-tee; 1378–1455) and Donatello (doh-nah-TAY-lo) (Donato de' Bardi, 1386–1466). Ghiberti's *Gates of Paradise*, from the doors of the Baptistry in Florence, show the same

concern for rich detail, humanity, and feats of perspective evident in Florentine painting. Ghiberti, who trained as a goldsmith and painter, creates beautiful surfaces with delicate detail. He also conveys a tremendous sense of space in each of the ten panels. In *The Story of Jacob and Esau* (Figure 8.1), for example, he uses receding arcades to create depth and perspective. The bold relief of these scenes took Ghiberti twenty-one years to complete.

The greatest masterpieces of fifteenth-century Italian Renaissance sculpture came from the unsurpassed master of the age, Donatello. He had a passion for antiquity, and began his career as an assistant on the Florentine Baptistery doors. His early statues were similar to medieval works in that they were architectural and designed to occupy niches. His magnificent *David* (Figure 8.2) was the first freestanding nude since classical times. Unlike classical nudes, David is partially clothed. His armor and helmet, along with bony elbows and

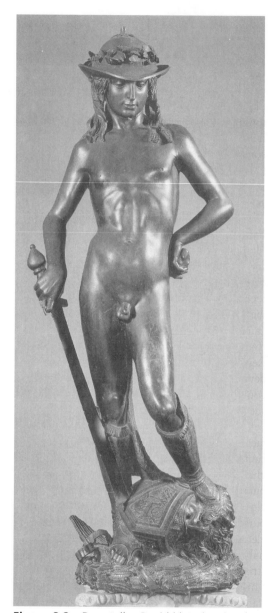

Figure 8.2 Donatello, *David* (dated variously 1430–1440). Bronze, height 5'2¼". Scala/Art Resource, New York.

Figure 8.1 Lorenzo Ghiberti, *The Story of Jacob and Esau,* panel of the Gates of Paradise, Baptistry, Florence, c. 1435. Gilt bronze, 31¼" square. Archivi Alinari/Art Resource, New York.

adolescent character, invest him with a highly individualized nature. Donatello has returned to classical *contrapposto* stance, but the carefully executed form expresses a new humanity suggesting that the statue is almost capable of movement. The work symbolizes Christ's triumph over Satan. The laurel crown on the helmet and laurel wreath on which the work stands allude to the Medici family, in whose palace the statue was displayed in 1469.

Architecture

Early Renaissance architecture was centered in Florence and departed from medieval architecture in three significant ways. First was its concern with the revival of classical models along technical lines. Ruins of Roman buildings were measured carefully, and their proportions became those of Renaissance buildings. Rather than seeing Roman arches as limiting factors, Renaissance architects saw them as geometric devices by which a formally derived design could be composed. The second departure from the medieval was the application of decorative detail—nonstructural ornamentation—to the façade of the building. Third, and a manifestation of the second difference, was a radical change in the outer expression of structure. The outward form of a building was previously closely related to the structural support of the building. In the Renaissance, these supporting elements were hidden from view, and the external appearance was no longer sacrificed to structural concerns. Classical ornamentation can be seen in Filippo Brunellechi's (broo-nuhl-ES-kee; 1377–1446) Pazzi (PAHT-zee) Chapel (Figure 8.3). Modest in scale, it uses its walls to serve as a plain background for surface decoration. Concern for proportion and geometric design is clear, but the overall composition is not a slave to pure arithmetical considerations. Rather, the Pazzi Chapel reflects Brunelleschi's sense of classical aesthetics.

Figure 8.3 Filippo Brunelleschi, Pazzi Chapel, Santa Croce, Florence (c. 1440–1461). Alinari/Art Resource, New York.

Brunelleschi's influence was profound in the first half of the fifteenth century, and he served as a model and inspiration for later Renaissance architects.

The High Renaissance in Rome

As important and revolutionary as the fifteenth century was in Italy, the high point of the Renaissance came in the early sixteenth century. Its importance as the apex of Renaissance art has led scholars to call this period the High Renaissance. Painters of the High Renaissance included giants of western visual art: Leonardo da Vinci, Michelangelo, and Raphael. The reestablishment of papal authority, the wealth of the popes, and their desire to rebuild and transform Rome on a grand scale contributed significantly to the shift in style and the emergence of Rome as the center of patronage.

Leonardo da Vinci

The work of Leonardo da Vinci (1452–1519) contains an ethereal quality that he achieved by blending light and shadow (called *sfumato* [sfoo-MAH-toh]—literally, "smoked," from the Italian). His figures hover between reality and illusion as one form disappears into another, and only highlighted portions emerge. This can be seen vividly in works like *The Madonna of the Rocks.*

Da Vinci's well-known painting, *The Last Supper* (Figure 8.4), captures the drama of Christ's prophecy, "One of you shall betray me," at the moment when the apostles are responding with disbelief. Here human figures and not architecture are the focus. The figure of Christ dominates the center of the painting, forming a stable yet active central triangle. All line, actual and implied, leads outward from his face, pauses at various subordinate focal areas, is directed back into the work, and returns to the central figure. Various postures, hand positions, and groupings of the disciples direct the eye from point to point. Figures emerge from the gloomy architectural background in strongly accented relief.

CYBER EXAMPLE

Leonardo da Vinci, *Madonna of the Rocks* (Louvre Museum)

http://www.louvre.fr/img/photos /collec/peint/grande/inv0777.jpg

Michelangelo

Perhaps the most dominant figure of the High Renaissance was Michelangelo Buonaroti (1475–1564; see the box on p. 142). Michelangelo's Sistine Chapel ceiling (Figures 3.7 and 3.8) is a shining example of the ambition and genius of this era and its

Figure 8.4 Leonardo da Vinci (1492–1519), *The Last Supper* (c. 1495–1498). Fresno, 421.6cm × 901cm. Santa Maria delle Grazie, Milan, Italy. Bridgeman Art Library.

philosophies. Some scholars see in this monumental work a blending of Christian tradition and a Neoplatonist (see Glossary) view of the soul's progressive ascent through contemplation and desire. In each of the triangles along the sides of the chapel, the ancestors of Christ await the Redeemer. Between them, amidst painted pillars, are the sages of antiquity. In the corners, Michelangelo depicts various biblical stories, and across the center of the ceiling he unfolds the episodes of the first book of the Bible, Genesis. The center of the ceiling captures the Creation of Adam (Figure 8.5) at the moment of fulfillment, and does so in sculpturesque human form and beautifully modeled anatomical detail. God, in human form, stretches outward from the matrix of angels to a reclining but dynamic Adam, awaiting the divine infusion, the spark of the soul. The figures do not touch, and we are left with a supreme feeling of anticipation of what we imagine will be the power and electricity of God's physical contact with mortal man.

The Sistine Chapel ceiling creates a visual display of awesome proportions. It is not possible to get a comprehensive view of the entire ceiling standing at any point in the chapel. If we look upward and read the scenes back toward the altar, the prophets and sibyls appear on their sides. If we view one side as upright, then the other appears upside down. These opposing directions are held together by the structure of simulated architecture, whose transverse arches and diagonal bands separate vault compartments. Twenty nudes appear at intersections and harmonize the composition because they can be read either with the prophets and sibyls below them or with the Genesis scenes at the corners. We thus see the basic High Renaissance principle of composition created by the interaction of component elements.

Michelangelo broke with earlier Renaissance artists in his insistence that measurement was subordinate to judgment. He believed that measurement and proportion should be kept "in the eyes," and so established a rationale for the release of genius to do what it would, free from any preestablished "rules." This enabled him to produce works such as *David* (Figure 4.10), a colossal figure and the earliest monumental sculpture of the High Renaissance.

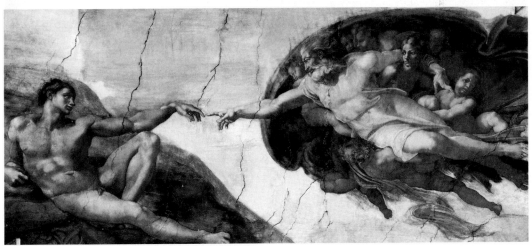

Figure 8.5 Michelangelo Buonarroti, *The Creation of Adam,* Sistine Chapel ceiling (detail), Vatican Palace, Vatican State. Scala/Art Resource, New York.

Michelangelo
David

Towering some eighteen feet above the floor, including its base, Michelangelo's *David* (Figure 4.10) exudes a pent-up energy. The upper body moves in opposition to the lower. The viewer's eye is led downward by the right arm and leg, then upward along the left arm. The entire figure seeks to break free from its confinement through thrust and counter-thrust.

Much of the effect of *David*—the bulging muscles, exaggerated rib cage, heavy hair, undercut eyes, and frowning brow—may be due to the fact that these features were intended to be read from a distance. The work was originally meant to be placed high above the ground on a buttress for Florence Cathedral. Instead, the city leaders, believing it to be too magnificent to be placed so high, put it in front of the Palazzo Vecchio (pah-LAHT-soh VEHK-kee-oh). It also had to be protected from the rain, since the soft marble rapidly began to deteriorate.

The political symbolism of the work was recognized from the outset. *David* stood for the valiant Florentine Republic. It also stood for all of humanity, elevated to a new and superhuman power, beauty, and grandeur.

Raphael

Raphael (rah-fah-EL; 1483–1520) is generally regarded as the third painter in the High Renaissance triumvirate, although it has been argued that he did not reach the same level of genius and accomplishment as Leonardo and Michelangelo. In *The Alba Madonna* (Cyber Example), the strong central triangle appears within the geometric parameters of a *tondo*, or circular shape. The tendency of a circle to roll (visually) is counteracted by strong parallel horizontal lines. The solid baseline of the central triangle is described by the leg of the infant John the Baptist (left), the foot of the Christ Child, the folds of the Madonna's robes, and the rock and shadow at the right. The left side of the central triangle comprises the eyes of all three figures and carries along the back of the Child to the border. The right side of the triangle is created by the edge of the Madonna's robe, joining with the horizontal shadow at the right border.

CYBER EXAMPLE

Raphael, *The Alba Madonna* (National Gallery of Art, Washington, DC)

http://www.nga.gov/cgi-bin
/pinfo?Object=32+0+none

Within this formula, Raphael depicts a comfortable, subtly modeled, and idealized Mary and Christ Child. The textures are soft and warm, and Raphael's treatment of skin creates an almost tactile sensation—we can almost discern the warm blood flowing beneath it, a characteristic relatively new to two-dimensional art. Raphael's figures express lively power, and his mastery of three-dimensional form and deep space is noteworthy.

Mannerism

Papal patronage had assembled great genius in Rome at the turn of the sixteenth century. It had also ignited and supported a brilliant fire of human genius in art. The Spanish invasion

and sack of Rome doused the flame of Italian art in 1527 and scattered its ashes across Europe, contributing to the disillusionment and turmoil of religious and political strife that marked the next seventy years. The sixteenth century marked the Protestant Reformation, a political and religious struggle that began earlier, but centers on the year 1517, when Martin Luther nailed his "Ninety-five Theses" to the door of the church in Wittenberg (in what is now Germany). Emerging after the sack of Rome and, arguably, the end of the High Renaissance came a style or trend called mannerism. The term originates from the mannered, or affected, appearance of subjects in paintings. These works are coldly formal and inward looking. Their oddly proportioned forms, icy stares, and subjective viewpoint can be puzzling yet intriguing. Nevertheless, we find an appealing modernism in their emotional, sensitive, subtle, and elegant content. At the same time, mannerism has an intellectual component that distorts reality, alters space, and makes often obscure cultural allusions. Anticlassical emotionalism and the abandonment of classical balance and form, alongside clear underpinnings of formality and geometry, suggest the troubled nature of this style and the times in which it flourished. (See the Cyber Example in Chapter 1, p. 15.)

Bronzino's (brahn-ZEEN-oh) *Portrait of a Young Man* (Figure 8.6) makes the point. A strong High Renaissance triangle dominates the basic composition of this work. Its lines, however, have a nervous and unstable quality—incongruously juxtaposed rectangular and curved forms create an uneasy feeling. The colors are very cold, and the starkness of the background adds to the feeling of discomfort. Shadows are harsh, and skin quality is cold and hard. Light and shade create some dimension, but the absence of perspective brings background objects inappropriately into the forward plane of the picture. The human form is attenuated and disproportionate. The head is too small for the body, and particularly for

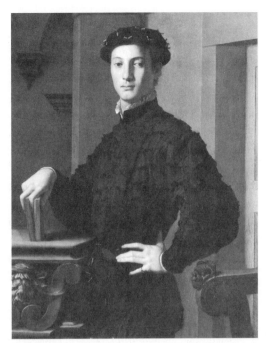

Figure 8.6 Bronzino (Agnolo di Cosimo di Mariano) (1503–1572), *Portrait of a Young Man* (c. 1535–1540). Oil on wood, 95.6cm × 74.9cm (37⅝″ × 29½″). Metropolitan Museum of Art, New York. H. O. Havemeyer Collection. Bequest of Mrs. H. O. Havemeyer, 1929 (29.100.16).

the hands. Finally, the pose and affected stare are typical of the artificiality that gave this movement its name.

Another painter of the mannerist style, Sophonisba Anguissola (ahn-ghih-SOH-la; 1532–1625) specialized in portraiture, and we sample her work in a self-portrait.

CYBER EXAMPLE

Mannerism

Sophonisba Anguissola, *Self-Portrait* (Kunsthistorisches Museum, Vienna)

http://www.csupomona.edu/~plin /women/anguissola.html

THE BAROQUE— ORNATENESS AND EMOTION

The seventeenth century in Europe brought an age of intellectual, spiritual, and physical action. Along with the new age came a tremendously diverse new style, the baroque. In many cases, it meant opulence, intricacy, ornateness, and appeal to the emotions, and it outdid previous styles in reflecting the grandiose expectations of its patrons. In other cases, it was intellectual and more subdued. The idea of proving one's position to one's peers using overwhelming art infected both the aristocracy and the bourgeoisie (middle classes), as well as the Roman Catholic Church, whose strategy for coping with the Reformation and the spread of Protestantism included attracting worshipers back into the church with magnificent art and architecture.

Systematic rationalism (see Glossary) sprang forth as a means of explaining the universe in secular and scientific terms, and as an organizational concept for works of art. Thus, in all baroque art a sophisticated organizational scheme subordinates a multitude of single parts to the whole and carefully merges one part into the next to create an exceedingly complex but highly unified design.

In the baroque, color and grandeur are emphasized, as is dramatic use of lights and darks that carry the viewer's eye off the canvas. Baroque art takes Renaissance clarity of form and recasts it into intricate patterns of geometry and fluid movement. Open composition is used to symbolize the notion of an expansive universe and a wider reality. The human figure, as an object or focus in painting, can be monumental in full Renaissance fashion, but it now can also be a minuscule figure in a landscape— part of, but subordinate to, an overwhelming universe. Above all, baroque style is characterized by intensely active compositions that emphasize feeling rather than form, emotion rather than intellect. Paintings exhibit clear

individuality, and virtuosity emerged as artists sought to establish a style that was distinctly their own.

Painting

Baroque painting is fairly easily identified as a general style, although its uses were diverse and pluralistic, not conforming to a simple mold. It spread throughout Europe with examples in every area, between 1600 and 1725.

The Catholic Reformation was one of the Roman Catholic Church's responses to the Protestant Reformation, which took place at the same time as the Renaissance and perhaps represented the most shattering blow the Christian Church has ever experienced. It did not just appear out of the blue, but was, rather, the climax of centuries of sectarian agitation. The Reformation also was perhaps as much an economic and political circumstance as it was religious.

In Rome—the center of early baroque— papal patronage and the Catholic Reformation (different from the Counter-Reformation; see Glossary) spirit brought artists together to make Rome the "most beautiful city of the entire Christian world." Caravaggio (kah-rah-VAHJ-joh; 1569–1609) was probably the most significant of the Roman baroque painters. His extraordinary style carries verisimilitude to new heights. In *The Calling of St. Matthew* (Figure 8.7), highlight and shadow create a dynamic portrayal of the moment when the future apostle is touched by divine grace. Here a religious subject is depicted in contemporary terms. Caravaggio uses realistic imagery and an everyday setting. The call from Christ streams, in dramatic chiaroscuro, across the two groups of figures. This painting expresses central themes of Catholic Reformation belief: Faith and grace are open to all who have the courage and simplicity to transcend intellectual pride, and spiritual understanding is a personal, mysterious, and overpowering emotional

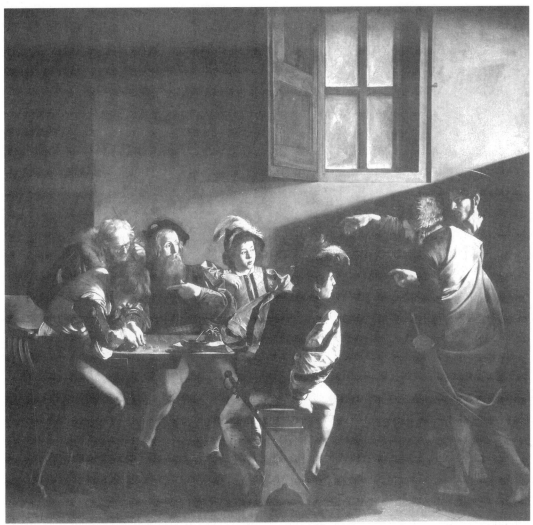

Figure 8.7 Caravaggio, *The Calling of St. Matthew* (c. 1596–1598). Oil on canvas, 11'1" × 11'5". Contarelli Chapel, Santo Luigi dei Francesi, Rome. Scala/Art Resource, New York.

experience. Another example of this approach to baroque style can be seen in Vanni's *Holy Family with Saint John* (Plate 6).

Peter Paul Rubens (1577–1640) is noted for his vast, overwhelming paintings and fleshy female nudes. But he was equally at home with religious (see Plate 1) and aristocratic themes.

In 1621 to 1625, he painted a series of works as a commission from Maria de' Medici, a Florentine princess, the widow of the French king Henri IV, and regent during the minority of her son Louis XIII. This series totals twenty-one canvases that give an allegorical version of the queen's life. The instigation of this work is

the patron and reflects Marie de' Medici's own attempt to hold on to power by representing herself in such epic terms.

As is typical of all Ruben's works, ornate curvilinear composition predominates, with strong contrasts and enhanced dynamics between lights and darks and between lively and more subdued tones. Rubens produced works at a prolific rate, primarily because he ran what was virtually a painting factory where he employed numerous artists and apprentices to assist in his work. He priced his paintings on the basis of their size and depending on how much actual work he, personally, had done on them. We should not be overly disturbed by this, especially when we consider the individual qualities and concepts expressed in his work. His unique baroque style emerges from every painting. Clearly artistic value here lies in the conception, not merely in the handiwork.

CYBER EXAMPLE

Peter Paul Rubens, *The Apotheosis of Henry IV* and the *Proclamation of the Regency of Maria de' Medici* (Louvre Museum)

http://www.louvre.fr/img/photos /collec/peint/grande/inv1779.jpg

Rembrandt van Rijn (1606–1669), in contrast to Rubens, could be called a middle-class artist. He became what can only be called a capitalist artist. He believed that art had value not only in itself but also in its market worth. He reportedly spent huge sums of money buying his own works so as to increase their value.

Rembrandt's genius lay in depicting human emotions and character. He suggests rather than depicts great detail, as seen in *The Night Watch* (Plate 11). He concentrates here on atmosphere and shadow, implication and emotion. As in most baroque art, the viewer is invited to share in an emotion, to enter into an experience rather than to observe as an impartial witness.

The huge canvas now in the Rijksmuseum in Amsterdam is only a portion of the original, which was cut down in the eighteenth century to fit into a space in the Amsterdam town hall. It no longer shows the bridge that members of the watch were about to cross. Group portraits, especially of military units, were popular at the time. They usually showed the company in a social setting such as a gathering around a banquet table. Rembrandt chose to break with the norm and portrayed the watch as if on duty. The result was a scene of greater vigor and dramatic intensity, true to the baroque spirit—but it displeased his patrons, who believed that because they all contributed equally to the cost of the work, they should be portrayed equally on canvas.

A recent cleaning has revealed the vivid color of the original, making it a good deal brighter than it was in its previous state. However, it has not explained its dramatic highlights and shadows—no analysis of light can solve the problem of how these figures are illuminated, for there is no natural light whatsoever in the scene. Another problem lies in the title of the work. It has been suggested that this is, in fact, a "Day Watch," so that the intense light at the center of the work can be explained as morning sunlight. But it seems that Rembrandt made his choice of highlights for dramatic purposes only. While the figures are rendered with a fair degree of lifelikeness, no such claim can be made for the light sources.

Not all baroque art was overwhelming in scale or intent, as we can see from the intricate detail and scale of a still life by Rachel Ruysh (roysh; 1664–1750) in the following Cyber Example.

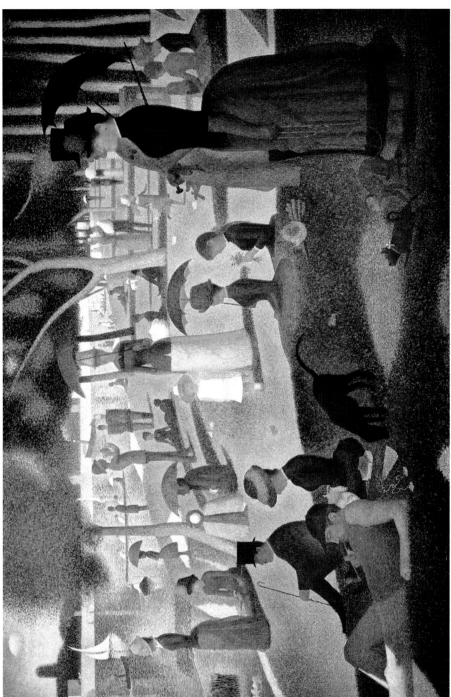

Plate 16 Georges Seurat (French, 1859–1891), *A Sunday on La Grande Jatte* (1884–1886). Oil on canvas, 207.6cm × 308cm (6'9½" × 10'3⁄8"). Helen Birch Bartlett Memorial Collection (1926.224). Photograph © 2001, The Art Institute of Chicago. All rights reserved.

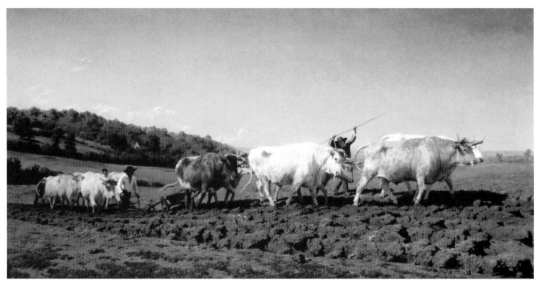

Plate 17 Rosa Bonheur, *Plowing in the Nivernais* (1849). Oil on canvas, 1.8m × 2.6m (5'9" × 8'8"). Musée d'Orsay, Paris, France. © Photo RMN-Gerard Blot.

Plate 18 Helen Frankenthaler, *Buddha* (1983). Acrylic on canvas, 6'2" × 6'9". Private collection/Helen Frankenthaler.

Plate 19 Frank Stella, *Ragga II* (1970). Synthetic polymer and graphite on canvas, 340.8cm × 762.0cm (120" × 300"). Gift of Mr. and Mrs. Gordon Hanes. North Carolina Museum of Art (82.16). Stella/CORBIS/Artists Rights Society (ARS), New York.

Plate 21 Judy Chicago, *The Dinner Party* (1979). White tile floor inscribed in gold with 999 women's names; triangle table with painted porcelain, sculpted porcelain plates and needlework. Mixed media, 48' × 42' × 3' installed. Photograph.
© Donald Woodman. © 2002, Jucy Chicago/Artists Rights Society (ARS), New York.

Plate 20 Georgia O'Keeffe (American) *Dark Abstraction* (1924). Oil on canvas, 63.18cm × 53.02cm (24⅞″ × 20⅞″). St. Louis Art Museum. Gift of Charles E. and Mary Merrill (187:1995). The Saint Louis Art Museum (Modern Art) (ISN 11327). © 2000, The Georgia O'Keefe Foundation/Artists Rights Society (ARS), New York.

CYBER EXAMPLE

Baroque

Rachel Ruysh, *Flowers in a Vase* (National Museum of Women in the Arts, Washington, DC)

http://www.nmwa.org/legacy/views/vruysch.htm

CYBER EXAMPLE

Pierre Puget, *Milo of Crotona* (Louvre Museum)

http://www.louvre.fr/img/photos/collec/sculp/grande/mr2075.jpg

Architecture

The baroque style in architecture emphasized the same contrasts between light and shade and the same action, emotion, opulence, and ornamentation as the other visual arts of the period. Because of its scale, however, the effect was one of dramatic spectacle. There were many excellent baroque architects, among them Giacomo della Porta (dehl-lah-POHR-tah; 1540–1602). His church of Il Gesù (eel jay-ZOO; Figure 8.9 on page 149), although not the most ornate example of the style, is the mother church of the Jesuit order, which was founded in 1534, and it had a profound influence on later church architecture, especially in Latin America. This church truly represents the spirit of the Catholic Reformation. Il Gesù is a compact basilica. By eliminating the side aisles, the design literally forces the congregation into a large, hall-like space directly in front of the altar.

Probably no monarch better personified the baroque era than King Louis XIV of France, and probably no work of art better represents the magnificence and grandeur of the baroque style than the grand design of the Palace of Versailles (vair-SY; Figure 8.10 on page 150), along with its sculpture and grounds. The palace became Louis XIV's permanent residence in 1682. French royalty was at the height of its power, and Versailles was the symbol of the monarchy and of the divine right of kings. As a symbol and in practical fact, Versailles played a fundamental role in keeping

Sculpture

The baroque style was particularly suited to sculpture. Form and space were charged with energy, carrying beyond the limits of actual physical confines. As with painting, sculpture appealed to the emotions by inviting participation rather than neutral observation. Feeling was the focus. Baroque sculpture also treated space pictorially, almost like a painting, to describe action scenes rather than single sculptural forms. The best examples are those of sculptor Gianlorenzo Bernini (buhr-NEEN-ee; 1598–1680), whose *David* (Figure 8.8) exudes dynamic power, action, and emotion as he curls to unleash his stone at an imagined Goliath standing some distance away. Our eyes sweep upward along a diagonally curved line and are propelled outward by the concentrated emotion of David's expression. Throughout the work the curving theme is repeated in deep, rich, and fully contoured form. A wealth of elegant and ornamental detail occupies the composition. Again the viewer participates emotionally, feels the drama, and responds to the sensuous contours of dramatically articulated muscles. Bernini's David flexes and contracts in action, rather than repressing pent-up energy as does Michelangelo's giant-slayer (Figure 4.10). A further example of baroque sculpture can be seen in Pierre Puget's *Milo of Crotona*.

Figure 8.8 Bernini, *David* (1623). Marble, height 5′7″. Galleria Borghese, Rome. Alinari/Art Resource, New York.

Figure 8.9 Giacomo della Porta, Interior of Il Gesù, Rome (1568–1584). Scala/Art Resource, New York.

France stable. Its symbolism as a magnificent testament to royal centrality and to France's sense of nationalism is fairly obvious. As a practical device, Versailles served the purpose of pulling the aristocracy out of Paris, where they could foment discontent, and isolated them where Louis XIV could keep his eye on them and keep them busy. Versailles further

served as a giant engine to develop and export French taste and the French luxury trades.

As much care, elegance, and precision were employed in the interior as on the exterior. With the aim of supporting French craftsmen and merchants, Louis XIV had his court live in unparalleled luxury. He also decided to put permanent furnishings in his château,

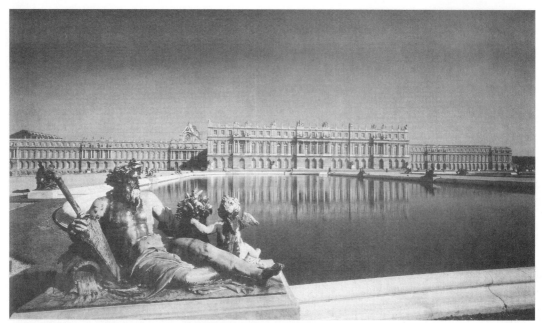

Figure 8.10 Louis LeVau and Jules Hardouin-Mansart, garden façade, Palace of Versailles (1669–1685). Scala/Art Resource, New York.

something that was unheard of at the time. The result was a fantastically rich and beautiful interior. Royal workshops produced mirrors (Figure 5.29), tapestries, and brocades of the highest quality, and these goods became highly sought-after throughout Europe.

The baroque influence of the court of Louis XIV came to England with the Restoration, the return of the monarchy, under King Charles II in 1660. Over the next fifty years, London witnessed numerous significant building projects directed by its most notable architect, Christopher Wren (rehn; 1632–1723). Two of these projects, St. Paul's Cathedral (Figure 5.13) and the remodeling of Hampton Court (Figure 5.22) illustrate the intricate but restrained complexity of English baroque style. The impact of Wren's genius, obvious in his designs, is attested to in an inscription in St. Paul's: "If you seek his monument, look around you."

THE ENLIGHTENMENT— CONFIDENCE IN THE POWER OF REASON

The eighteenth century has often been called the "Age of Enlightenment." It was an age of change and revolution in some areas and prosperous stability in others. The idea of the absolute monarch, characterized by Louis XIV of France, was challenged—though with varying success. The middle classes rose to demand their place in society, and social philosophy attempted to make a place for all classes in the scheme of things. The *philosophes*—a group of writers and scholars—undertook the challenge of making the great ideas and texts of human intellect accessible to the general public. In short, they were popularizers. Knowledge, for them, was a transcendent and universal goal. The aristocracy

found itself in decline, and the rococo style reflected their increasingly delicate condition. The pendulum then swung back from exquisite refinement and artifice to intellectual seriousness, at least for a while. The structural clarity of classicism returned in painting, sculpture, and architecture.

Rococo Style

The change from grand baroque courtly life to that of the small salon and intimate townhouse was reflected in a new style called rococo. Among other characteristics, it satirized the customs of the age, but criticized with humor. Its grace and charm reflect the social ideals and manners of the period. Informality replaced formality in both life and painting. The logic and academic character of the baroque style were found lacking in feeling and sensitivity; its overwhelming scale and grandeur were regarded as too ponderous. In rococo art, deeply dramatic action gives way to lively effervescence and melodrama. Love, sentiment, pleasure, and sincerity become predominant themes. None of these characteristics conflicts significantly with the overall tone of the Enlightenment, whose major goal was the refinement of humankind. The art of the period dignified the human spirit through social consciousness and bourgeois social morality, as well as through the graceful gamesmanship of love.

The quandary of the declining aristocracy can be seen in the rococo paintings of Antoine Watteau (wah-TOH; 1683–1721). Although largely sentimental, Watteau's work avoids frivolity. *Embarkation for Cythera* (Plate 12) gives an idealized picture of aristocratic social graces. Cythera is a mythological land of enchantment—the island of Venus, the Roman goddess of love. Watteau portrays aristocrats waiting to depart, idling away their time in amorous pursuits. The fantasy quality of the landscape is created by fuzzy color areas

and hazy atmosphere. A soft, undulating line underscores the human figures, all posed in slightly affected attitudes. Watteau's fussy details and decorative treatment of clothing stand in contrast to the diffused quality of the background. Each grouping of couples engages in graceful conversation and love games typical of the age. Delicacy pervades the scene, over which an armless bust of Venus presides. The doll-like figurines, which are only symbols, engage in sophisticated and elegant pleasure, but their usefulness is past, and the softness and affectation of the work counterbalances gaiety with languid sorrow. Many of the same themes can be found in the work of another rococo painter, Jean-Honoré Fragonard (frah-goh-NAR; 1732–1806), whose *The Swing* is illustrative (see Cyber Examples).

CYBER EXAMPLES

Jean-Honoré Fragonard, *The Swing* (National Gallery of Art, Washington, DC)

http://www.nga.gov/cgi-bin/pinfo?Object=45833+0+none

Étienne-Maurice Falconet, *Venus of the Doves* (National Gallery of Art, Washington, DC)

http://www.nga.gov/cgi-bin/pinfo?Object=41443+0+none

Rococo Churches

http://www.bergerfoundationch/vertige/english/merveilles.html

Rococo painting also turned toward portraiture and landscapes. One of the most influential artist of the time was Thomas Gainsborough (1727–1788), whose landscapes bridge the gap between baroque and romantic style and whose portraits range from lightheartedness to sensitive elegance. Françoise

Duparc (doo-PAHR; 1726–1778) exhibits remnants of the strong use of highlight and shadow typical of the baroque style in her *Portrait of an Old Lady* (Cyber Example).

In addition, a new bourgeois flavor can be found in the mundane (genre) subjects of France's Jean-Baptiste Siméone Chardin (shar-DAN; 1699–1799). He was the finest still-life and genre painter of his time, on a par with Dutch masters of the previous century such as Johannes Vermeer (vur-MEER; Plate 4). Chardin's early works are almost exclusively still lifes. These paintings illustrate how the everyday can be imbued with interest. With gentle insight, the artist invests cooking pots, ladles, pitchers, bottles, corks, slabs of meat, and other small items with significance. Richness of texture and color combined with sensitive composition and the use of chiaroscuro make these humble items somehow noble. There is pure poetry in Chardin's brush. We are subtly urged to go beyond the surface impression of the objects themselves into a deeper reality.

Rococo style in sculpture found expression in the work of Étienne-Maurice Falconet (fahl-coh-NAY; 1716–1791) and Claude Michel, known as Clodion (cloh-dee-YOHN; 1738–1814), with their myriad decorative cupids and nymphs. Rococo is not on the monumental scale of its predecessors. Rather, in the spirit of decoration that marks the era, it often takes the form of delicate and graceful porcelain and metal figurines. Venus appears frequently, often depicted in the thinly disguised form of a prominent lady of the day. Madame de Pompadour, a mistress of Louis XV who for the French epitomized love, charm, grace, and delicacy, often appears as a subject in sculpture as well as in painting.

Rococo's refinement and decorativeness applied nicely to furniture and décor, as illustrated in the music room pictured in Figure 8.11. It also was a popular style in Germany for church architecture.

Neoclassicism

In 1738, the ancient Roman city of Herculaneum (hur-kyoo-LAYN-ee-uhm) was partially excavated, and in 1748 the city of Pompeii was discovered virtually intact. These discoveries

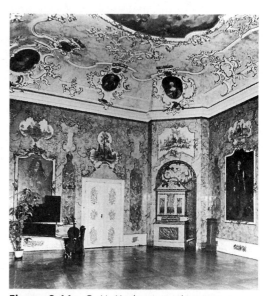

Figure 8.11 G. H. Krohne, music room, Thuringer Museum, Eisenach, Germany (1742–1751).

and various studies of Greek classicism and aesthetics sent the interests of late eighteenth-century artists and thinkers back into antiquity. A principal proponent of neoclassicism in painting was Jacques-Louis David (dah-VEED; 1748–1825). His works illustrate the newly perceived grandeur of antiquity, and this is reflected in his subject matter, composition, and historical accuracy. Propagandist in tone—he sought to inspire French patriotism and democracy—his paintings have a strong, simple compositional unity. In *The Oath of the Horatii* (hoar-AY-shee-eye; Figure 8.12), David exploits his political ideas using a

Roman theme. In this case, the subject suggests a devotion to ideals so strong that one should be prepared to die in their defense. The story of the painting concerns the conflict between love and patriotism. In legend, the leaders of the Roman and Alban armies decided to resolve their conflicts by means of an organized combat between three representatives from each side. The three Horatius brothers represented Rome. A sister of the Horatii was the fiancée of one of the opposition. The painting depicts the Horatius brothers swearing on their swords to win or die for Rome, disregarding the anguish of their sister. The context here is the time leading

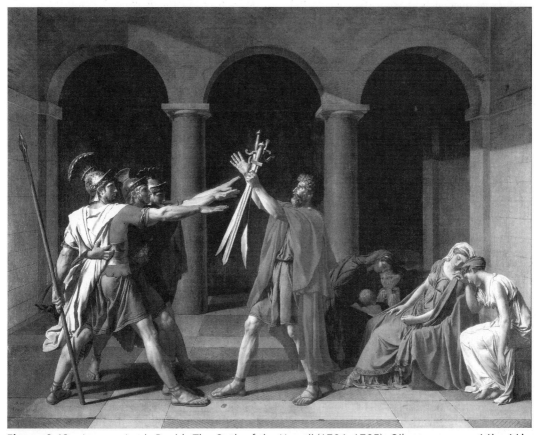

Figure 8.12 Jacques-Louis David, *The Oath of the Horatii* (1784–1785). Oil on canvas, c. 14′ × 11′. Musée du Louvre, Paris, France. Giraudon/Art Resource, New York.

to the French Revolution (1789). The painting's exhibition in 1785 caused a sensation, because viewers saw in it an exposition of the values they found sorely lacking in the king and his court. Although David probably did not intend it to be so, the painting was seen as an overt anti-monarchist statement.

In the mid-eighteenth century, the aims of architecture altered to embrace the complex philosophical concerns of the Enlightenment. The result was a series of styles and sub-styles broadly referred to also as "neoclassical." Excavations at Herculaneum and Pompeii, philosophical concepts of progress, and a new formulation of aesthetics all expressed and created a new view of antiquity. Neoclassicism was thus a new way of examining the past. Rather than seeing the past as a single continuous cultural flow broken by a medieval collapse of classical values, theoreticians of the eighteenth century saw history as a series of separate compartments—antiquity, the Middle Ages, the Renaissance, and so on. In architecture,

neoclassicism encompasses a variety of treatments and terminologies. The identifiable forms of Greece and Rome are basic to it.

In America, the architectural designs of Thomas Jefferson (Figure 8.13) were highly influenced by the sixteenth-century Italian architect Andrea Palladio (puh-LAH-dee-oh). In a uniquely eighteenth-century way, Jefferson looked at architecture objectively, within the framework of contemporary thought. He believed that the architecture of antiquity embodied indisputable natural principles, and he made Palladian reconstructions of the Roman temple the foundation for his theory of architecture. His country house, Monticello, consists of a central structure with attached Doric porticos, or porches, and short, low wings attached to the center by continuing Doric entablatures. The simplicity and refinement of Jefferson's statement here goes beyond mere reconstruction of classical prototypes, and appeals directly to the viewer's intellect and sensibilities.

Figure 8.13 Thomas Jefferson, Monticello, Charlottesville, Virginia (1770–1784; rebuilt 1796–1800).
© Wayne Andrews/Esto. All Rights Reserved.

CYBER SOURCES FOR ADDITIONAL STUDY

c.1400–c.1500

Italy (early Renaissance—Fra Angelico, Fra Lippi Lippi, Botticelli, Ghirlandaio, Masaccio, Mantegna, Perugino)

http://www.artcyclopedia.com/history/early-renaissance.html

Northern Renaissance (Schongauer, Dürer, Baldung Grien)

http://www.artcyclopedia.com/history/northern-renaissance.html

c.1480–c.1550

High Renaissance (Leonardo da Vinci, Michelangelo, Raphael, Bellini, Giorgione, Titian)

http://www.artcyclopedia.com/history/high-renaissance.html

c.1550–c.1570

Mannerism (Bronzino, Parmigianino, Tintoretto, Breughel the Elder

http://www.artcyclopedia.com/history/mannerism.html

c.1570–c.1700

Baroque Art (Bomenichino, Caravaggio, Velásquez, Rubens, Poussin, Rembrandt, van Ruysdael, Vermeer)

http://www.artcyclopedia.com/history/baroque.html

c.1700–c.1800

Rococo Art (Watteau, Boucher, Chardin, Canaletto, Fragonard, Gainsborough)

http://www.artcyclopedia.com/history/rococo.html

Neoclassicism (David, Ingres)

http://www.artcyclopedia.com/history/neoclassicism.html

9

Fragmenting Images, Emotions, and Individualism

Romanticism, Realism, Impressionism, Postimpressionism, and Art Nouveau, c. 1800–c. 1900

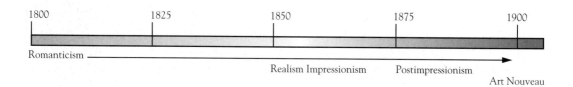

| 1800 | 1825 | 1850 | 1875 | 1900 |

Romanticism

Realism Impressionism Postimpressionism

Art Nouveau

What's in This Chapter?

We lessen our stride to a mere one hundred years as we hit the Industrial Age of the nineteenth century. Nonetheless, we have five important styles to examine: (1) romanticism, (2) realism, (3) impressionism, (4) postimpressionism, and (5) Art Nouveau.

ROMANTICISM—THE MAXIMUM IN ANTICLASSICISM

The nineteenth century has been called many things. On one hand it is called the Age of Industry because it was the time of the Industrial Revolution, when industry became "modern."

It has been called the Victorian Age, in honor of the reign of England's Queen Victoria (1819–1901; r. 1837–1901), whose British Empire circled the globe. The nineteenth century has also been called the Romantic Age because of a prevalent philosophy that spanned the entire century. "The Romantic Age" refers specifically to the style and direction of art, literature, and philosophy of the late eighteenth and nineteenth centuries, and, in this context, the word *romantic* has a different connotation from our customary use. Of course, the word means "having to do with romance"—that is, a love affair—but it also has to do with a romance, which is a long narrative story dealing with the exploits of a chivalrous hero. *Romantic* also means "having to do with

romanticism," an assertion of subjective experience and feeling in opposition to the form and objectivity of classicism. Thus, when we speak of the Romantic Age, we speak of living, thinking, perceiving, and communicating with a focus on subjectivity rather than objectivity. The classical/anticlassical pendulum has swung again, and this time it will swing further than ever toward emotionalism. The temperament of the artist becomes a filter through which the world is viewed, and the only limits placed on art are the practicalities of the artistic media themselves.

The romantic style in art has emotional appeal and tends toward the picturesque, nature, the Gothic, and, often, the macabre. Romanticism sought to break the geometric compositional principles of classicism, instead fragmenting images. The intent was to dramatize, to personalize, and to escape into imagination.

Painting

Romantic painting reflected a striving for freedom from social and artistic rules and an intense introversion. Formal content was subordinated to expressive intent. As the French novelist Émile Zola said of Romantic naturalism, "A work of art is part of the universe as seen through a temperament." Romanticism explored the capacity of color and line to affect the viewer independently of subject matter. Many romantic painters are worthy of

Figure 9.1 Théodore Géricault, *The Raft of the "Medusa"* (1819). Oil on canvas, 491cm × 716cm (16' × 23'). Louvre, Paris, France. Bridgeman Art Library.

note, but a detailed look at Théodore Géricault, Francisco Goya, and Rosa Bonheur will suffice for our overview

The Raft of the "Medusa" (Figure 9.1) by Théodore Géricault (zhay-ree-KOH; 1791–1824) illustrates both an emerging rebellion against classicism in painting and a growing criticism of social institutions in general. The painting tells a story of governmental incompetence that resulted in tragedy. In 1816, the French government allowed an unseaworthy ship, the *Medusa,* to leave port, and it was wrecked. Aboard a makeshift raft, the

survivors endured tremendous suffering, and were eventually driven to cannibalism.

Géricault's painting captures the ordeal in romantic style tempered by classical and even High Renaissance influences. He creates firmly modeled flesh, realistic figures, and a precise play of light and shade. In contrast to other paintings of the time, which expressed classical tendencies to two-dimensionality and order, Géricault used a complex and fragmented compositional structure based on two triangles rather than one strong central triangle. Géricault captures the moment when a

Figure 9.2 Francisco de Goya, *Los Fusilamientos del 3 de Mayo 1808 (The Third of May 1808)* (1814). Oil on canvas, 8'6" × 11'4". Museo del Prado, Madrid.

potential rescue ship is sighted and sails on by. The painting surges with emotional response to the horror of the experience and the heroism of the survivors. It encompasses hope followed by despair.

The Spanish painter and printmaker Francisco de Goya (GOY-ah; 1746–1828) used his paintings to attack the abuses perpetrated by governments—both the Spanish and the French. His highly imaginative and nightmarish works capture the emotional character of humanity and nature, and often their malevolence.

The Third of May 1808 (Figure 9.2) tells a true story. On that date, the citizens of Madrid rebelled against the invading army of Napoleon, but the uprising was suppressed by the French, who summarily executed many of the rebels. Using compositional devices to fragment the painting, Goya captures the climatic moment. It is impossible to escape the focal point of the painting, the man in white who is about to die.

Goya leads us beyond the death of individuals here. These figures are not realistically depicted people. Napoleon's soldiers are not even human types. Their faces are hidden, and their rigid, repeated forms become a line of subhuman automatons. Goya is making a social and emotional statement. The murky quality of the background strengthens the value contrasts in the painting, and this charges the emotional drama of the scene. Color areas have hard edges, and a stark line of light running diagonally from the oversized lantern to the lower border irrevocably separates executioners and victims. Goya has no sympathy for French soldiers as human beings here. His subjectivity fills the painting, which is as emotional as the irrational behavior he condemns.

Rosa Bonheur (boh-NUHR; 1822–1899 has been labeled both a realist and a romantic in style. Her subjects are mostly animals, and she draws out their raw energy. "Wading in pools of blood," as she put it, she studied ani-

PROFILE

Rosa Bonheur (1822–1899)

Rosa Bonheur focused her artistic attention almost solely on animals. Born in Bordeaux, France, she was the eldest of four children of an amateur painter. After early instruction from her father, she studied with Léon Cogniet at the École des Beaux-Arts in Paris, and soon began to specialize in animal subjects, studying them wherever she could. Her early paintings won awards in Paris, and in 1848 she won a first-class medal for *Plowing in the Nivernais*. By 1853, her work had reached full maturity, and she received high acclaim in Europe and the United States. Her paintings were much admired and she became widely known through engraved copies. She was also well known as a sculptor, and her animal subjects led to her success among her contemporary French sculptors.

Rosa Bonheur had an independent spirit and fought to gain acceptance on a level equal to that of male artists of the time. Her ability and popularity earned her the title of Chevalier of the Legion of Honor in 1865, and she was the first woman to receive the Grand Cross of the Legions. Befriended by Queen Victoria of Britain, who became her patron, Bonheur was also a favorite among the British aristocracy.

mal anatomy, even in slaughter houses. She was particularly interested in animal psychology. *Plowing in the Nivernais* (Plate 17) expresses the tremendous power of the oxen on which European agriculture depended before the Industrial Revolution. The beasts appear

almost monumental, and each detail is precisely executed. This painting reveals Bonheur's reverence for the dignity of labor and humankind's harmony with nature.

Sculpture

Romantic sculpture never developed into a uniform style. Those works not clearly of the neoclassical and rococo traditions show a generally eclectic spirit. The term *romantic* is often applied loosely to almost anything of the nineteenth century, and this is the case with the most remarkable sculptor of the era, Auguste Rodin (roh-DAN; 1840–1917). Rodin's textures, more than anything else, reflect impressionism (see p. 164). His surfaces appear to shimmer as light plays on their irregular features. They are more than reflective surfaces—they give his works dynamic and dramatic qualities that present, in a fair degree of lifelikeness, a reality beneath the surface—as for example, in *The Thinker* (Figure 9.3).

Architecture

One of the characteristics of romantic architecture is its borrowing of styles from other eras. A vast array of buildings revived Gothic motifs, adding a major element of fantasy to create the picturesque style. Eastern influence and whimsy abound in the Royal Pavilion at Brighton, England (Figure 9.4), designed by John Nash (1752–1835). "Picturesque" also describes the most famous example of romantic architecture, the Houses of Parliament in London (Figure 9.5). Significantly, its exterior walls function as a screen, and suggest nothing of structure, interior design, or usage—a modern tendency in architectural design. Conversely, the inside has absolutely no spatial relationship to the outside. Note, too, the strong contrast of forms and asymmetrical balance.

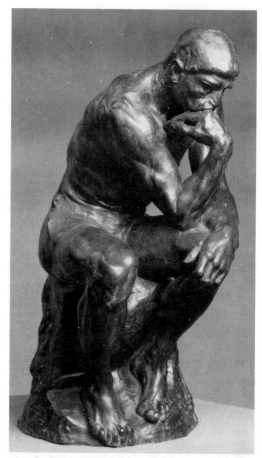

Figure 9.3 Auguste Rodin (French, 1840–1917), *The Thinker* (Le Penseur) (first modeled c. 1880, executed c. 1910). Bronze statuette, height 27½″. Metropolitan Museum of Art, New York. Gift of Thomas F. Ryan, 1910 (11.173.9).

The nineteenth century was an age of industry, of experimentation, and of new materials. In architecture, iron, steel, and glass came to the fore. At first it took courage for an architect actually to display structural honesty by allowing support materials to be seen as part of the design. In all, romantic architecture highlighted the growing divergence of function (as reflected in the arrangement of interior spaces), surface decoration, and structure.

Figure 9.4 John Nash, Royal Pavilion, Brighton, England (remodeled 1815–1823). © Kelley-Mooney Photography/CORBIS.

REALISM—OBJECTIVE OBSERVATIONS OF OBJECTIVE REALITY

A new painting style called *realism* arose in the mid-nineteenth century. The term "reality" came to have special significance in the nineteenth century because the camera—a machine to record events, people, and locations—thrust itself into what had previously been considered the painter's realm. The realists attempted to present the world as it appears to the everyday senses, but believed that an artist's vision of true reality might well be expressed in "unrealistic" forms. Based on observation, the realists sought to depict the

Figure 9.5 Sir Charles Barry and Augustus Welby Northmore Pugin, Houses of Parliament, London (1839–1852)/SuperStock, Inc.

ordinary lives of ordinary people without exaggeration or idealization. It was, in effect, a reaction against romanticism.

Courbet

The central figure of realism was Gustave Courbet (coor-BAY; 1819–1877). His aim was to make an objective and unprejudiced record of the customs, ideas, and appearances of contemporary French society. He depicted everyday life in terms of the play of light on surfaces, as seen in *The Stone Breakers* (Plate 13). This painting was the first to display his philosophy to the full. Courbet painted two men as he had seen them, working beside a road. The painting is life-size, and the treatment seems objective, and yet it makes a sharp comment on the tedium and laborious nature of the task. As a social realist, Courbet was more intent on political message than on meditative reaction.

Manet

Edouard Manet (mah-NAY; 1832–1883) strove to paint "only what the eye can see." Yet his works go beyond a mere reflection of reality to encompass an artistic reality: Painting has an internal logic different from that of familiar reality. Manet thus liberated the canvas from competition with the camera. As indicated in the catalogue for an exhibition he produced when he was excluded from the International Exhibition in Paris in 1867, Manet believed that he presented in his art sincere—rather than faultless—perception.

His sincerity carried a form of protest—his impressions. To a certain extent, Manet was both a conformist and a protester. He came from a comfortable bourgeois background, and yet maintained a conviction about socialism. His work leans heavily on the masters of the past—for example, Raphael and Watteau— and at the same time explores completely new

ground. He sought acceptance in salon circles while aiming to shock those same individuals. Striving to be a man of his own time, he rejected the superficiality he found in romantic themes. He gave the reality of the world around him a different and more straightforward interpretation. As a result, he is often hailed as the first modern painter.

Déjeuner sur l'Herbe (*The Picnic*; Figure 9.6) shocked the public when it first appeared in 1863. Manet sought specifically to "speak in a new voice." The setting is pastoral, but the people are real and identifiable: Manet's model, his brother, and the sculptor Leenhof. The apparent immorality of a naked frolic in a Paris park outraged the public and the critics. Had his figures been nymphs and satyrs, all would have been well; but Manet wanted both to be accepted by the official salon, and to shock its organizers and visitors. The painting is modern while commenting upon similar themes of the past. But the intrusion of reality into the sacred confines of the mythical proved more than the public could handle.

Figure 9.6 Edouard Manet, *Déjeuner sur l'Herbe (The Picnic)* (1863). Oil on canvas, 208cm × 264cm (7′ × 8′10″). Musée d'Orsay, Paris, France. Bridgeman Art Library.

Manet's search for harmonious colors, subjects from everyday life, and faithfulness to observed lighting and atmospheric effects led to the development of a style described in 1874 by a hostile critic as impressionism.

IMPRESSIONISM—COMMON PASSIONS IN PURSUIT OF SPONTANEITY

In France, the impressionists created a new way of seeing reality, seeking to capture "the psychological perception of reality in color and motion." It emerged in competition with the newly invented technology of the camera, for the impressionists tried to beat photography at its own game by portraying the essentials of perception that the camera cannot capture. The style lasted only fifteen years in its purest form, but it profoundly influenced all art that followed.

Working out of doors, the impressionists concentrated on the effects of natural light on objects and atmosphere. They emphasized the presence of color within shadows and based their style on an understanding of the interrelated mechanisms of the camera and the eye: Vision consists of the result of light and color making an "impression" on the retina. Their experiments resulted in a profoundly different vision of the world around them and a new way of rendering that vision. For them, the painted canvas was first of all a material surface covered with pigments and filled with small patches of color, which together create lively and vibrant images.

Despite the individualistic nature of the nineteenth century, impressionism is as collective a style as any seen thus far. It reflects the common concerns of a relatively small group of artists who met frequently and held joint exhibitions. As a result, the style has marked characteristics that apply to all its

exponents. The paintings are relatively small and use clear, bright colors. Composition appears casual and natural. Typical subjects are everyday scenes such as landscapes, rivers, streets, and cafés.

Monet

On the Bank of the Seine, Bennecourt (Figure 9.7) by Claude Monet (moh-NAY; 1840–1926) illustrates several of the concerns of the impressionists. It portrays a pleasant, objective picture of the times, in contrast with the often subjective viewpoint of the romantics. It suggests a fleeting moment—a new tone in an era when the pace of life has increased. Monet, along with Renoir and Berthe Morisot, among others, was a central figure in the development of impressionism.

Renoir

Pierre Auguste Renoir (rehn-WAH; 1841–1919) specialized in portraying the human figure, seeking out what was beautiful in the body. His paintings sparkle with the joy of life. In *Le Moulin de la Galette* (Plate 15) he depicts the bright gaiety of a Sunday crowd in a popular Parisian dance hall. He celebrates the liveliness and charm of these everyday folk as they talk, crowd the tables, flirt, and dance. Sunlight and shade dapple the scene and create a floating sensation in light. There is a casualness here, a sense of life captured in a fleeting and spontaneous moment. A much wider scene seems to extend beyond the canvas—the composition is open. The viewer is invited to become part of the action. People are going about their everyday routine with no reaction to the painter's presence. As opposed to the classicist, who focuses on the universal and the typical, the impressionist seeks realism in the "incidental, the momentary and the passing."

Figure 9.7 Claude Monet (French, 1840–1926), *On the Bank of the Seine, Bennecourt* (1868). Oil on canvas, 81.5cm × 100.7cm (31⅞″ × 39½″). Potter Palmer Collection (1922.427). Photograph. © 2001, The Art Institute of Chicago. All Rights Reserved.

Morisot

The original group of impressionists included Berthe Morisot (bairt mohr-ee-ZOH; 1841–1895), on equal terms. Her introspective works often focus on family members. Her view of contemporary life often is edged with pathos and sentimentality. In *In the Dining Room* (Figure 9.8) she uses impressionist techniques to give a penetrating glimpse of psychological reality. The servant girl has a personality, and she stares back at the viewer with complete self-assurance. The painting captures a moment of

disorder: The cabinet door stands ajar with what appears to be a used tablecloth merely flung over it. The little dog playfully demands attention. Morisot's brushstroke is delicate, and her scenes are full of insight.

POSTIMPRESSIONISM— A DIVERSITY OF PERSONALISM

In the last two decades of the nineteenth century, impressionism evolved gently into a collection of rather disparate styles called, simply,

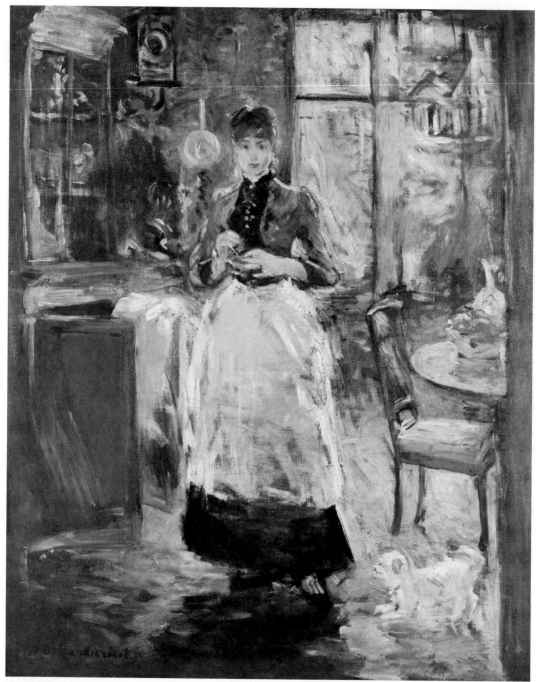

Figure 9.8 Berthe Morisot (French, 1841–1895), *In the Dining Room* (1886). Oil on canvas, 0.613cm × 500cm (24⅛″ × 19¾″); framed: 0.787m × 0.673m (31″ × 26½″). Chester Dale Collection. © 2000, Board of Trustees, National Gallery of Art, Washington, DC.

postimpressionism. In subject matter postimpressionist paintings are similar to impressionist ones: landscapes, familiar portraits, groups, and café and nightclub scenes. The postimpressionists, however, gave their subject matter a profoundly personal significance.

The postimpressionists were deeply concerned about the formal language of art and its ability to capture sensory experience. They maintained the contemporary philosophy of art for art's sake, and rarely attempted to sell their works. They did wish to share their subjective impressions of the real world, but moved beyond the romantic and impressionist world of pure sensation. They were more interested in the painting as a flat surface carefully composed of shapes, lines, and colors, an idea that became the foundation for most of the art movements that followed.

The postimpressionists called for a return to form and structure in painting, characteristics they believed were lacking in the works of the impressionists. Taking the evanescent light qualities of the impressionists, they brought formal patterning to their canvases. They used clean color areas, and applied color in a systematic, almost scientific, manner. The postimpressionists sought to return painting to traditional goals while retaining the clean palette of the impressionists.

Cézanne

Paul Cézanne (say-ZAHN; 1839–1906) is considered by many to be the father of modern art. *Mont Sainte-Victoire* (Plate 14) illustrates his concern for formal design with its nearly geometric configuration and balance. Foreground and background are tied together systematically so that both join in the foreground to create patterns. Shapes are simplified and outlining is used throughout. Cézanne employed geometric shapes—the cone, the sphere, and the cylinder—as metaphors of the permanent reality that lay beneath surface appearance.

Cézanne tried to invest his paintings with a strong sense of three-dimensionality. He took great liberty with color and changed traditional ways of rendering objects, utilizing the cones and other shapes just mentioned. His use of colored planes is much like Georges Seurat's use of dots.

Seurat

Georges Seurat (sur-AH; 1859–1891) is often described as a neoimpressionist rather than a postimpressionist (he called his approach and technique *divisionism*). He took the impressionist method of painting one step further. In his patient and systematic technique, specks of paint are applied with the point of the brush, one small dot at a time. He used paint in accordance with his theories of optics and of color perception: *A Sunday on La Grande Jatte* (Figure 9.9) illustrates his concern for the accurate depiction of light and color. Its composition and depiction of shadow show attention to perspective, and yet Seurat willfully avoids three-dimensionality. As in much postimpressionist art, Japanese influence is apparent: Color areas are fairly uniform, figures are flattened, and outlining is continuous. Throughout the work we find conscious systematizing. The painting is broken into proportions of three-eighths and halves, which Seurat believed represented true harmony. He also selected his colors by formula. Physical reality for Seurat was just a pretext for the artist's search for a superior harmony, for an abstract perfection.

Gauguin

A highly imaginative approach to postimpressionist goals came from Paul Gauguin (goh-GAN; 1848–1903). He and his followers were known as symbolists or nabis (the Hebrew word for prophet). An artist without training, and a nomad who believed that all European

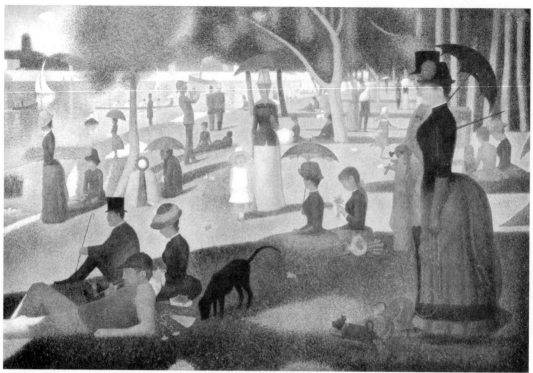

Figure 9.9 Georges Seurat, *A Sunday Afternoon on La Grande Jatte.* Oil on canvas, 207.6cm × 308cm (6'9½" × 10'3⁄8"). Helen Birch Bartlett Memorial Collection (1926.224). Photograph. © 2001, The Art Institute of Chicago. All Rights Reserved.

society and its works were sick, Gauguin devoted his life to art and wandering, spending many years in rural Brittany and the end of his life in Tahiti and the Marquesas Islands. The first picture Gauguin painted in Tahiti was *la Orana Maria* ("We Hail Thee Mary"; Figure 9.10). In this portrayal, Mary is a strong Polynesian woman, and the Christ Child is a completely relaxed boy of perhaps two or three years of age. In Tahiti, Gauguin believed he could reenter the Garden of Paradise, and the rich, warm colors and decorative patterns suggest that life in this "uncivilized" world is, indeed, sweet and innocent. The table piled high with fruit illustrates that the people of this garden, like Adam and Eve in the Garden of

Eden, need only pick the fruit off the trees. The table is the closest object to the viewer, and it, and its promise, appear to invite the viewer to leave the industrialized world for a more peaceful one.

Van Gogh

Vincent van Gogh (1853–1890) took yet another approach. His intense emotionalism in the pursuit of form is unique. His turbulent life included numerous short-lived careers, impossible love affairs, a tempestuous friendship with Gauguin, and, finally, serious mental illness. Biography is essential here, because van Gogh gives us one of the most personal and

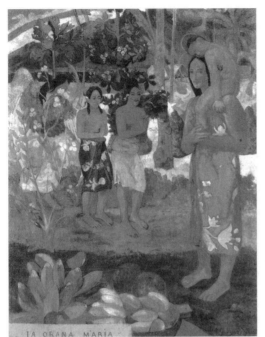

Figure 9.10 Paul Gauguin (1848–1903), *Ia Orana Maria* ("We Hail Thee, Mary"), c. 1891–1892. Oil on canvas,113.7cm × 87.7cm (44¾" × 34½"). S/D 1991. The Metropolitan Museum of Art, New York. Bequest of Samuel A. Lewisohn, 1951 (51.112.2).

subjective artistic viewpoints in the history of western art. Works such as *Harvest at La Crau* (lah croh; "The Blue Cart"), which Van Gogh produced during his Arles period, reflects an interest in complementary colors (colors on opposite sides of the color wheel—see p. 27).

Unlike Seurat, for example, who applied such colors in small dots, van Gogh, inspired

by Japanese prints, placed large color areas side by side. Doing so, he believed, expressed the quiet, harmonious life of the rural community. Notice that the brushwork in the foreground is active while the fields in the background are smooth. Subtle diagonals break the predominantly horizontal line of the work, giving the painting, overall, a tranquil atmosphere.

The Starry Night (Figure 1.8) explodes with frenetic energy manifested in the brushwork. Flattened forms and outlining also reflect Japanese influence. Here there is tremendous power and controlled focus; dynamic, personal energy and mental turmoil. This work represents one of the earliest and most famous examples of a style yet to come: expressionism (see p. 172).

Figure 9.11 Antoni Gaudí, Casa Batlló, Barcelona, Spain (1904–1906)/SuperStock, Inc.

CYBER EXAMPLE

Vincent Van Gogh, *Harvest at Le Crau* (J. Paul Getty Museum, Pasadena, CA)

http://www.artsednet.getty.edu /ArtsEdNet/Images/P/harvest.html

ART NOUVEAU—POPULAR ART IN WHIPLASH

Art Nouveau (French for "new art") pervaded the visual arts in the 1890s and early 1900s. It dominated popular culture at the end of the nineteenth century and was affiliated with the Decorative Art movement of the time (see p. 77). Characteristic is the lively serpentine curve known as the "whiplash." The style reflects a fascination with plant and animal life and organic growth. The influence of Japanese art is evident in its undulating curves. Art Nouveau incorporates organic and often symbolic motifs, treating them in a linear, relief-like manner. One of its greatest exponents was the Spanish architect Antoni Gaudí (gow-DEE; 1852–1926), whose work is well represented by the Barcelona townhouse Casa Batlló (Figure 9.11). Works of other artists in this style, such as Klimt and Tiffany can be referenced through the URL noted in the Cyber Sources.

CYBER SOURCES FOR ADDITIONAL STUDY

c. 1800–c.1905

Romanticism (Goya, Gros, Géricault, Delacroix, Constable, Turner)

http://www.artcyclopedia.com/history/romanticism.html

Realism (Courbet, Manet, Daumier)

http://www.artcyclopedia.com/history/realism.html

Impressionism (Manet, Monet, Renoir, Degas)

http://www.artcyclopedia.com/history/impressionism.html

Postimpressionism (Seurat, van Gogh, Cézanne, Gauguin)

http://www.artcyclopedia.com/history/post-impressionism.html

Art Nouveau (Gaudi, Maillol, Klimt, Tiffany)

http://www.artcyclopedia.com/history/art-nouveau.html

Viva Innovation and Experimentation

An Explosion of Art in the Early to Mid-Twentieth Century, c. 1900–c. 1960

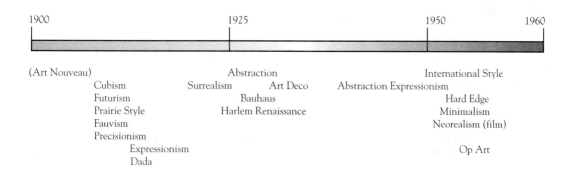

1900 1925 1950 1960

(Art Nouveau)
Cubism Abstraction
Futurism Surrealism Art Deco International Style
Prairie Style Bauhaus Abstraction Expressionism
Fauvism Harlem Renaissance Hard Edge
Precisionism Minimalism
Expressionism Neorealism (film)
Dada Op Art

What's in This Chapter?

As the timeline for this chapter suggests, a lot is happening in the arts during the early to mid-twentieth century. At the root of the many directions art takes during this time is the concept of *modernism*. In fact, a careful examination will reveal that some of the styles at the end of the nineteenth century exhibited characteristics of modernism. In Chapter 9 (p. 167) we called Cézanne the "father of modern art" without really defining what "modern art" might be. So, here are a few observations.

Modernism is usually identified as an artistic trend that began around the end of the nineteenth century and dominated cultural expression until World War II or after (such assessments vary widely). The concept of modernism is also identified with the Renaissance idea of modernity, which gained prominence during the scientific revolution of the seventeenth century and grew during the Enlightenment (p. 150). Modernity repudiated the authority of the past—specifically, the idea that western civilization had reached its height in ancient Greece and Rome. Rather,

171

modernity placed its confidence in human progress through rationality and technological advances. The term "modernism" was also applied to reforming tendencies in Christianity that sought to reconcile religious doctrine with scientific thought and social change. Modernism views the Bible, for example, as symbolically and morally, but not literally, true, and is at odds with "fundamentalism."

Modernism in the arts developed in reaction to romanticism (p. 156) and realism (p. 161), rejecting conventional narrative content and conventional modes of expression to depict a world seen as altogether new and constantly in flux. In the words of one art critic, modernism created the "tradition of the new." As a movement, modernism is not coherent. Rather, it is an approach to creation that broke old rules to express new thoughts and certain assumptions, often pessimistic, about the state of the world. That is what we will find in the art of this chapter, all of which falls within the rough parameters just noted. Because of the spirit of experimentation and newness that mark the age, the artistic directions we now examine come fast and furious. In painting and sculpture, we will trace six of these directions and two geographic topics: Expressionism, Cubism, Mechanism and Futurism, Abstraction, Dada, and Surrealism, followed by the Harlem Renaissance and American Painting. Architecture and a brief look at a revolutionary style in cinema close the chapter.

EXPRESSIONISM— JOINT REACTIONS

Expressionism traditionally refers to a movement in Germany between 1905 and 1930; but used more broadly, the term applies to a focus on the joint reaction of artist and viewer to composition elements. Any element (line, form, color, and so on) can be emphasized to elicit a specific response. The artist consciously tries to stimulate a reaction specifically relating to his or her feelings about, or commitment to, the subject matter or content. From the expressionist artist's viewpoint, content itself mattered little; what counted was the artist's attempt to evoke in the viewer a similar response to his or her own. The term *expressionism* as a description of this approach to visual art and architecture first appeared in 1911. It emerged following six years of work by an organized group of German artists who called themselves *Die Brücke* (The Bridge). Trying to define their purposes, the painter Ernst Ludwig Kirchner (KIRSH-nur; 1880–1938) wrote: "He who renders his inner convictions as he knows he must, and does so with spontaneity and sincerity, is one of us." The intent was to protest against academic naturalism. They used simple media such as woodcuts and created often brutal, but nonetheless powerful effects that expressed inner emotions. In Max Beckmann's *Christ and the Woman Taken in Adultery* (Figure 10.1), the artist's revulsion against physical cruelty and suffering is transmitted through distorted figures crushed into shallow space. Linear distortion, changes of scale and perspective, and spirituality communicate Beckmann's reactions to the horrors of World War I.

The early expressionists maintained representationalism to a degree; but later expressionist artists, for example those of the Blue Rider group between 1912 and 1916, created some of the first completely abstract or nonobjective works of art. Color and form emerged as stimuli extrinsic to subject matter, and without any natural spatial relationships or recognizable objects, paintings took a new direction in internal organization.

Closely associated with the expressionist movement were the *fauves* (the French word for "wild beasts"). The label was applied in 1905 by a critic in response to a sculpture that seemed to him "a Donatello in a cage of wild beasts." Violent distortion and outrageous

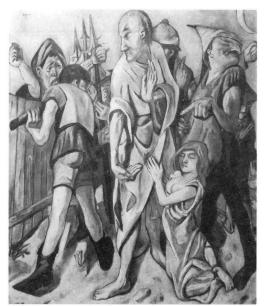

Figure 10.1 Max Beckmann (German, 1884–1950), *Christ and the Woman Taken in Adultery* (1917). Oil on canvas, 58³/₄″ × 49⁷/₈″. Saint Louis Art Museum. Bequest of Curt Valentin. © 1998, Artists Rights Society (ARS), New York/VG Bild-Kunst, Bonn (E7608).

coloring mark the work of the fauves, whose two-dimensional surfaces and flat color areas were new to European painting.

The best-known artist of this short-lived movement was Henri Matisse (mah-TEES; 1869–1954). Matisse tried to paint pictures that would "unravel the tensions of modern existence." The *Blue Nude* (see Cyber Example) illustrates the wild coloring and distortions in the paintings of this style. The painting takes its name from the energetically applied blues, which occur throughout the figure as dark accents. For Matisse, color and line were indivisible devices, and the bold strokes of color in this work both reveal forms and stimulate a purely aesthetic response. Matisse literally "drew with color." His purpose was not, of course, to draw a nude as he saw it in life. Rather, he tried to express his feelings about the nude as an object of aesthetic interest.

CUBISM— VISUAL FRAGMENTATION

The years between 1901 and 1912 witnessed an emerging approach to pictorial space, called cubism. Cubist space violated all usual concepts of two- and three-dimensional perspective. Until this time, the space within a composition had been thought of as an entity separate from the main subject of the work— that is, if the subject were removed, the space would remain, unaffected. Cubism was a response to the lush sensuality of impressionism (p. 164). It focused on the idea that space is visually and conceptually ambiguous and that reality resides in the mind's perception of it (space). The cubist response to depicting volume on a flat plane was to see an object simultaneously from all sides, including the inside, and thus to reveal its essence.

Pablo Picasso (1881–1973; see Profile (p. 32) and Georges Braque (brahk; 1882–1963) changed that relationship. In their view, the artist should paint "not objects but the space they engender." The area around an object became an extension of the object itself, and if the object were removed, the space around it would collapse. Cubist space is typically quite shallow and gives the impression of reaching forward out of the frontal plane toward the viewer.

Pablo Picasso
Les Desmoiselles d'Avignon

Les Demoiselles d'Avignon has become the single most discussed image in modern art. Its simplified forms and restricted color were adopted by many cubists as they reduced their palettes in order to concentrate on spatial exploration. A result of personal conflicts on the part of the artist, combined with his ambition to be recognized as the leader of the avant-garde, the painting deliberately breaks with the traditions of Western illusionistic art. The painter denies both classical proportions and the organic integrity and continuity of the human body.

Les Demoiselles d'Avignon (Avignon in the title refers to a street in Barcelona's red-light district) is aggressive and harsh, like the world of the prostitutes who inhabit it. Forms are simplified and angular, and colors are restricted to blues, pinks, and terracottas. Picasso breaks his subjects into angular wedges that convey a sense of three-dimensionality. We do not know whether the forms protrude out or recess in. In rejecting a single viewpoint, Picasso presents "reality" not as a mirror image of what we see in the world, but as images that have been reinterpreted within the terms of new principles. Understanding thus depends on knowing rather than seeing.

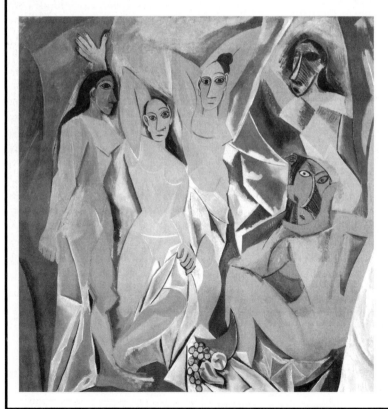

Pablo Picasso, *Les Demoiselles d'Avignon* (June–July 1907). Oil on canvas, 243.9cm × 233.7cm (8′ × 7′8″). The Museum of Modern Art, New York. Acquired through the Lillie P. Bliss Bequest. Photograph: © 2001, The Museum of Modern Art, New York. © 2000, Estate of Pablo Picasso/Artists Rights Society (ARS), New York.

Essentially, the style developed as the result of independent experiments by Braque and Picasso with various ways of describing form. Newly evolving notions of the time-space continuum were being proposed by Albert Einstein at this time. We do not know whether the Theory of Relativity influenced Picasso and Braque, but it was being talked about at the time, and it certainly helped to make their works more acceptable. The results of both painters' experiments brought them to remarkably similar artistic conclusions.

Like Picasso, Braque took a new approach to spatial construction and reduced objects to geometric shapes, drawing upon the ideas of Cézanne. It was from Braque's geometric forms that the term "cubist" first came. Unfortunately, the label has led many observers to look for solid cubic shapes rather than for a new kind of space "which was only visible when solid forms became transparent and lost their rigid cubical contours" (Hamilton, *Nineteenth and Twentieth Century Art: Painting, Sculpture, Architecture*, p. 211).

CYBER EXAMPLES

Cubism

Georges Braque, *Man with a Guitar*

http://www.artchive.com/artchive/B/braque/man_guit.jpg.html

Max Weber, *Interior of the Fourth Dimension* (National Gallery of Art, Washington, DC)

http://www.nga.gov/cgi-bin/pinfo?Object=70385+0+none

MECHANISM AND FUTURISM— DYNAMIC MACHINES

Themes dealing with mechanism proved to be popular in the early twentieth century, as life became more and more dominated by

machines. A brief movement in Italy, mechanism, sought to express the spirit of the age by capturing speed and power through representation of vehicles and machines in motion. Mechanistic themes can be seen clearly in the works of Marcel Duchamp (doo-SHAWM; 1887–1968), who is often associated with the dada movement (see p. 178) and whose famous *Nude Descending a Staircase, No. 2* (Figure 10.2) is sometimes called "proto-dadaist." To Duchamp, apparently, men and women were machines that

Figure 10.2 Marcel Duchamp, *Nude Descending a Staircase, No. 2* (1912). Oil on canvas, 58" × 35". Philadelphia Museum of Art (Louise and Walter Arensberg Collection © Succession Marcel Duchamp/DACS 1999.

ran on passion as fuel. Like those of the dadaists, many of Duchamp's works also exploit chance and accident.

Sculptors turned to further explorations of three-dimensional space and what they could do with it. Technological developments and new materials also encouraged the search for new forms to characterize the age. This search resulted in a style called futurism, which was really more of an ideology than a style. Futurism encompassed more than just the arts, and it sought to destroy the past—especially the Italian past—in order to institute a totally new society, a new art, and new poetry. Its basis lay in "new dynamic sensations." In other words, the objects of modern life, such as "screaming automobiles" that run like machine guns, have a new beauty—speed—that is more beautiful than even the most dynamic objects of previous generations. Futurists found in the noise, speed, and mechanical energy of the modern city a unique exhilaration that made everything past drab and unnecessary. The movement was particularly strong in Italy and among Italian sculptors. In searching for new dynamic qualities, the Italian futurists in the visual arts found that many new machines had sculptural form. Their own sculptures followed mechanistic lines and included representations of motion.

Umberto Boccioni's (boh-CHOH-nee; 1882–1916) *Continuity of a Form in Space* (Figure 10.3) takes the mythological subject of Mercury, messenger of the gods, and turns him into a futuristic machine. The overall form is recognizable and the outlines of the myth move the viewer's thoughts in a particular direction. Nonetheless, this is primarily an exercise in composition. The intense sense of energy and movement is created by the variety of surfaces and curves that flow into one another in a seemingly random, yet highly controlled, pattern. The overall impression is of the *motion* of the figure rather than of the figure itself.

Figure 10.3 Umberto Boccioni (1882–1916), *Continuity of a Form in Space* (1913; cast 1931), 3'7⅞" high. Galleria d'Arte Moderna, Italy. Scala/Art Resource, New York.

ABSTRACTION— THE DISSOLVING IMAGE

Abstraction in art takes two general forms: (1) the reduction of images from the natural world into shapes suggested by, but not conventionally representational of, actual objects; (2) the "pure" use of color, line, shadow, mass, and other traditional, formal elements of painting and sculpture to create an image whose only reference is itself. In other words, abstract art seeks to explore the expressive qualities of formal design elements and materials in their own right. These elements are assumed to stand apart from subject matter. The aesthetic

PROFILE

Georgia O'Keeffe

The American painter Georgia O'Keeffe was born near Sun Prairie, Wisconsin. She grew up on the family farm in Wisconsin before deciding that she wanted to be an artist. She spent 1904 to 1905 at the Art Institute in Chicago and 1907 to 1908 at the Art Students League of New York, then supported herself by doing commercial art and teaching at various schools and colleges in Texas and the South. Her break came in 1916, when her drawings were discovered and exhibited by the famous American photographer Alfred Stieglitz (see p. 105), who praised and promoted her work vigorously. They maintained a lifelong relationship, marrying in 1924, and O'Keeffe became the subject of hundreds of Stieglitz's photographs. After meeting Stieglitz, O'Keeffe spent most of her time in New York, with occasional periods in New Mexico, but she moved permanently to New Mexico after her husband's death in 1946.

Her early pictures lacked originality, but by the 1920s she developed a uniquely individualistic style. Many of her subjects included enlarged views of skulls and other animal bones, flowers, plants, shells, rocks, mountains, and other natural forms. Her images have a mysterious quality about them, with clear color washes and a suggestive, psychological symbolism that is often implicitly erotic. Her rhythms undulate gracefully, and her works bridge the gap between abstraction and biomorphic form. Her later works exalt the New Mexico landscape that she loved.

theory underlying abstract art maintains that beauty can exist in form alone and that no other quality is needed. Many painters explored these approaches, and several groups, such as *de stijl* (duh stile), the suprematists, the constructivists, and the Bauhaus painters, have pursued its goals. The works of Piet Mondrian (peet MOHN-dree-ahn; 1872–1944) (see Figure 2.22 and associated discussion) and Kasimir Malevich (mahl-YAY-vich; 1878–1935), and Georgia O'Keeffe (1887–1986) illustrate many of the principles at issue in abstract painting.

A work such as *Suprematist Composition: White on White* (Figure 10.4) by Kazimir Malevich seems simple but confusing, even by abstract standards. For Malevich, such works go beyond reducing a painting to its basic common denominator of oil on canvas. Rather, he sought basic pictorial elements that could "communicate the most profound expressive reality."

Figure 10.4 Kazimir Malevich, *Suprematist Composition: White on White* (c. 1918). Oil on canvas, 79.4cm × 79.4cm (31¼″ × 31¼″). Museum of Modern Art, New York. Acquisition confirmed in 1999 by agreement with the estate of Kazimir Malevich and made possible with funds from the Mrs. John Hay Whitney Bequest (by exchange). Photograph © 2001, Museum of Modern Art, New York.

The American Georgia O'Keeffe has proved to be one of the most original artists of the twentieth century. Her imagery draws on a diverse repertoire of objects abstracted in a uniquely personal way. In *Dark Abstraction* (Plate 20), an organic form becomes an exquisite landscape that, despite its modest size, appears monumental. Her lines flow gracefully upward and outward with skillful blending of colors and rhythmic grace. Whatever the subject of the painting, it expresses a mystical reverence for nature. O'Keeffe creates a sense of reality that takes us well beyond our surface perceptions.

The original mobiles of Alexander Calder (1898–1976) put abstract sculpture into motion. Deceptively simple, these colorful shapes (Figure 4.3) turn at the whim of subtle breezes or are powered by motors. Here is the discovery that sculpture can be created by movement in undefined space.

DADA—ANTIART ART?

The horrors of World War I caused tremendous disillusionment. One expression of this was the birth of dada. (Considerable debate exists about when and how the word *dada*—it is French for "hobby-horse"—came to be chosen. The dadaists themselves accepted it as two nonsense syllables, like one of a baby's first words.) During the years 1915 and 1916, many artists gathered in neutral capitals in Europe to express their disgust at the direction western societies were taking. Dada was thus a political protest, and in many places the dadaists produced more left-wing propaganda than art.

By 1916, a few works of dada art began to appear, many of them found objects (see p. 71) and experiments in which chance played an important role. For example, Jean Arp (1888–1966) produced collages that he made by dropping haphazardly cut pieces of paper onto a surface and pasting them

down just where they fell. Max Ernst (1891–1976) juxtaposed strange, unrelated items to produce unexplainable phenomena. This use of conventional items placed in circumstances that alter their traditional meanings is characteristic of dadaist art. Irrationality, meaninglessness, and harsh mechanical images are typical effects, as shown in *Woman, Old Man, and Flower* (Figure 10.5). This is a nonsensical world in which pseudo-human forms with their bizarre features and proportions suggest a malevolent unreality. Dada emphasizes protest and leads to the idea that one element of the arts must be to shock. Perhaps the most vivid exponent of dada was Marcel Duchamp, whose proto-dadaist expressions of futurism we have already seen in *Nude Descending a Staircase* (Figure 10.2).

SURREALISM—THE UNCONSCIOUS MIND

As the work of Sigmund Freud became popular, artists became fascinated by the subconscious mind. By 1924, a surrealist manifesto stated some specific connections between the subconscious mind and painting. Surrealist works were thought to be created by "pure psychic automatism," whose goal was to merge reason and unreason, consciousness and the unconscious into an "absolute reality—a super-reality." Its advocates saw surrealism as a way to discover the basic realities of psychic life by automatic associations. Supposedly, a dream could be transferred directly from the unconscious mind of the painter to canvas without control or conscious interruption. Surrealism was born from dada's preoccupation with the irrational and illogical, and reaches back to Marcel Duchamp (see p. 175).

Surrealist art took two directions. The metaphysical fantasies of Girogio de Chirico (KEE-ree-koh; 1888–1978), for example, present fantastic, hallucinatory scenes in a

Figure 10.5 Max Ernst, *Woman, Old Man, and Flower* (1923–1924). Oil on canvas, 96.5cm × 130.2cm (38″ × 51¼″). Museum of Modern Art, New York. Purchase. Photograph: © 2001, Museum of Modern Art, New York.

hard-edged, realistic manner. In works such as *The Nostalgia of the Infinite* (Plate 3), strange objects are irrationally juxtaposed: they come together as in a dream. These bizarre works reflect a world that human beings do not control. In them, Chirico said, "There is only what I see with my eyes open, and even better, closed."

Another surrealist who followed this same direction was Mexican painter Frieda Kahlo (KAH-loh; 1907–1954). Her works (more than one-third of which are self-portraits) are studies in great pain and suffering, both mental and physical. A bus crash at age eighteen resulted in the loss of her right leg. Works such as *The Bro-*

ken Column (Plate 2) portray a nightmarish quality typical of surrealism—here, a myriad of emotions, as the subject appears both as a sufferer and a savior. The broken column displayed in the open chasm of the torso juxtaposes a graphic architectural form, perhaps suggesting her own spine and brokenness, with her body itself, punctured by numerous nails and held together by a cloth harness. The self-portrait stands before a barren monochromatic landscape and darkened sky.

The second direction of surrealism—the abstract—can be seen in works by Joan Miró (Plate 7). These are based on spontaneity and chance, using abstract images.

THE HARLEM RENAISSANCE

From 1919 to 1925, Harlem, a neighborhood in upper Manhattan, became the international capital of African-American culture. "Harlem was in vogue," wrote the poet Langston Hughes. African-American painters, sculptors, musicians, poets, and novelists joined in a remarkable artistic outpouring. Some critics at the time attacked this work as isolationist and conventional, and the quality of the Harlem Renaissance still stirs debate.

The movement took up several themes: Glorification of the Black American's African heritage, the tradition of Black folklore, and the daily life of Black people. In exploring these subjects, Harlem Renaissance artists broke with previous African-American artistic traditions. But they celebrated Black history and culture and defined a visual vocabulary for Black Americans.

African-American intellectuals such as W. E. B. DuBois (doo-BOYS; 1868–1963) and Alain Locke (1886–1954) spearheaded the movement. Among the notable artists were the social documentarian and photographer James van der Zee (1886–1983), the painter William Henry Johnson (1901–1970), the sculptor Meta Vaux Warrick Fuller (1877–1968), and the painter Aaron Douglas (1889–1979). Douglas was particularly well known for his illustrations and cover designs for many books by African-American writers. In his highly stylized work, he explores a palette of muted colors. *Aspects of the Negro Life* (Figure 10.6), at the New York Public Library's Cullen branch,

CYBER EXAMPLES

Meta Vaux Warrick Fuller, *Pieta* (University of Maryland Art Gallery)

http://www.inform.umd.edu/EdRes/Colleges/ARHU/Depts/ArtGal/.WWW/exhibit/98-99/driskell/exhibition/sec1/full_m_01.htm

William H. Johnson, *Self-Portrait* (National Museum of American Art, Washington, DC)

http://nmaa-ryder.si.edu/johnson/intro3.html

Figure 10.6 Aaron Douglas, *Aspects of the Negro Life: From Slavery through Reconstruction,* (detail) (1934). Oil on canvas, entire work 60″ × 139″. Schomburg Center for Research in Black Culture, Art and Artifacts Division, New York Public Library, Astor, Lenox, and Tilden Foundations.

documents, in four panels, the emergence of an African-American identity. The first portrays the African background in images of music, dance, and sculpture. The next two panels bring to life slavery and emancipation in the American South and the flight of Blacks to the cities of the North. The fourth panel returns to the theme of music.

AMERICAN PAINTING— A WEALTH OF DIVERSITY

During the early twentieth century, America came of age artistically. Until the early twentieth century, painting in the United States had done little more than adapt European trends to the American experience. Strong and vigorous American painting emerged in the early twentieth century, however, and it encompasses so many people and styles that we will have to be content with only a few representative examples.

An early group called "the Eight" appeared in 1908 as painters of the American scene. They were Robert Henri, George Luks, John Sloan, William Glackens, Everett Shinn, Ernest Lawson, Maurice Prendergast, and Arthur B. Davies. These painters shared a warm and somewhat sentimental view of American city life, and they presented it both with and without social criticism. Although uniquely American in tone, the works of the Eight often revealed European influences, for example, of impressionism.

The realist tradition continued in the works of Grant Wood (see p. 13) and followed in the footsteps of an earlier American realist, Henry O. Tanner (1859–1937). Tanner studied at the Philadelphia Academy of Fine Arts with the American realist painter Thomas Eakins, who encouraged both African Americans and women at a time when professional careers were essentially closed to them. *The Banjo Lesson* presents its

CYBER EXAMPLES

Robert Henri, *Snow in New York* (National Gallery of Art, Washington, DC)

http://www.nga.gov/cgi-bin /pinfo?Object=42656+0+none

John Sloan, *The City from Greenwich Village* (National Gallery of Art, Washington, DC)

http://www.nga.gov/cgi-bin /pinfo?Object=51796+0+none

Maurice Prendergast, *Sunset and Sea Fog* (Butler University Museum of Art)

http://www.butlerart.com/pc_book/pages /maurice_brazil_prendergast_1858.htm

images without sentimentality and achieves its focus through the contrast of clarity in the central objects and less detail in the surrounding areas. Tanner skillfully captures an atmosphere of concentration and shows us a warm relationship between teacher and pupil.

CYBER EXAMPLE

Henry O. Tanner, *The Banjo Lesson* (Hampton Institute, Hampton, VA)

http://www.pbs.org/ringsofpassion/love /tanner.html

Diego Rivera (ree-VAY-rah; 1886–1957) revived the fresco mural as an art form in Mexico in the 1920s. Working with the support of a new revolutionary government, he produced large-scale public murals that picture contemporary subjects in a style that blends European and native traditions. The fresco painting *Enslavement of the Indians* (Figure 10.7) creates a dramatic comment on that chapter in Mexican history. The composition

Figure 10.7 Diego Rivera, *Enslavement of the Indians* (1930–1931). Fresco. Palacio de Cortes, Cuernavaca, Mexico. Schalkwijk/Art Resource, New York. © Banco de Mexico Diego Rivera Museum Trust.

is not unlike that of Goya's *The Third of May 1808* (Figure 9.2). A strong diagonal sweeps across the work, separating the oppressed from the oppressor, and provides a dynamic movement stabilized by the classically derived arcade framing the top of the composition.

ABSTRACT EXPRESSIONISM— FROM BRUSHWORK TO CONTENT

The first fifteen years following the end of World War II (or, actually, beginning around 1940) were dominated by a style called abstract expressionism. The style originated in New York (with the eponymous New York

school), and it spread rapidly throughout the world on the wings of modern mass communications. Two characteristics identify abstract expressionism. One is nontraditional brushwork, and the other is nonrepresentational subject matter. This complete freedom to reflect inner life led to the creation of works with high emotional intensity. Absolute individuality of expression and the freedom to be irrational underlie this style. This may have had some connection with the confidence inspired by postwar optimism and the triumph of individual freedom.

Arguably, the most acclaimed painter to create his own particular version of this style was Jackson Pollock (1912–1956). A rebellious spirit, Pollock came upon his characteristic approach to painting only ten years before his death. Although he insisted that he had absolute control, his compositions consist of what appear to be simple dripping and spilling of paint onto huge canvases. (He placed his canvases on the floor in order to work on them.) His work (Figure 2.2), often called "action painting," conveys a sense of tremendous energy. The viewer seems to feel the painter's motions as he applied the paint.

Included among the work of the abstract expressionists is the "color-field" painting of Mark Rothko (1903–1970), whose highly individualistic paintings follow a process of reduction and simplification. Rothko left all "memory, history, and geometry" out of his canvases. These, he said, were "obstacles between the painter and the idea." Rothko's careful juxtaposition of hues has a deep emotional impact on many viewers.

CYBER EXAMPLE

Mark Rothko, *1968* (National Gallery of Art, Washington, DC)

http://www.nga.gov/cgi-bin /pinfo?Object=66460+0+none

The abstract expressionist tradition continued in the work of Helen Frankenthaler (FRANK-en-thahl-ur; b. 1928). A second-generation abstract expressionist, she began her painting career just as an earlier group of artists, including Pollock, Rothko, and Willem de Kooning, were gaining widespread public attention.

Her innovative technique, seen in *Buddha* (Plate 18), involved pouring paint directly onto the unprimed surface of a canvas (allowing the color to soak into its support), rather than painting on top of an already sealed canvas, as was customary. This highly intuitive process, known as "stain painting," became the hallmark of her style and enabled her to create color-filled canvases filled with amorphous shapes that seemed to float on air. The image created thus has infinite potential meaning, apart from that suggested by whatever title Frankenthaler chooses, because the very freedom of the form means that viewers are free to choose their own associations.

POP ART—FROM WHERE WE LIVE

Pop art, which evolved in the 1950s, concerned itself above all with representational images. The term *pop*, an abbreviation of *popular*, was coined by the English critic Lawrence Alloway, and it simply meant that the subjects of these works are found in popular culture. The treatments of pop art also came from mass culture and commercial design. These sources provided pop artists with what they took to be the essential aspects of the visual environment that surrounded them. The pop artists themselves traced their heritage back to dada (see p. 178), although much of the heritage of the pop tradition continues to be debated. The compelling paintings of Roy Lichtenstein (LIHK-ten-styn; 1923–1997) are the most familiar examples of pop art (Figure 10.8). These magnified cartoon-strip paintings use the effect created by the dots of the screen that is used in color printing in comics (called benday dots—see

Figure 10.8 Roy Lichtenstein, *Whaam!* (1963). Acrylic on canvas, 5'8" × 13'4". Tate Gallery, London/Art Resource, New York. © Estate of Roy Lichtenstein.

Glossary). Using dot stencils about the size of a coin, Lichtenstein built his subjects, which are original, up into stark and dynamic, if sometimes violent, images.

In the 1960s, Andy Warhol (1928–1987) focused on popular culture and contemporary consumerism in his ultra-representational art. The very graphic *Green Coca-Cola Bottles* (Figure 1.1) is a good example of his style. The starkness and repetitiousness of the composition are broken up by subtle variations. The apparently random breaks in color, line, and texture create moving focal areas, none of which is more important than another, yet each significant enough to keep the viewer's eye moving continuously through and around the painting. In these subtle variations, the artist takes an almost cubistlike approach to the manipulation of space and image.

MINIMALISM—REDUCTIO AD INFINITUM

In the late 1950s and 1960s, in painting and sculpture, a style called minimalism sought to reduce the complexity of both design and content as far as possible. Instead, minimalist artists concentrated on nonsensual, impersonal, geometric shapes and forms. No communication was to pass between artist and respondent, no message was to be conveyed. Rather, the minimalists wanted to present neutral objects free of their own interpretations and leave response and "meaning" entirely up to the viewer. Another term applied to minimalism is *hard-edge* or *hard-edged abstraction*. Representative of this movement is the work of Frank Stella (b. 1936). Its flat color areas have hard edges that carefully separate one area from another. Essentially, hard-edge is an exploration of design for its own sake. Stella often abandoned the rectangular format of most canvases in favor of irregular shapes in order to be

sure that his paintings bore no resemblance to windows. The odd shape of the canvas thus became part of the design itself, as opposed to being a frame or a formal border within which the design was executed.

Some of Stella's paintings have iridescent metal powder mixed into the paint, and the metallic shine further enhances the precision of the composition. *Ragga II* (Plate 19) stretches just twenty-five feet across, with interspersed surging circles and half-circles of yellows, reds, and blues. The intensity of the surface, with its jarring fluorescence, counters the grace of its form, while the simplicity of the painted shapes is enriched by the variety of the repetitions.

Minimalist influence reaches into sculpture in what has been labeled as the "primary structures" movement, which pursues extreme simplicity of shapes and a kinship with architecture. Viewers are invited to share an experience in three-dimensional space in which they can walk around and/or through the works. Form and content are reduced to their most "minimal" qualities.

CYBER EXAMPLE

David Smith, *Cubi XXVI* (National Gallery of Art, Washington, DC)

http://www.nga.gov/cgi-bin /pinfo?Object=56336+0+none

In David Smith's *Cubi* series, the seemingly precarious balance and curious combinations of forms convey a sense of urgency; yet, the works are in perfect balance. The texture of the luminescent stainless steel has a powerful tactile effect, yet it also creates a shimmering, almost impressionistic, play of light. The forms are simple rectangles, squares, and cylinders, and scale gives them a vital importance.

ARCHITECTURE—EXPERIMENTS IN MODERNISM

Louis Sullivan and Frank Lloyd Wright

An influential figure in the development of the skyscraper and in the whole philosophy of modern architecture was Louis Sullivan (1856–1924). The first truly modern architect, he worked in the last decade of the nineteenth century in Chicago, then the most rapidly developing metropolis in the world. Sullivan designed buildings characterized by dignity, simplicity, and strength. Most importantly, he created a rubric for modern architecture by combining form and function: In his theory, the former flows from the latter. By this, he meant that purpose should be the first—but not the only—consideration in design. This principle, which also implied that beauty resides in the purity of unornamented form, was applied in a great deal of "modern" design between World War I and World War II—for example, in the geometrical austerity of Bauhaus architecture (p. 187). As Sullivan said to an observer of the Carson, Pirie, & Scott building (Figure 10.9), which he designed, "It is evident that we are looking at a department store. Its purpose is clearly set forth in its general aspect, and the form follows the function in a simple, straightforward way" (Helen Gardner, *Art Through the Ages*, p. 760).

Frank Lloyd Wright (1867–1959; see Profile, p. 89) was one of the most influential and innovative architects of the twentieth century. He wished to initiate new traditions. One such new tradition was the prairie style (Figure 10.10), which Wright developed around 1900. In creating these designs, Wright drew on the flat landscape of the Midwest as well as the simple horizontal and vertical accents of the Japanese style. Wright followed Louis Sullivan in his pursuit of

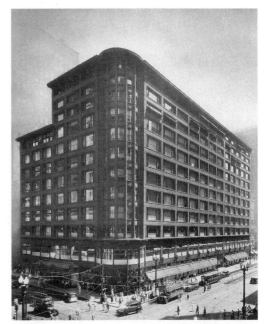

Figure 10.9 Louis Henry Sullivan, Carson, Pirie, & Scott Department Store, Chicago (1899–1904). © Bettmann/CORBIS.

form that expressed function, and he took painstaking care to devise practical arrangements for his interiors and to make the exteriors of his buildings reflect their interiors.

Wright also designed some of the furniture for his houses. In doing so, comfort, function, and integration with the total design were his chief criteria. Textures and colors in the environment were duplicated in the materials, including large expanses of wood, both in the house and for its furniture. He made a point of giving furniture several functions. Tables, for example, might also serve as cabinets. All spaces and objects were precisely designed to present a complete environment. Wright was convinced that houses profoundly influence the people who live in them, and he saw the architect as a "molder of humanity." Wright's works range from the simple to the complex,

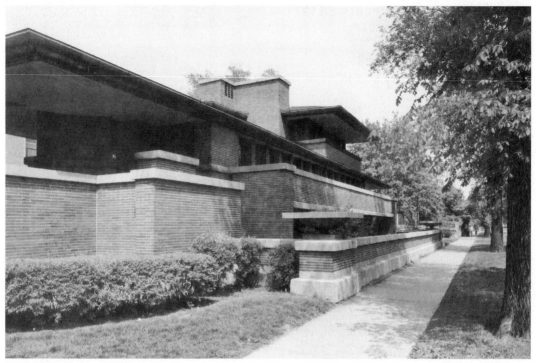

Figure 10.10 Frank Lloyd Wright, Robie House, Chicago (1907–1909). Ezra Stroller © Esto. All Rights Reserved.

from the serene to the dramatic, and from interpenetration to enclosure of space. He was always experimental, and his designs explore the various interrelationships between space and geometric design.

Wright's insistence on the integration of the context of the building and the creation of indoor space that was an expression of outdoor space led him to even more dramatic projects. The horizontality of the prairie style remains, but we see it in a completely different mode in the exciting Kaufmann House (Figure 10.11), also known as Falling Water. Cantilevered over a waterfall, its imagery is dramatic. It seems to erupt out of its natural rock site, and its beige concrete terraces blend harmoniously with the colors of the surrounding stone. Wright has blended two seemingly dissimilar styles here:

The house is part of its context, yet it has the rectilinear lines of the international style, to which Wright was usually opposed, and whose elements we see clearly in another modern architect, Le Corbusier.

Le Corbusier

During the 1920s and 1930s, Le Corbusier (luh kor-boo-ZYAY; 1887–1965) was concerned with integrating structure and function, and he was especially interested in poured concrete. He demonstrated his belief that a house was "a machine to be lived in" in several residences of that period. By "machine" Le Corbusier did not mean something depersonalized. Rather, he meant that a house should be efficiently constructed from standard, mass-produced parts,

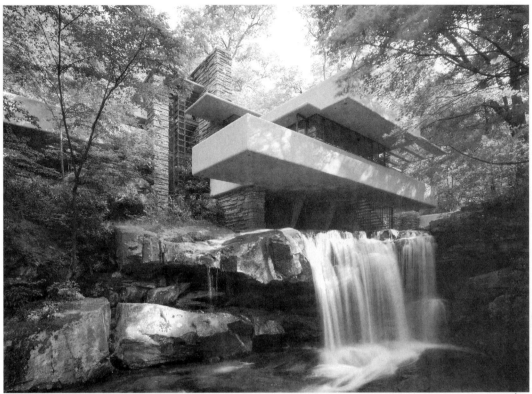

Figure 10.11 Frank Lloyd Wright (1869–1959), Kaufmann House, Falling Water, seen from below. Bear Run, Pennsylvania (1936–1937). © ARS, New York. Western Pennsylvania Conservancy/Art Resource, New York.

and logically designed for use, on the model of an efficient machine.

Le Corbusier had espoused a domino system of design for houses, using a series of slabs supported on slender columns. The resulting building was boxlike, with a flat roof, which could be used as a terrace. The Villa Savoye (Figure 10.12) combines these concepts in a building whose supporting structures free the interior from the necessity of weight-supporting walls. In many ways, the design of the Villa Savoye reveals a classical Greek inspiration, from its columns and human scale to its precisely articulated parts and coherent whole. The design is crisp and functional.

Bauhaus

The Bauhaus represents a conscious attempt to integrate the arts into a unified statement. For the most part, the Bauhaus and its goals were the result of the philosophy of its founder and primary visionary, Walter Gropius (GROH-pee-uhs; 1883–1969).

In Germany in the mid-1920s, led by Walter Gropius and Adolph Meyer, the Bauhaus School of Art, Applied Arts, and Architecture approached aesthetics from the point of view of engineering. Experimentation and design were based on technological and economic factors rather than on formal considerations. Spatial

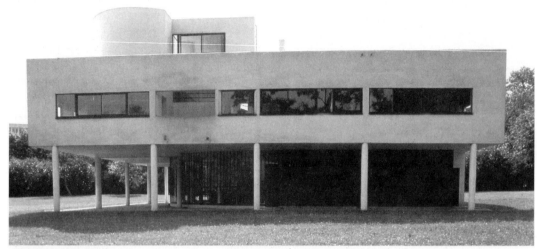

Figure 10.12 Le Corbusier, Villa Savoye, Poissy, France (1928–1930). Anthony Scibilia/Art Resource, New York.

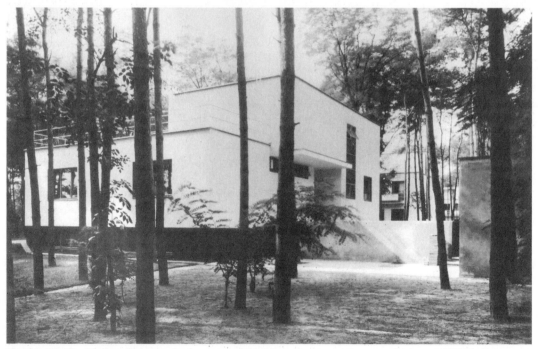

Figure 10.13 Walter Gropius, Professor Gropius's own house at Dessau, Germany (1925). Foto Marburg/Art Resource, New York.

imagination, rather than building and construction, became the Bauhaus objective. The design principles of Gropius and Meyer produced building exteriors that were completely free of ornamentation. Several juxtaposed, functional materials form the external surface, underscoring the fact that exterior walls are no longer structural, merely a climate barrier. Bauhaus buildings evolved from a careful consideration of what people needed their buildings to do, while at the same time, the architects were searching for dynamic balance and geometric purity, as illustrated by Gropius's own house at Dessau, Germany (Figure 10.13).

During the years of its existence, the Bauhaus embraced a wide range of visual arts: architecture, planning, painting, sculpture, industrial design, and theater stage design and technology. The Bauhaus sought a new and meaningful working relationship among all the processes of artistic creation, culminating in a new "cultural equilibrium," as Gropius described it, in the visual environment.

After World War II

The break in architectural construction during World War II separated what came after from what went before. The continuing careers of architects who had achieved significant accomplishments before the war soon bridged the gap, however. The focus of new building shifted from Europe to the United States, Japan, and even South America. The overall approach still remained modern—or international—in flavor.

A resurgence of skyscraper building occurred in the 1950s with the familiar glass-and-steel-box approach that still continues. Inherent in much of this design is the concept of "set-back," the creation of open space around the building by setting the tower of the skyscraper back from the perimeter of the site. Thus, the building creates its own envelope of environment, or its *context*.

The rectangle, which has so uniformly and, in many cases, thoughtlessly become the mark of modern architecture, leads us to the architect who, before World War II, was among its advocates. Ludwig Mies van der Rohe (LOOT-vik mees vahn dair ROH-uh; 1886–1969) insisted that form should not be made an end in itself but, rather, that the architect should discover and state the function of the building. Mies van der Rohe pursued these goals, taking mass-produced materials—bricks, glass, and manufactured metals—at their face value and expressing their shapes honestly. This was the basis for the rectangularization that is the common ground of twentieth-century architecture. His search for proportional perfection was consummated in large-scale projects such as New York's Seagram Building (Figure 10.14).

The simple straight line and functional structure that were basic to Mies van der Rohe's vision were easily imitated and readily reproduced. This multiplication of steel and glass boxes, however, has not overshadowed exploration of other forms. Twentieth-century design has ultimately answered in various ways the question put by Louis I. Kahn, "What form does the space want to become?"

In the case of Frank Lloyd Wright's Guggenheim Museum (Figure 5.31), space has become a relaxing spiral that reflects the leisurely progress one should make through an art museum. Eero Saarinen's (ay-roh SAH-rin-en; 1910–1961) TWA (Trans-World Airlines) Terminal at New York's John F. Kennedy Airport emulates the shape of flight in its curved lines and spaces, carefully designed to accommodate large masses of people and channel them to and from waiting aircraft. Shapes like this can be executed only using modern construction techniques and materials such as reinforced concrete.

Two other noteworthy architects left their own signatures: the arch of Pier Luigi Nervi (peer loo-EE-jee NAIR-vee; 1891–1979),

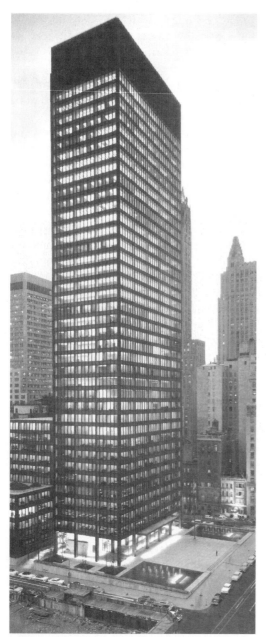

Figure 10.14 Mies van der Rohe and Philip Johnson, Seagram Building, New York (1958). Ezra Stroller © Esto. All Rights Reserved.

and the dome of R. Buckminster Fuller (1895–1983). The unencumbered free space of their work contrasts sharply with the self-contained boxes of the international style. Nervi's Small Sports Palace (Figure 10.15) and Fuller's Climatron (Figure 5.19) illustrate the trend toward spansion architecture, which stretches engineering to the limits of its materials.

CYBER EXAMPLE

Eero Saarinen, TWA Terminal, JFK Airport, New York

http://www.scandinaviandesign.com /eero_saarinen/index4.htm

CINEMA AND NEOREALISM

As Italy recovered from World War II, a new concept in cinema changed the way movies were shot and edited. In 1945, Roberto Rossellini's (rohs-sel-LEE-nee) *Rome, Open City* showed the misery of Rome during the German occupation. It was shot on the streets of Rome, using hidden cameras and mostly nonprofessional actors. Technically, the quality of the work was somewhat deficient, but its objective viewpoint and documentary style (p. 109) changed the course of cinema and inaugurated an important style called neorealism. The foreign film tradition, especially, remained dominated by this style into the 1960s, with works such as Fellini's (fel-LEE-nee) *La Strada* (1954) and *La Dolce Vita* (1960).

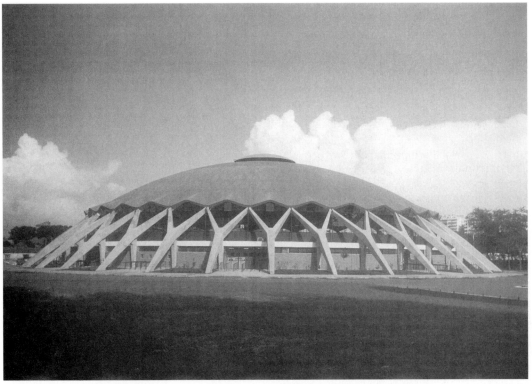

Figure 10.15 Pier Luigi Nervi, Small Sports Palace, Rome (1957).

CYBER SOURCES FOR ADDITIONAL STUDY

c. 1900–1960

Fauvism (Matisse, Rouault)

http://www.artcyclopedia.com/history /fauvism.html

Expressionism (Beckmann, Kandinsky, Klee, Kathy Kollwitz)

http://www.artcyclopedia.com/history /expressionism.html

Cubism (Picasso, Braque, Natalia Goncharova)

http://www.artcyclopedia.com/history /cubism.html

Futurism (Balla, Carrà)

http://www.artcyclopedia.com/history /futurism.html

Dada (Arp, Duchamp, Hannah Höch)

http://www.artcyclopedia.com/history /dada.html

Surrealism (Dali, de Chirico, Kahlo)

http://www.artcyclopedia.com/history /surrealism.html

American Painting (Ashcan School)

http://www.artcyclopedia.com/history /ashcan-school.html

Abstract Expressionism (de Kooning, Pollock, Frankenthaler, Rothko)

http://www.artcyclopedia.com/history /abstract-expressionism.html

Precisionism (Demuth, Sheeler)

http://www.artcyclopedia.com/history /precisionism.html

Pop Art (Lichtenstein, Indiana, Warhol)

http://www.artcyclopedia.com/history /pop.html

Op Art (Vasarely)

http://www.artcyclopedia.com/history /optical.html

Photorealism (Hanson, Close)

http://www.artcyclopedia.com/history /photorealism.html

Minimalism (Kelly, Stella)

http://www.artcyclopedia.com/history /minimalism.html

Pluralism in a Postmodern World

c. 1960–Present

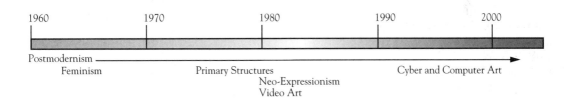

1960 1970 1980 1990 2000

Postmodernism
 Feminism Primary Structures Cyber and Computer Art
 Neo-Expressionism
 Video Art

What's in This Chapter?

The twentieth century is over. Societies exist in a global environment in which the actions of even the smallest nation or single individual can have worldwide ramifications that go well beyond the importance of the original cause. The uncritical optimism spawned by the victory of democracy over totalitarianism in World War II has faded, to be replaced by a more realistic, if less positive, appreciation of social inequities within democracy itself. The inevitable conflict that arises when a state pursues individual liberties as well as social rights, and the question of where one ends and the other begins, are among the most vexing problems facing humankind. The questions of individual responsibility versus individual rights, and of accommodating minority differences while maintaining cultural integrity, plague every turn.

The role (or roles) of art in these questions lies at the heart of a direction in culture, and defines postmodernism. At the beginning of Chapter 10, we attempted to define the concept of modernism. Now, as we look at the sweep of the arts since approximately 1960, *postmodernism* as a concept demands our attention.

Debates about postmodernism have dominated the cultural and intellectual scheme in many fields. In aesthetic and cultural theory, arguments emerged over whether "modernism" in the arts was or was not dead and what sort of "postmodern" art was succeeding it. In philosophy, discussion centered on the question of whether or not the tradition of modern philosophy had ended and been replaced by a new

"postmodern" philosophy associated with Nietzsche (NEE-cheh) and others. Eventually, the postmodern discussion produced new social and political theories, as well as theoretical attempts to define the multifaceted aspects of the postmodern phenomenon itself.

Postmodernism grew out of modernism in the second half of the twentieth century. It continued some of the trends of modernism—for example, stylistic experimentation—but it disdained others, such as concern with purity of form. Perhaps most significantly, postmodernism questions the idea of *metanarrative,* or *grand narrative,* which is the attempt to explain all of human endeavor in terms of a single theory or principle, as exemplified by such conceptual schemes as Marxism, Freudian psychology, and structuralism. (Structuralism holds that individual phenomena can be understood only within the context of the overall structures of which they are a part, and that these structures represent universal sets of relationships that derive meaning from their contrasts and interactions within a specific context.) Such attempts to comprehensively account for human history and behavior are, according to postmodernism, posited in terms that are in some respects mutually incompatible. Therefore, the postmodern solution to this contradiction is that there is no final narrative to which everything is reducible; rather, there are a variety of perspectives on the world, any of which may be valid, none of which can be privileged. This is, arguably, a skeptical viewpoint stemming from the conviction that contemporary society is so hopelessly fractured—for example, by the commercialization and trivialization of culture—that no coherent comprehension of it is possible. Within certain fields such as feminism and multiculturalism, postmodernism has created arguments between those who see it as supportive of their position (giving equal status with the prevailing western narrative) and those who see

postmodernism as so indiscriminate that it precludes any grounds for political action.

In the arts, postmodernism ("pomo" for short) is distinguished by eclecticism and anachronism, in which works may reflect and comment on a wide range of stylistic expressions and cultural-historical viewpoints. Often this results in an embrace of normlessness and cultural chaos, as well as in a conscious attempt to break down distinctions between "high art" and popular culture—for example, in *performance art,* which often involves a provocative mingling of musical, literary, and visual sources. The artist's self-conscious display of technique and artifice puts self-reference at the center of creation and presentation.

Our journey in this last chapter will move from painting and sculpture (including neo-expressionism, feminism, environments, earthworks, and installations) to architecture, and computer- and cyber art.

PAINTING AND SCULPTURE

The period from the late 1960s through the 1980s witnessed a variety of mostly individualistic reactions to the styles of the past, including the recent past of the twentieth century. Like the collective styles of the end of the nineteenth century, which were called postimpressionist, these styles, which seem to have no common thread, have been lumped together as *postmodernist* styles. These are highly individualistic, although some artists prefer to return art to the anonymity of pre-Renaissance times. One recognizable aspect of the postmodernist styles appears to be a desire to return recognizable content or meaning to works of art, and the artists following these paths were reacting to what they felt was a clutter and lack of content in previous styles. These artists took great pains to be "different." The question of difference, however, became complicated by the fact that many, like the postmodernist architects,

took great delight in eclectically borrowing from the past. They mixed old styles to create their own new ones. One common theme apparently shared by postmodernists is a basic concern for how art functions in society. An example of this individualistic painting style, rich with visual detail, is the work of Rafael Ferrer (b. 1933). The colorful emotionalism of *El Sol Asombra* (see Cyber Example) brings cultural relationship to the forefront. Similarly, the darkly provocative *Si Se Pudiera (If Only I Could)* by the Cuban painter and installation artist José Bedia, draws the viewer into the work whose restricted pallette poses questions to which the viewer wants to respond.

CYBER EXAMPLES

Rafael Ferrer, *El Sol Asombra* (Butler Institute of American Art)

http://www.butlerart.com/pc_book /pages/rafael_ferrer_b.htm

José Bedia, *Si Se pudiera (If Only I Could)* (Norton Museum of Art)

http://www.norton.org/collect /contempo/bedia/bedia.htm

Neo-Expressionism

One postmodern movement has been called *neo-expressionism*. One of its most notable adherents, the Italian artist Francesco Clemente (cleh-MEN-tay; b. 1952), records images "that the rest of us repress." In *Untitled from White Shroud* (Figure 11.1), he forces the viewer to confront what may well be repulsive images. The painting has nightmarish qualities, and yet the fluid watercolor medium gives it a softened, translucent quality. The contrasts of cool blues in the background and the bright red and yellow of the fishes capture interest and successfully balance form and color.

Like the expressionists, neo-expressionists seek to evoke a particular emotional response in the viewer. The German artist Anselm Kiefer (KEEF-uhr; b. 1945) invests his work with a strong emotive and empathetic content. In *Midgard* (Figure 11.2), he draws upon Nordic mythology to portray a desolate landscape of despair. "Midgard" means "middle garden," the term given by the Norse gods to the earth. In Nordic myth, the earth is destroyed by the Midgard serpent and other demons after three years of winter. Standing before this enormous painting, we find its scale and emotional power profoundly affecting. It takes up our whole field of vision and seems to surround us.

Feminism

Feminism is a social, political, and cultural movement seeking equal rights and status for women in all spheres of life. More radically, it pursues a new order in which men are no longer the standard against which equality and normality are measured. Like postmodernism, feminism is a diverse ideology of wide-ranging perspectives on the origin and constitution of gender and sexuality, the historical and structural foundations of male power and women's subjugation, and the proper means of achieving women's emancipation.

During the 1970s, feminist artists of the Women's Art Movement emerged. Substantially as a result of this movement, women began to achieve increased recognition in the American art world. Marches, protests, the organization of women's cooperative galleries, active promotion of women artists, critical exploration by women art historians, and the development of a feminist art program at the California Institute of the Arts, in 1971 brought about significant results. Illustrative of the social protests and marches was the Guerilla Girls, a group of anonymous women

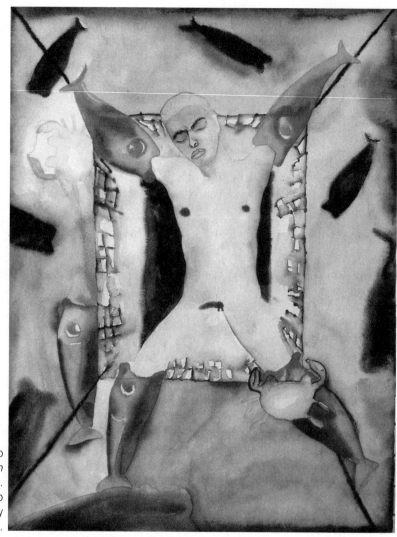

Figure 11.1 Francesco Clemente, *Untitled from White Shroud* (1983). Watercolor. Photo courtesy of Anthony d'Offay, Gallery, London.

artists who dressed in costume gorilla masks and plastered New York City with posters drawing the public's attention to the situation (http://www.guerrillagirls.com). Their chosen name is an appropriate play on words. *Guerilla,* anglicized, sounds like "gorilla"; its origins could be French (*guerre*—war) or Spanish (*guerra*—war; *guerrero*—warrior).

One of the founders of the CalArts program, Judy Chicago, can be seen as an example. At the end of the 1960s she began to use feminine sexual imagery to reveal the sexism of the male-dominated art world. *The Dinner Party* (Plate 21) records the names of 999 notable women, and pays homage to thirty-nine legendary women, including an Egyptian queen and Georgia O'Keeffe (see p. 177). At each side of the triangular table are thirteen settings (the number of witches in a coven and the number of men at the Last Supper). The

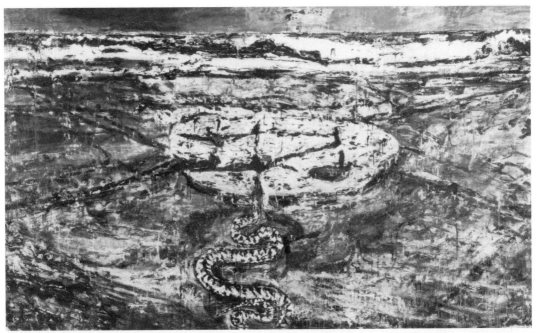

Figure 11.2 Anselm Kiefer (German, b. 1945), *Midgard* (1980–1985). Oil and emulsion on canvas, 142″ × 237¾″. Carnegie Museum of Art, Pittsburgh. Gift of Kaufmann's, the Women's Committee, and the Fellows of the Museum of Art.

triangular shape is a symbol for woman; during the French Revolution, it stood for equality. Each of the place settings at the table features a runner in a style appropriate to the woman it represents, in addition to a large ceramic plate. Included are traditional women's art forms such as stitchery, needlepoint, and china painting, which Chicago wished to raise to the status given to painting and sculpture. Suggestions of female genitalia throughout the painting are the artist's comment that that was all the women at the table had in common.

Susan Rothenberg (b. 1945) made a major place in American painting following her first New York exhibition in 1976. Images of horses predominate her work, as in *Cabin Fever* (see Cyber Example). Rough brushstrokes reveal the form, whose shading makes the image appear to separate from the canvas.

Betye Saar (b. 1926) likewise has achieved great attention, and her mixed media composition *The Liberation of Aunt Jemima* has become one of the most famous images in contemporary art. Aunt Jemima was a marketing symbol of surrogate motherhood applied

CYBER EXAMPLES

Susan Rothenberg, *Cabin Fever* (Modern Art Museum of Fort Worth)

http://www.mamfw.org/f_html/rothen.html

Betye Saar, *The Liberation of Aunt Jemima* (Getty Museum of Fine Art, Pasadena, CA)

http://www.artsednet.getty.edu/ArtsEdNet/Images/X/jemima.html

to pancake flour and syrup. In the immediate years after World War II, Aunt Jemima—that is, an African American woman dressed as "Aunt Jemima," demonstrating making pancakes with her brand of mix—was a staple at county fairs and public festivals around the country and as recognizable a corporate icon as Ronald McDonald is today.

Environments, Earthworks, and Installations

Environmental art sets out to create an inclusive experience. In the *Jardin d'Émail* (zhahr-DAN day-MY; Figure 11.3) by Jean Dubuffet (doo-boo-FAY; 1901–1985), an area made of concrete has a base coat of white paint

Figure 11.3 Jean Dubuffet (1901–1985), *Jardin d'Émail* (1973–1974). Concrete, epoxy, paint, and polyurethane, 66′8″ × 100′. State Museum Kröller-Müller Otterlo, The Netherlands. © ARS, New York. Rijksmuseum Kroeller-Mueller, Otterlo, The Netherlands.

accented by black lines. Surrounded by high walls, the whole construction is capricious in form. Inside the sculptural environment we find a tree and two bushes of polyurethane. Here Dubuffet has tried to push the boundaries of art to their known limits, perhaps. He has consistently opted for chaos, for *art brut*— a term denoting the untrained art of children, psychotics, and amateurs. The *Jardin d'Émail* is one of several projects in which he has explored this chaotic, disorienting, and inexplicable three-dimensional form.

The dynamic and dramatic landscape of *Spiral Jetty* (Figure 11.4) by Robert Smithson (1928–1973), in the Great Salt Lake of Utah, is an example of postmodernist environmental art. Because it, like similar works by other artists, uses natural materials found at the site, it has been called an *earthwork*. A number of concepts and ideas are represented here. Smithson wanted to take art out of the marketplace, where it had become a commodity, and return it to nature. The spiral shape represents the early Mormon belief that the Great Salt Lake was connected to the Pacific Ocean by an underground canal that, from time to time, caused great whirlpools on the lake's surface. In addition, the jetty is intended to change the quality and color of the water around it, thereby creating a color shift, as well as making a linear statement. Finally, the design is meant to be ephemeral as well as environmental. Smithson knew that eventually the forces of wind and water would transform, if not obliterate, the project. And, in fact, high water has submerged the jetty in recent years.

"Environments" which have been expanded into room-size settings are now called

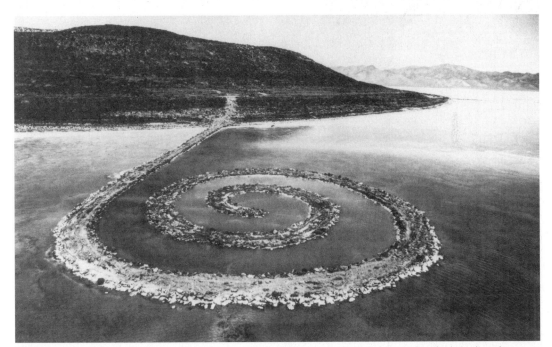

Figure 11.4 Robert Smithson, *Spiral Jetty* (April 1970). Great Salt Lake, Utah. Black rock, salt crystals, earth, and red water (algae). 160' diameter: 3½' × 15' × 1,500'. Estate of Robert Simthson. Courtesy of James Cohan Gallery, New York. Collection: DIA Center for the Arts, New York. Photo by Gianfranco Gorgoni.

"installations." The installations of Judy Pfaff (b. 1946) employ a variety of materials, including those of painting, in order to shape and charge architectural space. The art historian H. W. Janson likens her works to "exotic indoor landscapes," and finds her spontaneous energy similar to that of Jackson Pollock's action painting (see Figure 2.2). Nature seems to have inspired her installation *Deepwater* (Figure 11.5). Swirling tendrils hang like brightly colored jungle foliage. Fiery reds predominate, although Pfaff uses the entire color spectrum. All this stands out against the white walls of the room. The sweeping diagonals seem carefully juxtaposed against linear verticals, while, at the same time, a jumble of stringlike things in the far corner emanates confusion. The strong colors and proliferation

of lines suggest that paint has been flung into space and, magically, suspended there.

Video Art

Video Composition X by Nam June Paik (payk; b. 1932) turned a large room into a garden of shrubbery, ferns, and small trees. As one looked up from the greenery, thirty television sets were all running the same program in unison. Bill Viola's (b. 1951) *He Weeps for You* featured a drop of water forming at the end of a thin copper pipe and then falling on a drumhead. The image was blown up on a large television screen, and the sound of the falling drop was amplified into a thunderous boom.

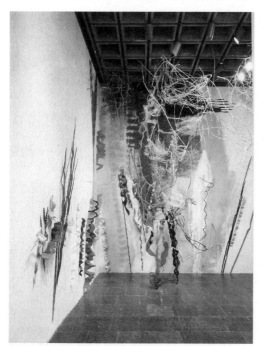

Figure 11.5 Judy Pfaff, *Deepwater* (1980). Mixed media as installed in 1981 Biennial exhibition (January 20–April 5, 1981). Collection of the Whitney Museum of American Art, New York. Photograph by Geoffrey Clements.

CYBER EXAMPLES

Nam June Paik, *Egg Grows* (San Francisco Museum of Modern Art)

http://www.sfmoma.org/collections /media_arts/ma_coll_paik.html

Bill Viola, *Passage 1987* (San Francisco Museum of Modern Art)

http://www.sfmoma.org/collections /media_arts/ma_coll_viola.html

A wide-ranging genre of sculpture called "video art" emerged from the rebellions of the 1960s as a reaction against conventional broadcast television. Since then, inexpensive portable recording and playback video equipment has made it possible for this art form to flourish. Video art has moved from nearly a photojournalistic form to one in which outlandish experiments exploit new dimensions in hardware and imagery.

Nam June Paik is perhaps the most prominent of the video artists. His work pioneered the use of television imagery in performance and other multimedia art. It takes television well beyond its primary function of reproducing imagery. Indeed, Nam June Paik's video art

historical themes and eclectically juxtaposes them to, as he describes it, prefigure a "new epoch." We see this eclectic juxtaposition in his public housing development called, with typical grandiosity, the Palace of Abraxas (Figure 11.7). Here columnar verticality is suggested by glass bays and by the cornice/capitals over them which give the appearance of a dynamic classicism.

Michael Graves (b. 1934) has reacted to the repetitive glass, concrete, and steel boxes of the international style by creating a metaphorical allusion to the keystone of the Roman arch (Figure 11.8). The bright red pilasters suggest fluted columns, and fiberglass garlands recall both Art Deco (see Glossary) and rococo.

Postmodern architecture focuses on meaning and symbolism, and it embraces the past. The postmodernist seeks to create buildings that explore the full context of society and the environment. Function no longer dictates form, and ornamentation is acceptable. The goals of postmodern architecture are social identity, cultural continuity, and sense of place.

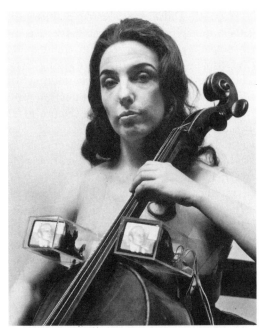

Figure 11.6 Nam June Paik, *TV Bra for Living Sculpture* (1969). Performance by Charlotte Moorman with television sets and cello. Photo. Peter Moore. © The Estate of Peter Moore/ Licensed by VAGA, New York, NY.

creates its own imagery. In *TV Bra for Living Sculpture* (Figure 11.6), he creates interactive images of a performance of classical music and miniature televisions with their own images. The combined video and live situations function as a third, overriding experience. The effect is bizarre, startling, fascinating, and, unlike the moment captured in the illustration, constantly changing.

ARCHITECTURE—
REVISIONISM REVISITED

Postmodern, or "revisionist," architecture takes past styles and does something new with them. The Spanish architect Ricardo Bofill (BOH-feel; b. 1939) derives much of his architectural language from the past, but he does so without copying. He seizes different

Figure 11.7 Ricardo Bofill, Palace of Abraxas, Marne-la-Vallée, near Paris (1978–1983). Courtesy of Ricardo Bofill, Taller de Arquitectura, Barcelona, Spain.

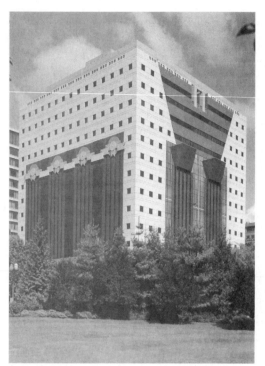

Figure 11.8 Michael Graves, Portland Public Office Building, Portland, Oregon (1979–1982). © Peter Aaron/Esto. All Rights Reserved.

Another clear repudiation of the glass-and-steel box of the international style and other popular forms in mainstream architecture can be seen in the design for the Pompidou (pohm-pee-DOO) Center in Paris (Plate 9). Here the building is turned inside out, with its network of ducts, pipes, and elevators color-coded and externalized, and its structure hidden. The interior spaces have no fixed walls, but temporary dividers can be arranged in any configuration that is wanted. The bright primary colors on the exterior combine with the serpentine, plexiglass-covered escalators to give a whimsical, lively appearance to a functional building. The Pompidou Center has become a major tourist attraction rivaling the Eiffel Tower, and, while controversial, it has gained wide popular acceptance.

Elizabeth Diller and Ricardo Scofidio together form Diller + Scofidio, a collaborative, interdisciplinary studio involved in architecture, the visual arts, and the performing arts. Their Blur Building, a media building for Swiss EXPO 2002, turns architecture into performance art. Blur Building (Figure 11.9) is a cloud measuring 300 feet wide by 200 feet deep hovering over Lake Nuechâtel in Yverdon-les-Bains, Switzerland, and floating at a height of 75 feet above the water. The cloud consists of filtered lake water shot as a fine mist through a dense array of high-pressure fog nozzles. The artificial cloud is a dynamic form that constantly changes shape in response to actual weather: A built-in weather station electronically adjusts the water pressure and temperature in thirteen zones according to shifting humidity, wind direction, and speed.

The public can approach the cloud from shore via pedestrian ramp. Upon entering, visual and acoustical references are slowly erased, leaving only an optical "white-out" and the "white noise" of pulsing fog nozzles. Sensory deprivation stimulates a sensory heightening: The density of air inhaled with every breath, the lowered temperature, the soft sound of water spray, and the scent of atomized water begin to overwhelm the senses. The public can circulate through the cloud, enter an interactive media space at its center, discover small media events distributed just outside in the fog, then proceed up and emerge, in the words of the architects, "like an airplane piercing a cloud layer" to the Angel Bar at the summit.

CYBER AND COMPUTER ART— A NEW WAY OF SEEING?

Cyber art, in contrast to modern art (that sought to bring three-dimensional images together with the two-dimensional and to diminish the importance of representing real

Figure 11.9 Diller + Scofidio, Blur Building, Yverdon-les-Bains, Switzerland (2002)/Diller & Scofidio.

space so as to emphasize other types of reality), created artificial environments that viewers experience as real space. Also known as *cyberspace, hyperspace,* or *virtual reality,* cyber artists allow viewers, by donning a set of goggles containing a small video monitor for each eye, to move in the environment and, to a degree, control it.

Computer art, in the strictest sense, is neither art form nor style. Computers (and other technologies) are tools, like brushes and paint, that artists use to bring their creative ideas to full visualization. In that sense—arguably the truest sense—discussion of computer art belongs in Chapter 2 or Chapter 5 as an exploration of an artistic medium. Arguably, the medium is always part of the product as well as the process, but in the case of some contemporary explorations it seems to come closer to

product than to process. It has, however, offered a different way to view the world and visualize in entirely new ways, as we discussed in the introduction (p. 10). One case in point is Lilla LoCurto and William Outcault's *Polyconic BSIsph (8/6) 7_98* (Figure 11.10). Here, using sophisticated technology, the artists digitally deconstructed photo images of their bodies into nearly nonrepresentational self-portraits that suggest a wider reality, perhaps encompassing even the cosmos. According to a 1999 statement by the artists, the final work was "intended to be processed through a computer and presented as projections (for example, a Mercator map projection). A projection, in cartographic terms, is the transference of details from a three-dimensional object, such as the earth, onto a single plane, such as a map, and we believed this process would serve to

Figure 11.10 Lilla LoCurto and William Outcault, *Polyconic BSIsph (8/6)7_98* (2000). Chromogenic Print, 48" × 62½"/LoCurto/Outcault.

deconstruct the human form in terms of its volumes by rendering it in absolute two dimensions." The project was actualized using a large three dimensional scanner, traditional mapping software, and a software to make the two compatible. The object, in one sense traditional—that is, in the desire to translate the three-dimensional human form into a two-dimensional painting or drawing—was to visualize the human form in an entirely new way.

CYBER SOURCES FOR ADDITIONAL STUDY

c. 1960–Present

http://www.panix.com/~fluxus/FluX/ESH.html
http://www.judychicago.com
http://www.audreyflack.com
http://www.pixcentrix.co.uk/pomo/arts/arts.htm
http://www.pixcentrix.co.uk/pomo/arch/arch.htm

PROFILES

Lillo LoCurto
William Outcault

After graduating with Master's of Fine Arts degrees in sculpture from Southern Illinois University in 1978, LoCurto and Outcault, who are husband and wife, pursued independent artistic careers. LoCurto built room-size installations of found and sculpted objects to make political or moral statements. Outcault created abstract sculptures from such materials as wood, plaster, fiberglass, and lead. His work suggested organic forms such as eggs, breasts, or cocoons while remaining essentially nonreferential. The use of repetition and the grid, typical of minimal art, also played a role in his sculpture. The artists regularly gave each other feedback, offering direct and honest critiques of each other's work. Conceptual input evolved into actual collaboration when they decided to pool their resources on a project.

They created their first collaborative work in 1992. They chose images of the fragmented body, their own and others, as a metaphor for the assault on the integrity of the private and public body in times of crisis.

Around 1996, the artists decided to return to a self-portrait project, working with digital technology, which then required over two years of research and development, culminating in a series of works called *selfportrait.map,* of which Figure 11.10 is one example.

(From the catalogue, *Selfportrait.map,* prepared by Helaine Posner, Lyman Allyn Museum of Art at Connecticut College)

12

Conclusion

Applying Critical Thought

What Is Art Criticism?

One of the questions we all seem to ask about an artwork is, "Is it any good?" Whatever the form or medium, judgments about the quality of the work often vary from one extreme to another, ranging from "I like it" and "interesting," to specific reasons why the artwork is thought to be effective or ineffective.

Because the word *criticism* implies many things to many people, we must first agree on what it means—and what it does not. Criticism does not necessarily mean saying negative things about a work of art. All too often we think of critics as people who pass judgments, giving their opinions on the value of a painting, sculpture, work of architecture, and so on. Personal judgment may result from criticism, but criticism implies more than passing judgment.

Criticism *should* be a *detailed process of analysis to gain understanding and appreciation*. Identifying the formal elements of an artwork—learning what to look for—is the first

step. We *describe* an artwork by examining its many facets, and then trying to understand how they work together to create meaning or experience. Next, we try to state what that meaning or experience is. Only when that process is complete should the critic attempt judgment.

Professional critics usually bring to the process a set of standards developed from personal experience. Whenever a critic or we apply personal standards, the process of criticism becomes complicated. First of all, knowledge of the art form may be shallow. Second, perceptual skills may be faulty; and finally, the range of personal experience may be limited. In addition, the application of personal standards can be problematic if judgement is based on preestablished criteria: If someone believes that "beauty" and/or usefulness, for example, are essential elements of a work of art, then any work that does not meet those criteria will be judged as faulty, despite other qualities that may make the work unique and profound. Preestablished

criteria often deny critical acclaim to new or experimental approaches in art.

What, then, are we to conclude? What if my criteria do not match yours? What if two "experts" disagree on the quality of a work of art? Does that make any difference to our experience of it? The answers to such questions are complicated. To begin with, value judgments are intensely personal, and some opinions are more informed than others, thus representing more authoritative judgments. However, disagreements about quality can actually enhance, rather than confuse, the experience of a work of art: If they lead to examination about why the differences might exist, we gain a deeper understanding of the artwork. Nonetheless, criticism may be exercised without involving any value judgment whatsoever—and this is the point: We can thoroughly analyze and dissect any work of art and describe what it comprises without making value judgments. For example, we can describe and analyze line, color, mass, balance, texture, composition, and/or message. We can observe how all these factors affect people and their responses. We can spend significant amounts of time and write at considerable length in such a process and never pass a value judgment at all.

Does this discussion mean all artworks are equal in value? Not at all. It means that in order to understand what criticism involves, we must separate descriptive analysis, which can be satisfying in and of itself, from the act of passing value judgments. We may not like the work we have analyzed, but we may have understood something we did not understand before. Passing judgment may play no role whatsoever in our understanding of an artwork. But we are still involved in criticism.

As an exercise in understanding, criticism is necessary. We must investigate and describe. We must experience the need to know enough about the process, product, and experience of art if we are to have perceptions that mean anything worthwhile to ourselves and if we are to have perceptions to share with others.

Now that we have examined briefly what criticism is and why we might engage in it, what criteria or approaches can we use?

TYPES OF CRITICISM

There are a number of ways to "criticize" or analyze works of art. Some are fairly straightforward, and some are relatively complex and theoretically involved. Let's begin with two basic types of criticism. These are *formal* criticism and *contextual* criticism. Once we have these concepts in hand, we can branch out a little to examine the theoretically involved and opposing critical theories of structuralism and deconstruction.

Formal Criticism

Formal criticism is a visual analysis applying no external conditions or information. The artwork is analyzed according to style, composition—elements of line, form, color, balance—technique, and so forth. Formal criticism approaches the artwork solely as an entity within itself. As an example, consider this brief analysis of J. M. W. Turner's *Slave Ship* (Figure 12.1).

When we first experience Turner's painting, the vibrant color slashing across the upper left to lower right diagonal presents us with a sense of energy. The *painterly* quality of the way Turner has applied his paint adds to the energy by diluting color edges rather than creating forms with distinct outlining. Line does describe a few forms: We can distinguish a ship in the churning sea, and if we look carefully, we find floating bodies. What strikes most, though, is the energy caused by line and color. Form recedes almost to the background, and were it not for the title of the painting, a formal analysis would give us nothing to

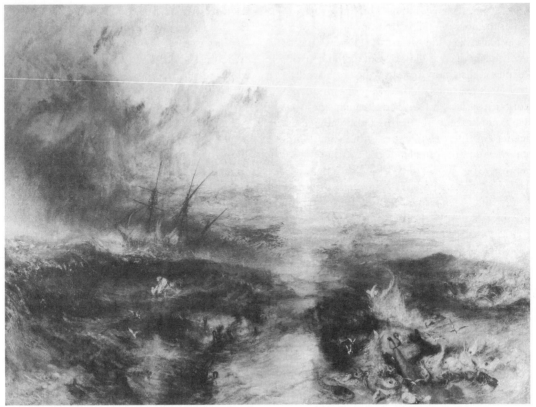

Figure 12.1 Joseph Mallard William Turner (British, 1775–1851), *Slave Ship (Slavers Throwing Overboard the Dead and Dying, Typhoon Coming On)* (1840). Oil on canvas, 90.8cm × 122.6cm (35¾″ × 48¼″). Henry Lillie Pierce Fund. Courtesy, Museum of Fine Arts, Boston. Reproduced with permission. © 2000, Museum of Fine Arts, Boston. All Rights Reserved.

suggest meaning other than the impression of color and intensity. We are left with the sense that high emotion is somewhere at the heart of how this painting works.

We have just described an initial reaction to, and description of, this work. Were we to go one step further, we would analyze more fully the elements of line, form, color, and principles of balance, rhythm, and so forth. We would look throughout the painting and explain how Turner has taken these basic qualities (qualities we discussed in Chapter 2) and used them to build the work—how the employment of elements reveals style and

makes the work affect the respondent. In so doing, we would develop a rather lengthy formal analysis of this artwork. In doing this, however, we would remain in our description and analysis strictly within the frame. In other words, all of the conclusions we would reach about Turner's *Slave Ship* would come solely from evidence that exists on the canvas. Thus, we can analyze a work of art thoroughly in a formal way by observing what there is to see, guided by our understanding of the formal and technical aspects of painting.

In this formal approach, external information—about the painter, the times, the story

behind the painting, and so on—is irrelevant. Consequently, the formal approach helps us analyze how an artwork operates and helps us decide why the artwork produces the response it does. We can apply this form of criticism to any work of art and come away with a variety of conclusions. Of course, knowledge about how artworks are put together, what they are, and how they stimulate us enhances the critical process. Knowing the basic elements of the artwork gives us a ready outline on which to begin a formal analysis.

Contextual Criticism

Contextual criticism seeks meaning by adding to formal criticism an examination of related information outside the artwork, such as facts about the artist's life, his or her culture, social and political conditions and philosophies, public and critical responses to the work, and so on. These can all be researched and applied to the work in order to enhance perception and understanding. Contextual criticism views the artwork as an artifact generated from particular contextual needs, conditions, and/or attitudes. If we carry our discussion of Turner's painting in this direction, we would note that certain historical events help clarify the work.

The painting visualizes a passage in James Thomson's poem *The Seasons,* which describes how sharks follow a slave ship in a storm, "lured by the scent of steaming crowds of rank disease, and death." The poem was based on an actual event in which the captain of a slave ship dumped his human cargo into the sea when disease broke out below decks.

If we were to pursue this path of criticism, we would pursue any and all contextual matters that might illuminate or clarify what happens in this painting. Contextual criticism may also employ the same kind of internal examination followed in the formal approach.

Structuralism

Structuralism applies to the artwork a broader significance, insisting, as we noted in Chapter 11 (p. 194) that individual phenomena—in this case, artworks—can be understood *only* within the context of the overall structures of which they are a part. These structures represent universal sets of relationships that derive meaning from their contrasts and interactions within a specific context. Structuralist criticism, associated with Roland Barthes (1915–1980), derives by analogy from structural linguistics, which sees a "text" as a system of signs whose meaning is derived from the pattern of their interactions rather than from any external reference. This approach opposes critical positions that seek to determine an artist's intent, for example. Thus, the meaning of Turner's *Slave Ship* lies not in what Turner may have had in mind, but in the patterns of contextual relationships that work within the painting. Finally, structuralism also opposes approaches, such as deconstruction, which deny the existent of uniform patterns and definite meanings.

Deconstruction

Deconstruction, associated with the French philosopher Jacques Derrida (dare-ee-DAH; b. 1930), was also originally associated with literary criticism, but has been applied to other disciplines. Derrida used the term *text*, for example, to include any subject to which critical analysis can be applied. Deconstructing something means "taking it apart." The process of deconstruction implies drawing out all the threads of a work to identify its multitude of possible meanings, and, on the other hand, undoing the "constructs" of ideology or convention that have imposed meaning on the work. All of this leads to the conclusion that there is no such thing as a single meaning in a work of art, nor can it claim any absolute

truth. Inasmuch as a work can outlast its author, its meanings transcend any original intentions. In other words, the viewer brings as much to the work as the artist; thus, there are no facts, only interpretations. The story of the slave ship in Turner's painting, for example, becomes only a sidebar to the interpretation that we, as viewers, bring to it based on our own experiences and circumstances.

Both structuralism and deconstruction are much more complex and philosophically and sociologically involved than the limited space available in this text allows us to discuss in detail. However, they illustrate the diversity of theories and approaches that are possible when encountering works of art. These theories—as well as the simple processes of formal and contextual criticism—merit further exploration and classroom discussion as ways in which we can engage, analyze, come to know as best we can, and, ultimately, judge works of art.

MAKING VALUE JUDGMENTS

Now that we have defined criticism and noted, however briefly, approaches we might take in pursuit of understanding and enjoying works of art, we can move on to another step: making value judgments.

There are several approaches to the act of judgment. Two characteristics, however, apply to all artworks: Artworks are *crafted,* and they *communicate* something about the experience of being human (the human condition). Making a value judgment about the quality of an artwork should address each of these characteristics.

Artisanship

Is the work well made? To make this judgment, we first need some understanding of the medium in which the artist works. For example, if the artist proposes to give us a lifelike vision

of a tree, can the artist handle the paint to make the tree look like a tree? Of course, that is an oversimplification: If artisanship depended only on the ability to portray content naturalistically, value judgment would be easy, and all artworks would look like illustrations. Thus, understanding artisanship means understanding the techniques, practices, and styles of artistic media. That may limit our ability to make sophisticated judgments about an artwork, but it does not prevent us from applying what we know and can see. In general, we can say that good artisanship means the work will have clarity and hold our interest. If the artwork does not appear coherent or attention providing, we need to take one further step to be sure the fault lies in the artwork and not in us. Then, we can proceed with judgments. The materials we have learned from this text provide a basic set of tools for approaching the task of making judgments about artisanship.

Communication

Evaluating what an artwork is trying to say offers, arguably, more immediate opportunity for judgment and less need for expertise. Johann Wolfgang von Goethe, the nineteenth-century German poet, novelist, and playwright, set out a basic, commonsense approach to evaluating communication in works of art. Because Goethe's approach provides an organized means for discovering an artwork's communication by progressing from analytical to judgmental functions, it is a helpful way to end our discussion on criticism. Goethe suggests that we approach the process by asking three questions: What is the artist trying to say? Does he or she succeed? Was the artwork worth the effort? These three questions focus on the artist's communication by making us identify first what was being attempted, and then on the artist's success in that attempt. The third question, about whether or

not the project was worth the effort, raises another important issue regarding value, and that is uniqueness and profundity. This question asks us to decide if the communication offered important or unique perceptions (as opposed to trivialities and inanities). A well-crafted work of art that merely restates obvious observations and insights lacks communicative quality. A work of art that offers both artisanship and profundity and uniqueness exhibits high quality.

A FINAL THOUGHT

We should think of art as we think of people. Adequate adjustment to the world cannot be made from social responses that simply divide the "good people" from the "bad people." We should be skeptical even of such categories as "the people I like" and "the people I don't like."

If we do maintain such divisions, we find individuals constantly moving from one group to the other. Eventually, we find human differences too subtle for easy classification, and the web of our relationships becomes too complex for analysis. We should, therefore, try to move toward more and more sensitive discrimination, so that there are those we can learn from, those we can work with, those good for an evening of light talk, those we can depend on for a little affection, and so on—with perhaps those very few with whom we can sustain a deepening relationship for an entire lifetime. If and when we have learned this same sensitivity and judgment with regard to works of art—when we have gone beyond the easy categories of the textbooks and have learned to regard our art relationships as part of our own growth—then we shall have achieved a dimension in living that is as deep and as irreplaceable as friendship.

Glossary

abacus: The uppermost member of the capital of an architectural column; the slab on which the architrave rests.

abstract: Nonrepresentational; the essence of a thing rather than its actual appearance.

abstract expressionism: In art, a style of nonrepresentational painting that combines abstract forms with expressionist emotional values.

abstraction: A thing apart; that is, removed from real life.

academic neoclassicism: A style of the late eighteenth and early nineteenth centuries, particularly in France, exemplified by the work of such painters as Jacques-Louis David, who was not only influenced by classical art but took classical themes for his subject matter. See also *neoclassicism*.

accent: Any device used to highlight or draw attention to a particular area.

acrylic: An artist's medium made by dispersing pigment in a synthetic medium.

action painting: A form of abstract expressionism, in which paint is applied with rapid, vigorous strokes or even splashed or thrown on the canvas.

additive: (1) In sculpture, those works that are built. (2) In color, the term refers to the mixing of hues of light.

aesthetic: Having to do with the pleasurable and beautiful as opposed to the useful.

aesthetics: A branch of philosophy dealing with the nature of beauty and art, and their relation to experience.

affective: Relating to feelings or emotions, as opposed to facts.

aleatory: Chance or accidental.

altarpiece: A painted or sculpted panel placed above and behind an altar to inspire religious devotion.

ambulatory: A covered passage for walking, found around the apse or choir of a church.

amphora: A two-handled vessel for storing provisions, with an opening large enough to admit a ladle and usually fitted with a cover.

apse: A large niche-like space projecting from and expanding the interior space of an architectural form such as a basilica.

aquatint: An intaglio process in which the plate is treated with a resin substance to create textured tonal areas.

arcade: A series of arches placed side by side.

arch: In architecture, a structural system in which space is spanned by a curved member supported by two legs.

architrave: In post and lintel architecture, the lintel or lowest part of the entablature, resting directly on the capitals of the columns.

art brut: The name given by the French painter Jean Dubuffet to art created by anyone from outside the art world, such as children, prisoners, and the mentally ill.

Art Deco: An individual decorative arts style occurring between World Wars I and II. The term *Art Deco* was coined from the name of the Exposition Internationale des Arts Décoratifs et Industriels Modernes, held in Paris in 1925. It applied to a variety of products and architecture and is characterized by slender forms, straight lines, and a sleekness expressive of modern technology. The style regained its popularity in the 1970s and 1980s.

aryballus: An Incan bottle-shaped pot with a pointed bottom, which fell over when empty. The word is also used for the round, narrow-necked container used in Greece, apparently to hold perfumed oil.

asymmetry: The balancing of unlike elements on either side of the axis, or centerline, of a work of art.

atmospheric perspective: The depiction of three-dimensional space or distance in a painting through the use of light and atmosphere. See also *linear perspective.*

automatism: A technique in which the artist foregoes the usual intellectual control over his or her medium

avant-garde: French for "advanced guard." A term used to designate innovators, whose experiments challenge established values.

balance: In composition, the equilibrium of opposing or interacting forces. See also *asymmetry* and *symmetry.*

balloon construction: Construction of wood using a skeletal framework. See also *skeleton frame* and *steel-cage construction.*

baroque: A widely diverse seventeenth- and eighteenth-century style of art and architecture that appeals to the emotions through opulence and intricacy.

barrel vault (tunnel vault): A series of arches placed back to back to enclose space.

bas relief: See *low relief.*

basilica: A large rectangular building usually containing clerestory and side aisles separated from the nave by colonnades. Used by the Romans as law buildings and adapted to Christian church use.

bay: One unit of a building's construction system. Bays divide the façade of a building into regular spatial units marked by elements like columns, piers, buttresses, windows, and vaults.

bearing-wall: A form of construction in which the wall supports itself, the roof, and floors. See also *monolithic construction.*

benday dots: Dots used in modern printing and typesetting, comprising the individual dots that, with others, make up lettering and images.

biomorphic: Representing life forms as opposed to geometric forms.

bridging shot: In film, a shot inserted at editing to cover a break in continuity.

burin: A metal instrument used to cut lines in a metal plate for engraving.

buttress: A type of architectural support, usually consisting of masonry, built against an exterior wall to brace the wall and strengthen the vaults.

camera obscura: A darkened box with a hole in the wall used for capturing images of nature in the Renaissance and later. Light passing through the hole projects the scene from

outside on a scrim fabric. This image then can be traced.

cantilever: An architectural structural system in which an overhanging beam is supported at only one end.

capital: The transition between the top of a column and the lintel.

caryatid: A sculpture of a draped female figure acting as a column to support the entablature of a building

cast: Sculptures that are created from molten material in a mold.

Catholic Reformation: A term given to the efforts of those Roman Catholics who wished to achieve an internal rebirth of Catholic sensibility during the time of the Protestant Reformation.

cella: The principal enclosed room of a temple; the entire body of a temple as opposed to its external parts.

chiaroscuro: Light and shade. In painting, the use of highlight and shadow to give the appearance of three-dimensionality.

chroma: The degree of saturation or purity of a color or hue.

cinematic motif: In film, a visual image that is repeated either in identical form or in variation. See also *motif*.

cinéma veritée: Candid camera; a television-like technique of recording life and people as they are. The hand-held camera, natural sound, and minimal editing are characteristic.

cire-perdue (lost wax): A method of casting metal in a mold, the cavity of which is formed of wax, which is then melted and poured away.

classic: Specifically relating to Greek art of the fifth century B.C.E.

classical: Adhering to traditional standards. May refer to Greek and Roman art in which simplicity, clarity of structure, and appeal to the intellect are fundamental.

clerestory: The upper stage or portion of the nave walls of a church or basilica, located above an adjoining roof and admitting light through a row of windows.

cognitive: Facts and objectivity as opposed to emotions and subjectivity. See also *affective*.

colonnade: A row of columns usually spanned or connected by lintels.

color wheel: A circle or wheel in which the primary colors—yellow, red, and blue—are separated by secondary and tertiary colors. The wheel shows the complementary color of each primary color.

colonnette: A small columnlike, decorative vertical element in architecture.

column: A round architectural element used for support and/or decoration.

complementary color: The primary and secondary colors opposite each other on the color wheel. Mixing complementary colors produces gray.

composition: The arrangement of line, form, mass, color, and so forth in a work of art.

compressive strength: The ability of a material to withstand crushing. See also *tensile strength*.

concrete: A building material invented by the Romans that is easily poured or molded when wet but that hardens (sets) into a strong, stonelike substance.

consonance: The feeling of a comfortable relationship between elements of a composition. Consonance may be physical and/or cultural in its ramifications.

content: The subject matter, ideas, artist's intention, and viewer's meaning in works of art.

contrapposto (counterpoise): A means of representing the standing human form in which the weight is shifted to one leg and the hips tilted.

conventions: The customs or accepted underlying principles of an art.

Corinthian: A specific order of Greek architecture. See also *order*.

cornice: The uppermost section of a classical entablature or, more generally, any horizontally projecting element of a building.

counter-reformation: A term denoting the efforts of those who, during the Protestant Reformation, were loyal to the pope and supportive of the customary practices of the Roman Catholic Church in order to counter the teachings and practices of the Protestant reformers.

crenellation: A pattern of open notches along the top of a parapet or battlement in fortified buildings.

crosscutting: In film, alternation between two independent actions that are related thematically or by plot to give the impression of simultaneous occurrence.

cross-hatching: A technique in printmaking and drawing that uses a set of parallel lines (hatching) at angles to another set of parallel lines to create shading and density.

crossing: The intersection of the nave and transept in a cross-shaped church.

cruciform: Anything that is cross-shaped.

cubism: A movement and style of art of the early twentieth century in which objects are represented as assemblages of geometric shapes.

curvilinear: Formed or characterized by curved lines.

cutting: The trimming and joining that occurs during the process of editing a film.

cutting within the frame: Changing the viewpoint of the camera within a shot by moving from a long or medium shot to a close-up, without cutting the film.

daguerreotype: An early photographic process using a metal plate to capture a photographic image. Invented by Louis-Jacques Mondé Daguerre.

deésis: An artwork representing Christ in majesty seated between the Virgin Mary and John the Baptist.

depth of focus: In film, when both near and distance objects are clearly seen.

design: A comprehensive scheme, plan, or conception.

diptych: Two panels of equal size, usually painted or decorated, hinged together.

direct address: In film, when a character addresses the audience directly.

dissolve: In film, to make an object or person appear or disappear from view.

dissonance: The occurrence of inharmonious elements. The opposite of consonance.

divisionism: The juxtaposition of tiny dots of unmixed paints, giving an overall effect of color when mixed optically by the viewer's brain. Also known as pointillism.

documentary: In photography or film, the recording of actual events and relationships using real-life subjects as opposed to professional actors.

dolly shot: In film, a shot taken by moving the camera, which is mounted on a "dolly," toward or away from an object or person.

dome: An architectural form based on the principles of the arch in which space is defined by a hemisphere used as a ceiling.

Doric: A Greek order of architecture having no base and only a simple slab as a capital. See also *order.*

drypoint: An intaglio printmaking process in which a pointed metal instrument (stylus) is used to inscribe a metal plate.

eclecticism: A combination of examples of several differing styles in a single composition.

editing: The composition of a film from various shots and sound tracks.

embossing: The creation of raised designs in the surface of, for example, paper, leather, or metal.

empirical: Based on experiment, observation, and practical experience, without regard to theory.

encaustic: A type of painting technique using pigments mixed with hot wax.

engaged column: A column, often decorative, which is part of, and projects from, a wall surface.

engraving: An intaglio process in which sharp, definite lines are cut into a metal plate.

entablature: The upper portion of a classical architectural order above the column capital.

entasis: A slight outward curve in the shaft of a column.

ephemeral: Transitory; not lasting.

establishing shot: In film, a long shot at the beginning of a scene to establish the time, place, and so forth. See also *master shot*.

etching: An intaglio process; lines are cut in the metal plate by an acid bath.

expressionism: A movement in art of the early twentieth century, in which artists attempted to express emotional experience rather than impressions of the external world. It was characterized by the distortion of reality and the use of symbols and stylization.

façade: The front of a building; or the sides, if they are emphasized architecturally.

fauvism: A style of painting, developed in the early twentieth century, characterized by the vivid use of color.

fenestration: Exterior openings, such as windows and archways, in an architectural façade.

ferroconcrete (reinforced concrete): Concrete reinforced with rods or mesh of steel.

fluting: Vertical ridges in a column.

flying buttresses: A semidetached buttress.

focal point (focal area): A major or minor area of visual attraction.

foreground: The area of a picture, usually at the bottom, that appears to be closest to the viewer.

form: The shape, structure, configuration, or essence of something: The purely visual elements of line, shape, color, texture, mass, and so on that constitute a work of art.

form cutting: In film, the reframing in successive shots of an object that has a shape similar to an image in the preceding shot.

found object: An object taken from life that is presented as an artwork.

frame: In film, a single or complete image.

fresco: A method of painting in which pigment is mixed with wet plaster and applied as part of the wall surface.

frieze: (1) The central portion of the entablature between the architrave and cornice. (2) Any horizontal decorative or sculptural band.

full-round: See *sculpture*.

genre: (1) A category of artistic composition characterized by a particular style, form, or content. (2) A style of painting representing an aspect of everyday life, such as a domestic interior or a rural scene.

geodesic dome: A dome-shaped framework constructed from short, straight, lightweight bars that form a grid of polygons.

geometric: Based on man-made patterns, such as triangles, rectangles, circles, ellipses, and so on. The opposite of *biomorphic*.

gestalt: A whole; the total of all elements in an entity.

glyptic: Sculptural works emphasizing the qualities of the materials from which they are created.

gopura: The monumental gateway to a Hindu temple.

Gothic: A medieval style of art, especially architecture, based on a pointed arch structure and characterized by simplicity, verticality, elegance, and lightness.

gouache: A watercolor medium in which gum is added to ground opaque colors and mixed with water.

graphic arts: Those media of the arts that utilize paper as a primary support.

Greek cross: A cross in which all arms are the same length.

groin vault: The ceiling formation created by the intersection of two tunnel or barrel vaults.

ground: (1) A surface to which paint is applied. (2) The coating material in which lines are scratched to produce designs in such processes as etching.

guardian figure: A figure made by ancestor-worshiping societies to watch over (guard) the remains of dead tribe members.

harmony: The relationship of like elements such as colors and repetitive patterns. See also *consonance* and *dissonance*.

Hellenistic: Relating to the time from Alexander the Great to the first century B.C.E.

hierarchy: Any system of people or things that has higher and lower ranks.

hieratic: (1) Of or used by priests. (2) Of or concerning Egyptian, Byzantine, or Greek traditional styles of art when the desire to communicate spiritual values results in a formalized, grand style for representing rulers or sacred or priestly figures.

high-relief (haut-relief): Relief sculpture in which the figures and forms project from the background by at least half their depth.

horizon line: A real or implied line across the picture plane, which, like the horizon in nature, tends to fix the viewer's vantage point.

hue: The spectrum notation of color; a specific, pure color with a measurable wavelength. There are primary hues, secondary hues, and tertiary hues.

hypostyle: A hall with a roof supported by rows of columns.

icon: Greek for "image." An image representing a sacred figure or event in the Eastern rite of the Christian church.

iconoclasm: Referring to the eighth- and ninth-century period in Byzantium and the sixteenth- and seventeenth-century period in Protestantism in which icons were banned.

iconography: Study of the subject matter of a representation and its meaning.

idealization: The striving to make forms and figures attain perfection or representation of figures in their ideal state—based on cultural values or ideals of the artist.

igneous rock: A very hard rock, such as granite, produced by volcanic or magmatic action and usually too hard to carve. See also *metamorphic rock* and *sedimentary rock.*

impasto: The painting technique of applying pigment so as to create a three-dimensional surface.

intaglio: The printmaking process in which ink is transferred from the grooves of a metal plate to paper by extreme pressure.

intensity: The degree of purity of a hue.

intrinsic: Belonging to a thing by its nature.

Ionic: A Greek order of architecture that employs a scroll-like (volute) capital with a circular base.

iris: In film and photography, the adjustable circular control of the aperture of a lens.

isolation shot: In film, the isolation of the subject of interest in the center of the frame.

jamb: The upright piece forming the side of a doorway or window frame.

jump cut: In film, the instantaneous cut from one scene to another or from one shot to another, often used for shock effect.

key: See *value.*

keystone: The topmost voussoir at the center of an arch. The pressure of the keystone holds the arch together.

kouros: An archaic Greek statue of a standing male youth (kouroi: male plural; kore: maiden; korai: feminine plural).

krater: A bowl for mixing wine and water, the usual Greek beverage.

kylix: A vase turned on a potter's wheel; used as a drinking cup.

lap dissolve: In film, the simultaneous fade in and fade out of two scenes so that they briefly overlap.

Latin cross: A cross in which the vertical arm is longer than the horizontal arm, through whose midpoint it passes.

lekythos: An oil flask with a long, narrow neck adapted for pouring oil slowly; used in funeral rites.

linear, linearity: An emphasis on line, as opposed to mass or color.

linear perspective (one-point, multiple point, mathematical, and sometimes, Renaissance perspective): The creation of the illusion of distance in a two-dimensional artwork through the convention of line and foreshortening. That is, the illusion that parallel lines come together in the distance. See also *atmospheric perspective* and *perspective.*

linear: See *sculpture.*

lintel: The horizontal member of a post and lintel structure system in architecture.

lithograph: A print made from a design drawn on a flat stone with a greasy crayon and based on the principle of the antithesis of oil and water.

lost-wax: See *cire-perdue.*

low relief (bas-relief): Relief sculpture in which figures and forms project only slightly from the background. See also *high relief.*

magnitude: The scope or universality of the theme in a film.

manipulation: A sculptural technique in which materials such as clay are shaped by the skilled use of hands.

masonry: In architecture, stone or brickwork.

mass: Actual or implied physical bulk, weight, and density of a work of art.

master shot: In film, a single shot of an entire piece of action. See also *establishing shot.*

medium: The process employed by the artist. Also, the binding agent that holds pigments together.

metamorphic rock: A rock such as marble that is formed by natural forces such as heat, pressure, or chemical reaction. See also *igneous rock* and *sedimentary rock.*

metope: The rectilinear spaces between the triglyphs of a Doric frieze.

middle ground: The space in an artwork that represents the middle distance of the image. See also *foreground.*

mobile: A constructed sculpture whose components have been connected by joints to move by force of wind or motor.

modeling: In painting, the process of creating the illusion of three-dimensionality on a two-dimensional surface using light and shade. In sculpture, the process of molding an object from a malleable material.

monolithic construction: A variation of bearing-wall construction in which the wall material is not jointed or pieced together.

montage: The process of making a single composition by combining parts of others. A rapid sequence of film shots bringing together associated ideas or images.

monumental: The appearance in a work of art of grandeur and excellence; actually or appearing larger than life size.

mosaic: Images created from small colored stone or glass pieces fixed to a hard surface.

motif: Any recurring element or theme in a work of art.

mural: A large painting done directly on a wall or affixed to a wall.

narthex: A porch or vestibule at the main entrance of a church.

naturalism, naturalistic: A style of depiction in which true-to-lifeness is primary.

nave: The main, central area of a church.

neoclassicism: Various artistic styles that borrow the devices or objectives of classical art.

Neoplatonism: Any of the schools of philosophy based on modified Platonism, but especially that developed by the followers of Plotinus in the third century C.E.

niche: A hollow recess in a wall or other solid architectural element.

nonobjective: Without reference to reality; may be differentiated from "abstract."

nonrepresentational: Any work of art that does not seek to picture the natural world, including abstract and nonobjective.

objective camera: A camera position based on a third-person viewpoint.

oculus (oculi): A circular opening at the apex of a dome.

oil painting: A painting using pigment suspended in oil.

objet d'art: A French term meaning "object of art."

opus: A single work of art.

order: A system of proportions in classical architecture. Composite: Combining Ionic and Corinthian. Corinthian: The most ornate of the orders, including a base, fluted columns, and elaborate, acanthus leaf carvings in the capitals. Its entablature has an architrave decorated with moldings, a frieze often with

sculptured reliefs, and a cornice with dentils. Doric: A fluted or smooth column shaft, no base, and an undecorated capital. The Doric entablature contains a plain architrave, a frieze with metopes and triglyphs, and a simple cornice. Ionic: A fluted shaft with a base, and a capital decorated with volutes. The architrave has two panels and moldings, a frieze, usually sculpted with reliefs, and a dentilated cornice.

orthogonal: Any line running back into the depicted space of a picture.

painterly: A style of painting emphasizing technique and surface effects of brushwork.

palette: The overall use of color in a work of art. A hand-held board on which paints are mixed.

pan: In film, to follow a moving object with the camera.

pantheon: A Greek word meaning all the gods of a people.

parallel development: The use in film of cross-cutting between scenes of contemporaneous action, often for tonal effect.

patina: The film, usually greenish, that forms on the surface of copper and bronze as a result of oxidation; also known as verdigris and aerugo. The word is also used for the gloss produced by age on wood and other surfaces.

pediment: A gable, usually triangular—over major architectural elements such as porticoes, windows, and doorways.

pendentive: A triangular part of the vaulting which allows the stress of the round base of a dome to be transferred to a rectangular wall base.

persistence of vision: The continuance of a visual image on the retina for a brief time after the removal of the object from sight.

perspective: The representation of distance and three-dimensionality on a two-dimensional surface. See also *atmospheric perspective* and *linear perspective.*

photojournalism: Photography of actual events that may have sociological significance.

picture plane: The theoretical spatial plane corresponding with the actual surface of a painting.

pier: A masonry support consisting of stones or rubble and concrete (as opposed to a column, which is of one piece). Usually rectangular in shape.

pietà: A depiction of the crucified Christ laid in his mother's lap.

pilaster: An engaged, rectangular columnar element used for decoration on a building.

plan: An architectural drawing of a building as seen from above that reveals in two dimensions the arrangement and distribution of interior spaces and walls, as well as door and window openings.

Planographic process: A method of printing from a flat surface, such as lithography.

plasticity: The capability of being molded or altered. In film, the ability to be cut and shaped. In painting, the accentuation of dimensionality of form through chiaroscuro.

platemark: The ridged or embossed effect created by the pressure used in transferring ink to paper from a metal plate in the intaglio process.

pointillism: In art, a kind of French postimpressionism in which color is applied in tiny dots or small, isolated strokes. Forms are visible only from a distance. Also known as divisionism.

porcelain: A variety of hard, nonporous, translucent ceramic ware, made from kaolin, feldspar, and quartz or flint.

portico: An open or partly enclosed roofed space, usually serving as an entrance and often the centerpiece of a façade.

post and lintel: An architectural structure system in which horizontal pieces (lintels) are held up by vertical columns (posts).

post-Columbian: The word used to denote the history, architecture, culture, and so forth of the Americas after Columbus landed there. See also *pre-Columbian.*

post-tensioned concrete (prestressed concrete): Concrete using metal rods and cables under

stress or tension to cause structural forces to flow in predetermined directions.

power figure: A figure regarded by tribal societies as a repository of magic, which could be activated by the insertion of nails.

precast concrete: Concrete cast in place using wooden forms around a steel framework.

pre-Columbian: The word used to denote the history, architecture, culture, and so forth of the Americas before Columbus landed there. See also *post-Columbian*.

prestressed concrete: See *post-tensioned concrete*.

primary colors: Colors that cannot be achieved by mixing other colors. In pigment, red, blue, and yellow. In light, red, blue, and green.

proportion: The relation, or ratio, of one part to another and of each part to the whole with regard to size, height, width, length, or depth.

prototype: The model on which something else is based.

putto (plural putti): A representation of a naked child, especially a cupid or cherub, particularly in Renaissance art.

pyramidal structure: In film, the rising of action to a peak, which then tapers to a conclusion.

realism: a style of art based on the theory that the method of presentation should be true to life. Employs selected details, without scientific or social theory, in contrast to naturalism.

rectilinear: The formed use of straight lines and angles.

register: A range or row, especially when one of a series.

reinforced concrete: See *ferroconcrete*.

relief: See *sculpture*.

relief printing: The process in printmaking by which the ink is transferred to the paper from raised areas on a printing block.

representational: Objects that are recognizable from real life. See also *abstract, non-objective*, and *nonrepresentational*.

rhythm: The relationship between recurring elements of a composition.

rib: In a vault system, a slender architectural support projecting from the surface.

rib vault: A structure in which arches are connected by diagonal as well as horizontal members.

rococo: A style of architecture and design, developed in France from the baroque and characterized by elaborate and profuse ornamentation, often in the form of shells, scrolls, and the like.

Roman cross: A cross with a long vertical arm and a shorter horizontal one; also known as a Latin cross.

Romanesque style: A broad style of visual art and architecture referring to vaulted medieval architecture preceding the Gothic style.

rotunda: Any building or part of a building constructed in a circular or, sometimes, polygonal, form and capped by a dome.

rustication: A rough (rustic), unfinished effect deliberately given to the exterior of a building.

saturation: In color, the purity of a hue in terms of whiteness.

scale: The mass of a building in relation to a given measurement, such as the human body.

sculpture: A three-dimensional art object. Among the types are *relief*, which is attached to a larger background; *full-round*, which is freestanding; and *linear*, which emphasizes two-dimensional materials.

sedimentary rock: A rock such as limestone or sandstone that is formed by erosion and deposition. See also *igneous rock* and *metamorphic rock*.

serigraphy: A printmaking process in which ink is forced through a piece of stretched fabric, part of which has been blocked out; for example, silk-screening and stenciling.

sfumato: In painting, a smoky, hazy effect. Characteristic of Leonardo da Vinci.

shape (form): An area or plane with distinguishable boundaries.

silhouette: A form as identified by its outline.

silk-screening: See *serigraphy*.

skeleton frame: Construction in which a skeletal framework supports the building. See also *balloon construction* and *steel-cage construction*.

spansion architecture: A style of architecture that takes to the extreme the horizontal distance between the supports of a bridge, arch, and so forth.

static: Devoid of movement or other dynamic qualities.

steel-cage construction: Construction using a metal framework. See also *balloon construction* and *skeleton frame*.

stela (stelae): A vertical stone slab decorated with inscriptions and/or reliefs.

stippling: Applying small dots of color with the point of a brush.

stucco: A plaster used as a finishing and protective covering on walls. A mixture including lime and powdered marble was used extensively in Europe for relief decorations (see *sculpture*) from the sixteenth century.

style: Those characteristics of a work of art that identify it with an artist, a group of artists, an era, or a nation.

stylization: Reliance on conventions, distortions, or theatricality; the exaggeration of characteristics that are essentially lifelike.

stylobate: The foundation immediately below a row of columns.

stylus: A pointed instrument used in printmaking for making a delicate scratch in a metal plate.

subject matter: See *content*.

substitution: A sculptural technique utilizing materials transformed from a plastic, molten, or fluid into a solid state.

subtractive: (1) In sculpture, referring to works that are carved. (2) In color, referring to the mixing of pigments as opposed to the mixing of colored light.

suspension construction: In architecture, the use of steel cables to suspend bridges, walkways, and the like.

surrealism: A movement in art developed in the 1920s in which artists gave free rein to the imagination, expressing the subconscious through the irrational juxtapositions of objects and themes.

symbol: A form, image, or subject standing for something else.

symbolism: The suggestion through imagery of something that is invisible or intangible. In art the word refers especially to the French and Belgian artists of the late nineteenth century who rejected realism and sought to express ideas, emotions, and attitudes by the use of symbolic objects, and so on.

symmetry: The balancing of elements in designs by placing physically equal objects on either side of a center line (axis).

synthesis: The combination of independent factors or entities into a compound that becomes a new, more complex whole.

systematic rationalism: In the seventeenth century, a system developed to explain the universe in both secular and religious terms.

tempera: A painting medium in which pigment is suspended in egg yolk and water and sometimes glue.

tensile strength: The internal strength of a material under tension, relative to twisting and stretching. See also *compressive strength*.

terracotta: An earth-brown clay used in ceramics and sculpture.

texture: The two- or three-dimensional quality of the surface of a work.

theme: The general subject of an artwork.

tint: A hue lightened by the addition of white.

tonality: The characteristics of value in color in an artwork.

tondo: A painting in a circular format.

tone: The overall lightness or darkness of an artwork. Also, the effect of saturation, intensity, or value of color.

tracking: In film, when the camera is moving in the same direction and at the same speed as a person or object being filmed.

tracery: Thin stone or wooden motifs cut into a window, screen, or panel.

transept: The crossing arm of a cruciform church, in contrast to the nave, to which it is at right angles.

transverse arch: In Romanesque and Gothic architecture, an arch separating one bay of a vault from another.

travertine: A hard limestone, found in Italy, used as a building material and for outdoor sculpture.

triglyph: Rectangular blocks between the metopes of a Doric frieze. Identifiable by its three carved vertical grooves.

triptych: An artwork in the form of a set of three panels with related subject matter, often designed as an altarpiece. See also *diptych*.

tompe l'oeil: French for "trick the eye" or "fool the eye." A two-dimensional artwork executed in such a way as to make the viewer believe that three-dimensional subject matter is being perceived.

tunnel vault: See *barrel vault*.

two-shot: In film, a close-up of two people.

tympanum: The open space above the door beam and within the arch of a medieval doorway.

value (value scale): the range of tonalities from white to black.

vanishing point: In linear perspective, the point on the horizon toward which parallel lines appear to converge and at which they seem to vanish.

variation: The repetition of a theme with minor or major changes.

verisimilitude: Lifelikeness or nearness to truth.

volute: A spiral scroll, most often seen on the capital of an Ionic column.

wash: A diluted watercolor or ink used to form broad tonal areas.

watercolor: (1) A pigment or coloring agent mixed with water for use as a paint. (2) An artwork produced with this medium.

wipe: In film, a line passes across the screen eliminating one scene as it reveals the next.

woodcut: A relief printing executed from a design cut in the plank of the grain.

wood engraving: A relief printing made from a design cut in the butt of the grain.

ziggurat: In Mesopotamia, a stepped, rectangular tower, topped by a temple.

Further Reading

Acton, Mary. *Learning to Look at Paintings*. London: Routledge, 1997.

Andreae, Bernard. *The Art of Rome*. New York: Abrams, 1977.

Arnheim, Rudolph. *Art and Visual Perception: A Psychology of the Creative Eye*. Berkeley: University of California Press, 1989.

Arnheim, Rudolph. *Film as Art*. Berkeley: University of California Press, 1997.

Bacon, Edmund N. *Design of Cities*. New York: Viking Press, 1976.

Bazin, Germain. *The Baroque*. Greenwich, CT: New York Graphic Society, 1968.

Benton, Janetta Rebold and Robert DiYanni. *Arts and Culture*. Upper Saddle River, NJ: Prentice Hall, 1999.

Bobker, Lee R. *Elements of Film*. New York: Harcourt Brace Jovanovich, 1979.

Bordwell, David, and Kristin Thompson. *Film Art: An Introduction*. Reading, MA: Addison-Wesley, 1996.

Campos, D. Redig de (ed.). *Art Treasures of the Vatican*. Upper Saddle River, NJ: Prentice Hall, 1974.

Canaday, John. *What is Art?* New York: Knopf, 1990.

Chadwick, Whitney. *Women, Art, and Society*. New York: Norton, 1991.

Ching, Frank D. K., and Francis D. K. Ching. *Architecture: Form, Space, & Order* (2nd ed). New York: Wiley, 1996.

Cook, David. *A History of Narrative Film*. New York: Norton, 1981.

Davis, Phil. *Photography*. Dubuque, IA: Brown, 1996.

De la Croix, Horst, Richard G. Tansey, and Dian Kirkpatric. *Gardner's Art Through the Ages* (9th ed.). San Diego: Harcourt, 1991.

Diehl, Charles. *Byzantium*. New Brunswick, NJ: Rutgers University Press, 1957.

Finn, David. *How to Look at Sculpture*. New York: Abrams, 1989.

Frampton, Kenneth. *Modern Architecture: A Critical History* (3rd ed.). London: Thames and Hudson, 1992.

Giannetti, Louis. *Understanding Movies*. Englewood Cliffs, NJ: Prentice Hall, 1996.

Giedion, Sigfried. *Space, Time, and Architecture: The Growth of a New Tradition* (5th ed.). Cambridge, MA: Harvard University Press, 1967.

Gilbert, Creighton. *History of Renaissance Art Throughout Europe: Painting, Sculpture, Architecture*. New York: Abrams, 1973.

Groenewegen-Frankfort, H.A., and Bernard Ashmole. *Art of the Ancient World*. Upper Saddle River, NJ: Prentice Hall and New York: Abrams, n.d.

Hamilton, George Heard. *Nineteenth- and Twentieth-Century Art: Painting, Sculpture, Architecture*. New York: Abrams, 1970.

Hartt, Frederick. *Art* (4th ed.). Upper Saddle River, NJ: Prentice Hall and New York: Abrams, 1993.

Hartt, Frederick. *Italian Renaissance Art* (3rd ed.). Upper Saddle River, NJ: Prentice Hall and New York: Abrams, 1987.

Held, Julius, and D. Posner. *17th and 18th Century Art*. New York: Abrams, n.d.

Henig, Martin (ed.). *A Handbook of Roman Art*. Ithaca, NY: Cornell University Press, 1983.

Heyer, Paul. *Architects on Architecture: New Directions in America*. New York: Walker, 1978.

Hitchcock, Henry-Russel. *Architecture: Nineteenth and Twentieth Centuries*. Baltimore: Penguin, 1971.

Honour, Hugh, and John Fleming. *The Visual Arts: A History* (4th ed.). Upper Saddle River, NJ: Prentice Hall and New York: Abrams, 1995.

Hyman, Isabelle, and Marvin Trachtenberg. *Architecture: From Prehistory to Post-Modernism/ The Western Tradition*. New York: Abrams, 1986.

Janson, H. W. *History of Art* (5th ed.). Upper Saddle River, NJ: Prentice Hall and New York: Abrams, 1995.

Le Corbusier, Charles-Édouard Jeaneret. *Towards a New Architecture*. New York: Dover, 1986.

Martin, Judy. *The Encylopedia of Printmaking Techniques*. Philadelphia: Running Press, 1998.

Nesbitt, Kate (ed.). *Theorizing a New Agenda for Architecture: An Anthology of Architectural Theory, 1965–1995*. New Haven, CT: Princeton Architectural Press, 1996.

Ocvirk, Otto G. (ed.) Robert E. Stinson, Philip R. Wigg, and Robe Bone. et al. *Art Fundamentals* (7th ed.). Madison, WI, and Dubuque IA: Brown and Benchmark, 1994.

Rasmussen, Steen Eiler. *Experiencing Architecture*. Cambridge, MA: MIT Press, 1984.

Rohmann, Chris. *A World of Ideas*. New York: Ballantine Books, 1999.

Sayre, Henry M. *A World of Art* (2nd ed.). Upper Saddle River, NJ: Prentice Hall, 1997.

Sporre, Dennis. *The Creative Impulse* (5th ed.). Upper Saddle River, NJ: Prentice Hall, 2000.

_____. *Perceiving the Arts* (6th ed.). Upper Saddle River, NJ: Prentice Hall, 2000.

_____. *Reality Through the Arts* (4th ed.). Upper Saddle River, NJ: Prentice Hall, 2001.

Stokstad, Marily. *Art History*. Upper Saddle River, NJ: Prentice Hall. and New York: Abrams, 1995.

_____. *Art: A Brief History* (rev. ed.). Upper Saddle River, NJ: Prentice Hall and New York: Abrams, 2000.

Summerson, John Newenham. *Classical Language of Architecture*. Cambridge, MA: MIT Press, 1984.

Thompson, Kristin, and David Bordwell. *Film History: An Introduction*. New York: McGraw-Hill, 1994.

Vacche, Angela Dalle. *Cinema and Painting: How Art Is Used in Film*. Austin, TX: University of Texas Press, 1996.

Yenawine, Philip. *How to Look at Modern Art*. New York: Abrams, 1991.

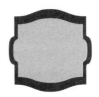

Index